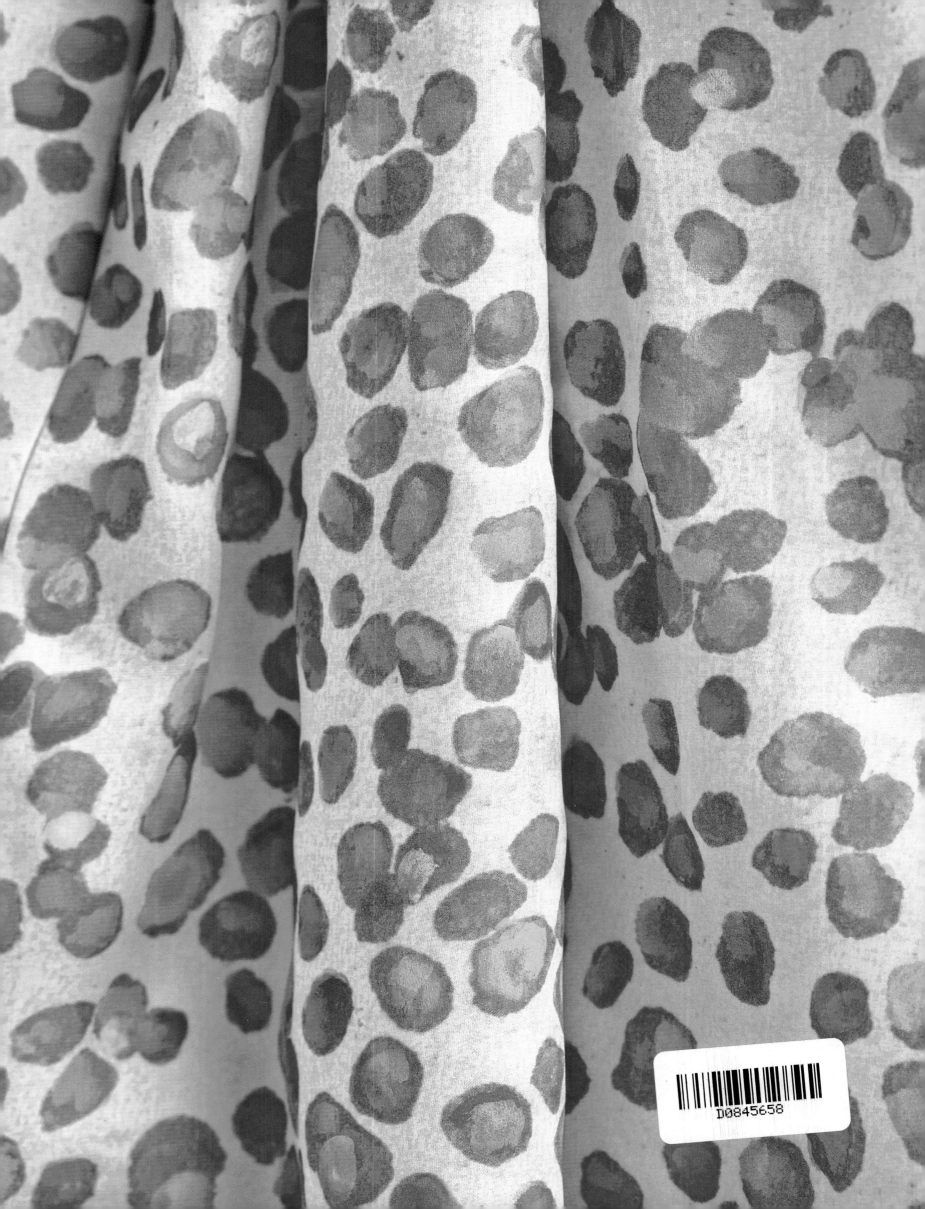

# isaac
# mizrahi

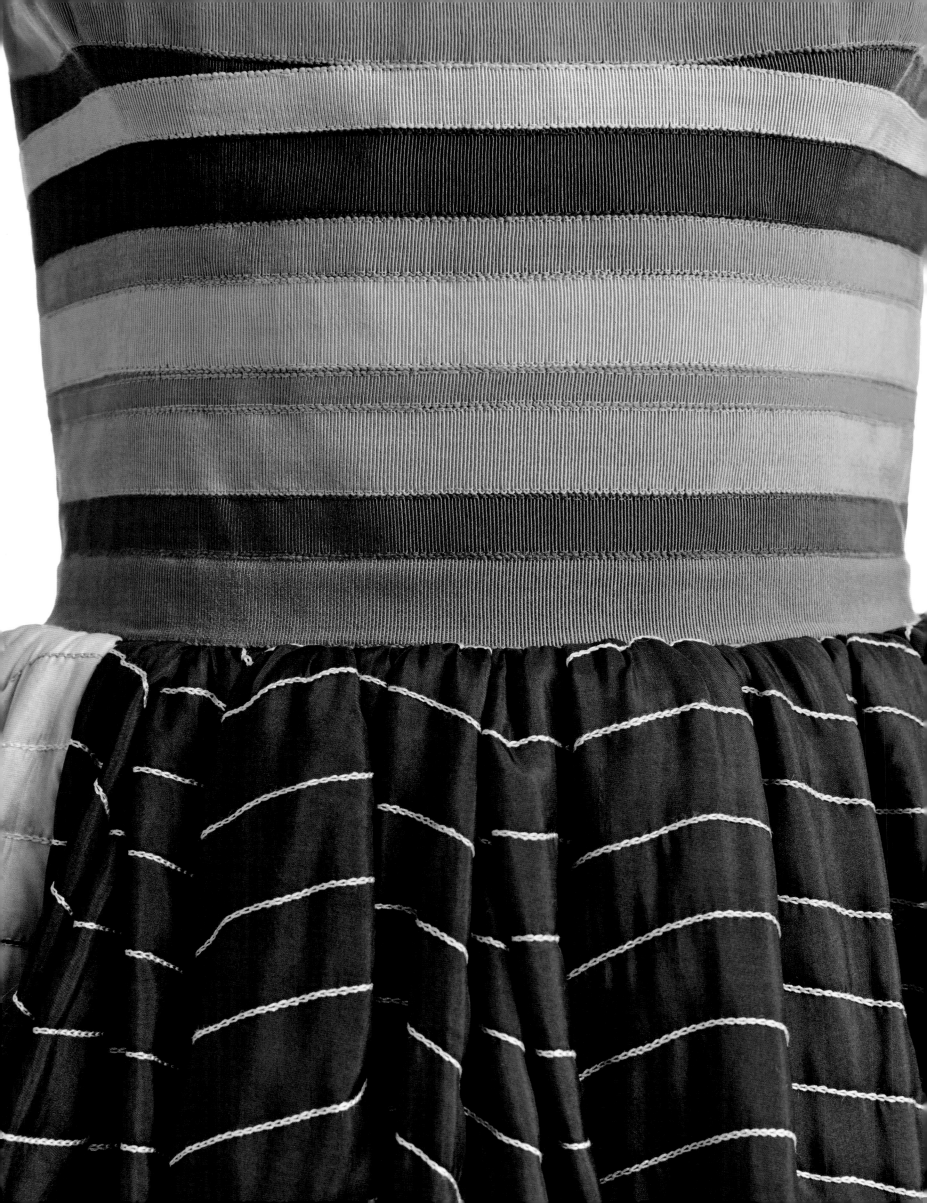

# isaac
# mizrahi

Chee Pearlman
With essays by Lynn Yaeger, Kelly Taxter, and Ulrich Lehmann

The Jewish Museum, New York
UNDER THE AUSPICES OF THE JEWISH THEOLOGICAL SEMINARY OF AMERICA

Yale University Press
New Haven and London

# donors and lenders to the exhibition

*Isaac Mizrahi: An Unruly History* is made possible by the Wilf Family Foundation, The Coby Foundation, Ltd., Xcel Brands, the May and Samuel Rudin Family Foundation, Inc., Target, and Friends of Isaac.

Endowment support is provided by The Peter Jay Sharp Exhibition Fund, The Skirball Fund for American Jewish Life Exhibitions, the Barbara S. Horowitz Contemporary Art Fund, and the Joan Rosenbaum Exhibition Fund.

**Friends of Isaac**

**Co-Chairs**
Natalie Portman
Audrey Wilf
Jane Frieder Wilf

**Members**
Hilary Feshbach
Liane Ginsberg
Pnina Hiller
Sharon Hurowitz
Linda Landis
Karen Mandelbaum
Sheree Mandelbaum
Beth Nash
Nancy Pantirer
Jerry Rose
Laraine Rothenberg
Fiona and Eric Rudin
Scott Salvator
Mara Sandler
Amy Rose Silverman

**Lenders**

Sarah Haddad Cheney
Anh Duong
Isaac Mizrahi
Sarah Jessica Parker
Paula Reed
Nina Santisi
Laurie Simmons
Target

# foreword

It has always been important to me to incorporate design, including architecture and fashion, into the art museums where I have had the privilege to hold positions; it would be no exception, then, upon my arrival at the Jewish Museum, to do the same. An interesting designer works within a very specific social context. A great designer—one who merits the extended attention of a museum—is a change maker, a visionary, someone who both captures a key cultural moment and creates it.

Like no other designer, Isaac Mizrahi absorbed the zeitgeist at the close of the twentieth century. From the moment in 1995 when his insightful and riotously funny documentary *Unzipped* appeared, it was clear that here was a designer for whom the exposure of the creative process was a thing to be celebrated.

New York City has always been a laboratory, a school, a performance space for all generations. Coming of age in the 1980s and early 1990s, I learned about art in the galleries and clubs of SoHo, the East Village, and the Lower East Side, where art, music, fashion, and theater mixed together in a fertile, cross-pollinating mash-up. At the time, clothing was taking on a new persona at such cutting-edge shops as Dianne B., IF, Charivari, Barney's on 7th Avenue, and in the spaces given to young designers at Bergdorf Goodman. I would visit these places as I visited the city's museums and galleries, learning to understand my culture.

Isaac Mizrahi was an important figure in the New York scene, in circles that overlapped with mine—the downtown realm of disruption and experimentation in fashion and style. He was one of the key people who made links between worlds: couture and voguing, street culture and high art, painting and dance, 57th Street and my neighborhoods of the Village and SoHo. Like me, Mizrahi was a child of the Pictures Generation: born into a world hypersaturated with images— movies, television, print—steeped in consumerism and fiercely critical of it. What made him stand out among the young designers of the 1990s was his extraordinary ability to synthesize ideas from every imaginable source. He had a magpie aesthetic; everything was fodder for his creativity, from discarded Coke cans to handcrafted Baccarat crystal. His designs had an intense materiality: fabric was not just fluid drapery, but a haze of color, or a splash, or a slap. And fabric was not just fabric; it was metal, plastic, glass, fiber. Mizrahi broke rules not for the sake of being a posturing bad boy, but because it was fruitful. He put real and fake fur together, for example, or a T-shirt with an evening skirt, at a time when these were believed to inhabit different universes.

Like the Pictures Generation artists, Mizrahi was driven less by a desire to innovate than by a hunger to make the most of the world as he found it. He mined the history of dress, citing everything from an Elizabethan ruff to a redingote to pantaloons. He made a skirt from a placemat, a ball gown inspired by shipping blankets. He explored the material world in all its squalor and splendor. Above all, he rediscovered color; he loved color as an entity in itself—unexpected, vibrant, expressive.

Isaac Mizrahi's achievement has inspired high ambition at the Jewish Museum. To achieve what we aimed for, we had all hands on deck; the process was extremely collaborative, with many players. The museum was fortunate to engage the talented Chee Pearlman as curator, supported with skill by Assistant Curator Kelly Taxter. Key people in the conceptual and logistical aspects of this ambitious project were Jens Hoffmann, Deputy Director, Exhibitions and Public Programs; Ruth Beesch, Deputy Director, Program Administration; Luke Hogan, Shanleigh Philip, and Sam Wilson, who work with Isaac Mizrahi; and of course Isaac himself. On the development side, I would like to thank Ellen Salpeter, Deputy Director, External Affairs, and Elyse Buxbaum, Director of Development. The exquisite creations of Mizrahi have been well-served by the breathtaking exhibition design of Galia Solomonoff and Solomonoff Architecture Studio, and the elegant graphics and book design of Abbott Miller and his team at Pentagram. Lynn Yaeger, Ulrich Lehmann, and Kelly Taxter contributed superb texts to the present publication, placing Mizrahi in both historical and scholarly contexts. Coordinating and editing the book was the Jewish Museum's exceptional editor, Eve Sinaiko. I thank, too, Al Lazarte, Senior Director of Operations and Exhibition Services, and his team of experts.

Private collectors and institutions have been generous with loans, and I thank them warmly. The Metropolitan Museum of Art graciously lent us the mannequins that appear in the exhibition; I thank Tom Campbell, Director, and Harold Koda, Curator in Charge, for their collegial assistance. As always, we are sustained and encouraged by the enthusiastic support of our Trustees under the fearless, staunch leadership of Board Chairman Robert Pruzan, President David Resnick, and in particular Trustees Audrey Wilf and Jane Frieder Wilf, who spearheaded the Friends of Isaac and raised substantial funding for the project. Above all, I owe warmest thanks to Isaac Mizrahi, who has been a sheer pleasure to work with, as well as a close and unstinting partner throughout.

Claudia Gould
Helen Goldsmith Menschel Director
The Jewish Museum

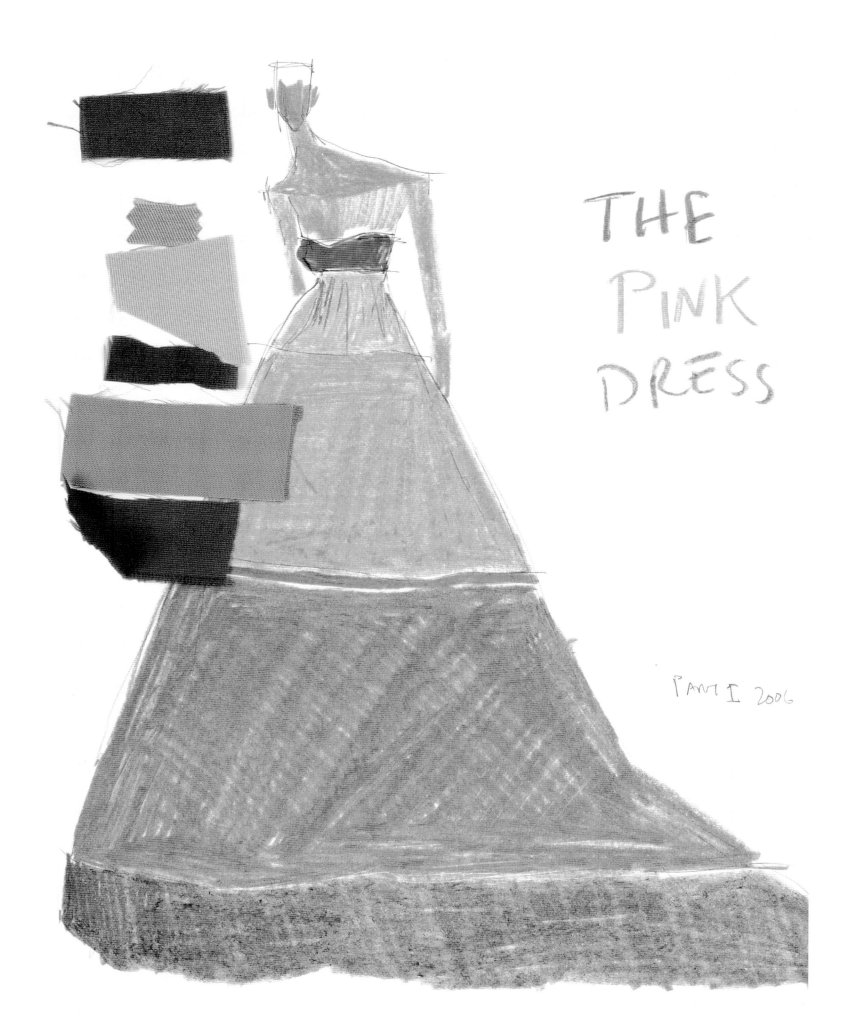

THE
PINK
DRESS

PART I 2006

# acknowledgments

This book and exhibition have been realized through the work of many dedicated and talented individuals. I am especially grateful to Claudia Gould, Helen Goldsmith Menschel Director at the Jewish Museum, for having the wise idea to do a large-scale survey on Isaac Mizrahi. She has championed every part of the project from the start, and her enthusiasm and vision have consistently raised the bar. I've had the pleasure of working with a special team at the Jewish Museum: Jens Hoffmann, Deputy Director, Exhibitions and Public Programs, has been generously encouraging and sage with his guidance and advice. Ruth Beesch, Deputy Director, Program Administration, has provided calm wisdom and counsel throughout the project. I cannot be more grateful to Assistant Curator Kelly Taxter, who has brought the rare dual talents of organizational expertise and scholarly ballast to the exhibition and to her catalogue essay in this volume. This project would not have been possible without her.

Special thanks are reserved for Eve Sinaiko, Director of Publications, for her editorial acumen and savvy polish of this publication. Others at the museum gave greatly of their time and skills and must be acknowledged with appreciation: Grace Astrove, Development Officer; Jennifer Ayres, Exhibitions Manager; Nelly Silagy Benedek, Director of Education; Maurice Berger, Curator, National Jewish Archive of Broadcasting; Elyse Buxbaum, Director of Development; Heidi Quicksilver, Digital Asset Manager; Rachel Herschman, Curatorial Assistant for Publications; Michelle Humphrey, Rights and Reproduction Coordinator; Marisa Kurtz, Curatorial Department Coordinator; Molly Kurzius, Senior Publicist; Al Lazarte, Director of Operations, and his talented staff; Julie Maguire, Senior Registrar; Ellen Salpeter, Deputy Director, External Affairs; Anne Scher, Director of Communications; Kirsten Springer, Visual Resources Coordinator; Colin Weil, Director of Marketing; and Susan Wyatt, Senior Grants Officer. The museum's wonderful interns merit recognition: Richie Khan; Lily Shoretz, Blanksteen Curatorial Intern; and Jessica Weiner. Audrey Wilf and Jane Wilf, co-chairs of the Friends of Isaac giving circle, have my warmest thanks.

I am grateful as well to the catalogue essayists, Lynn Yaeger and Ulrich Lehmann, for their rich and thoughtful insights into Isaac Mizrahi's contribution to the fashion and cultural landscapes. Many longtime friends and colleagues of Isaac have contributed their observations, recollections, and sometimes even the loan of their treasured fashions. My heartfelt thanks go to Sandra Bernhard, Hamish Bowles, Naomi Campbell, Margaux Caniato, Sarah Haddad Cheney, Anh Duong, Marjorie Folkman, Wendy Goodman, Betty Halbreich, Maira Kalman, Katell Le Bourhis, Debbie Millman, Mark Morris, William Norwich, Sarah Jessica Parker, Paula Reed, Elizabeth Saltzman, Nina Santisi, Laurie Simmons, Valerie Steele, Meryl Streep, Patsy Tarr, Rita Watnick, and Veronica Webb.

Sketch for *Kitchen Sink Pink* dress, fall 2006.

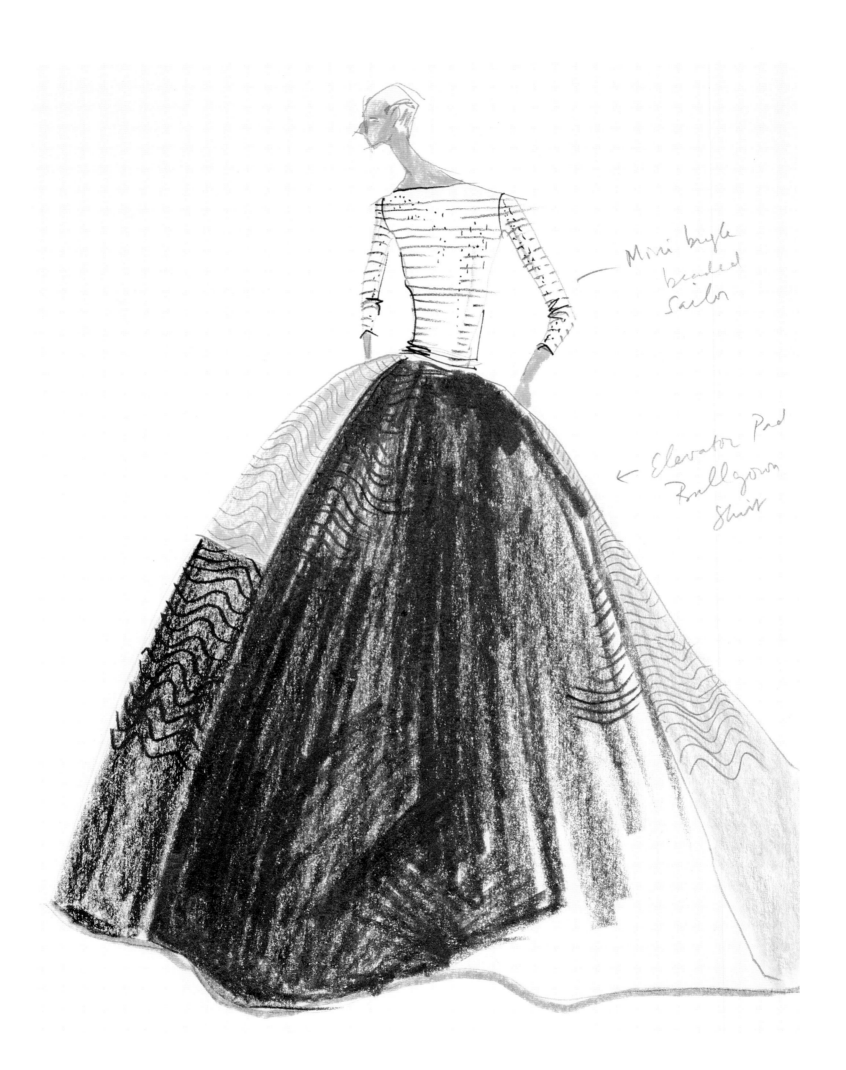

I thank Anna Wintour, Editor in Chief of American *Vogue*, for her early encouragement and support. Staff at the Costume Institute, the Metropolitan Museum of Art, New York, were more than generous with wise counsel and the loan of elegant mannequins. I am indebted to Harold Koda, Curator in Charge; Andrew Bolton, Curator; Nancy Chilton, Head of Communications; and Joyce Fung, Senior Research Associate. Many thanks also to Paul Austin for his advice and assistance.

I offer my warm gratitude to Team Mizrahi: Marisa Gardini, Luke Hogan, and Shanleigh Philip all brought generous enthusiasm and contributed greatly. Sam Wilson kindly supported us with curatorial insight drawn from his deep knowledge of the work of Isaac.

Many others provided unstinting assistance: at the Opera Theatre of Saint Louis: Tim O'Leary, General Director, and Paul B. Kilmer, Director of Artistic Administration; at Mark Morris Design Group: Mark Morris and Stephanie Sleeper; and at Target: Todd Waterbury, Daniel Griffis, and Kim Aldrin.

The exquisite exhibition design is the work of the talented Galia Solomonoff, Laura Beck, and Kate Christensen of Solomonoff Architecture Studio. The exhibition's lush multiscreen video installation was produced in collaboration with Dissident Industries; Matthew Shattuck and Amy Khoshbin.

This beautiful volume came into being through the vision and artistry of J. Abbott Miller and his team at Pentagram, including Andrew Walters and Yoon Chai; Jason Frank Rothenberg, photographer extraordinaire, who went above and beyond to beautifully photograph the collection, with his assistants Rebekah Birkan, Sherri O'Connor, and Stephanie Noritz; and Jasmine Pasquill, retoucher. David Burke handled the delicate restoration work with consummate skill. Brandon Lewis and Anna Lamb assisted with styling. Thanks are due also to everyone at AMS warehouse.

Extra special gratitude goes to Arnold Germer and Stephen Petranek, the most patient and generous of men.

Finally, working on a project with Isaac Mizrahi is a happy, hilarious, high-octane creative adventure, and I am privileged to have been on this journey. I extend my warmest appreciation to Isaac, the best collaborator an author and curator could ask for.

Chee Pearlman
Guest Curator

Sketch for *Elevator Pad* skirt and mini-bugle-beaded sailor top, spring 2003.

# preface

Honestly, I don't know what Claudia Gould was thinking when she asked me to make this show. When the Jewish Museum first invited me to think about an exhibition, I demurred. Aren't retrospectives mostly for dead artists? But this isn't a retrospective—it's a mid-career survey; it feels to me like the beginning of a story that will have lots of chapters added to it, beyond the most current work presented here, made in 2015.

To start thinking about the project, as a matter of course I went through many archives. It began as a slow slog through history, and the task felt a bit melancholy, but eventually it became a compelling kind of discipline. The more I looked, the more I learned. The more I was able to be objective about my own work, the more I was able to see my worth as an artist. As I shift into the middle of my career and as my neurosis about my work deepens, so do the pleasures I take in it. Work has always been the most important thing in my life, to the exclusion of everything else. I love my friends. I love my husband. I love my dogs. But I think I love them because they understand and allow me this quirk of humanity; they don't contest this creative ego that fuels my every waking hour.

I don't like looking at my own past, as anyone who has ever worked with me can attest. I find it a dirty, mushy, time-wasteful business. I think what got me where I am is my taste for new things. . . . As a matter of fact, to be easily bored is probably a prerequisite for any good fashion designer. And that impulse informs everything I do—writing, drawing, shows of any kind. Ideas move rapidly in my world, and I wanted to show that. The more I worked on this exhibition and catalogue, the more I wanted them to be about the underlying ideas that have always informed my work. Ideas that I've been able to manifest in different forms over time. Simply put, this project puts a set of key ideas of mine in a narrative order, so as to tell the story of the last thirty years of my life.

And to my huge surprise, I've ended up taking profound pleasure in the catharsis of this process. The making of this show has made me more of an artist. It has forced me to look back over three decades of work, and this has begun to point out where I'm going over the next three decades or so. Which will be the subject of my next museum show—and that one *will* be a retrospective.

It's the easiest thing in the world to look at other people's work, to criticize it and edit it. It's another thing entirely to look at your own work. It's something I would not have gotten through, had it not been for a few wonderful people whom I'd like to thank: Claudia Gould for thinking the thought to begin with; Jens Hoffmann for being so energetic and optimistic; Kelly Taxter for making me feel relevant; Sam Wilson for his rightness at all times; Luke Hogan for his cool disposition under fire; Jason Frank Rothenberg for being a saint; Galia Solomonoff for her chic perspective; Abbott Miller for his eye; Simone Brin for her hands; Brandon Lewis for his attention to detail; Eve Sinaiko for a lot of great ideas. And Chee Pearlman for brilliantly putting the whole thing together, piece by piece.

Isaac Mizrahi
New York, 2015

# introduction

Chee Pearlman

Long before he was a celebrated name in the fashion stratosphere, Isaac Mizrahi was a raconteur. He started in the theater, specifically puppet theater, at age ten. Retreating from a difficult school and social life to his parents' garage, he would work with balsa wood and found materials to make his characters. Within a few years he was creating complete fabulist worlds—puppet shows that he wrote, directed, performed, built, and, naturally, costumed for his diminutive actors. The puppet passion grew into full-fledged marionette musicals that he performed at birthday parties in his neighborhood, the Midwood section of Brooklyn. Even then, barely a teen, Mizrahi was honing his gift for storytelling, dazzling fashion, and inventive fantasy. The pursuit of these narratives has remained core to his many creative obsessions.

For Mizrahi, creating a scenario drives ideas. At the drawing board, he doesn't simply sketch a glamorous evening gown; he creates a *mise-en-scène* around the person wearing it. Eventually that scene becomes more than fantasy. It is presented at elaborately staged fashion shows where his models embody the lives of characters, gliding down the runway, the audience following the narrative with accompanying program notes:

| | |
|---|---|
| Veronica | wraps her Easter gifts wearing a<br>BLACK FAILLE SNAPPER JACKET AND PUFF PINK<br>CHEERY-O FAILLE FLIRT DRESS |
| Christy | knows how to marry a millionaire in a<br>CITRON HAPPY PLAID COTTON FAILLE TEXAS TRENCH DRESS |

As if they were a series of short plays, he gives names to the collections and subtitles to each act. The spring 1992 runway, for example, saw a passage of twenty-three ensembles for a made-up Western shindig entitled Champagne at the O.K. Corral. Mizrahi nicknamed his protagonists Gisele My Belle, Git Along Kimora, and Oh My Darlin' Daniella; each appeared in his collection of jeweled-and-tooled haute Western wear. Every model, every outfit has a part in the performance, and the women proudly, even joyously inhabit the role as well as the clothing. There are no pouty models on a Mizrahi runway. His women channel the designer's dreamscape of the possibilities of a life lived wearing that dress.

Barely twenty-seven when he produced his first runway show, Mizrahi had already developed a clear sartorial point of view. Working in the design studios of three important mentors—Perry Ellis, Jeffrey Banks, and Calvin Klein—after graduating from New York's Parsons School of Design, he was a fast study. He learned not just expert tailoring and textile savvy, but every aspect of the industry, from courting high-end department stores to the complexities of production on a relentless seasonal cycle, not to mention building a world-class brand. A few weeks after leaving Calvin Klein in 1987, he launched his first label, Isaac Mizrahi New York.

If anything could be described as a meteoric rise, it would be the house of Mizrahi. Fashion followers and retailers were electrified by the freshness and energy of his clothes, which could not be readily categorized. But it was clear within just a few seasons that Mizrahi had redefined what it meant to be an American fashion designer who wasn't looking to Europe for cues. He upended the rules of how the modern woman wears high style, banishing the all-black

Mizrahi photographed by Annie Leibovitz, *Vogue*, December 1995.

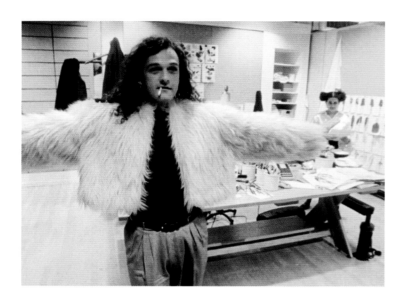

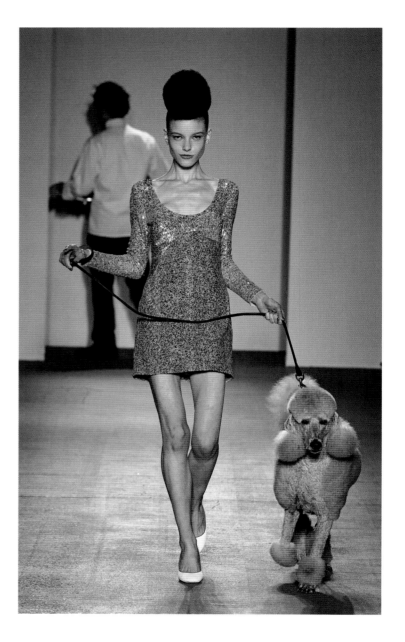

Mizrahi's friend Mark Morris tries on a version of the *Beast Coat* in *Unzipped*, 1995.

A pink dress and matching pink poodle on the runway from the Cake collection, fall 2011. Mizrahi's sense of humor and theater persists.

Preparing the fall 2007 collection: Mizrahi's design process is intense and at times hilarious, with many rounds of fittings and much impromptu experimentation.

uniform and splashing brilliant color into the sartorial vocabulary. With his iconoclastic mash-up of high and low, he radically reassessed codified norms of beauty.

Mizrahi has never marched to the lockstep conventions of the fashion industry. Beginning in the 1990s his love of theater and dance drew him into those worlds, where he has designed costumes for the choreographers Twyla Tharp and Mark Morris, a longtime friend and creative ally.

He has also worked extensively in the theater—his costumes for *The Women*, produced at the Roundabout Theatre in New York, earned him a 2001 Drama Desk Award—which has led to directorial commissions, including productions of *The Magic Flute* and *A Little Night Music* for the Opera Theatre of Saint Louis. He has had dozens of walk-on movie roles, starting with an appearance in *Fame* (based on the High School of Performing Arts, his alma mater) in 1980, and including parts in three Woody Allen films. Performative pursuits have always unfolded alongside Mizrahi's fashion career, even as that career has morphed and evolved. The ability to cross-pollinate among art forms may seem messy to purists, but it has long been a defining trademark of his radical edge.

Mizrahi's collections are nearly a direct alter ego, displaying his personal passions and drawing upon his autobiography. The designer, famously insomniac, thrives on an avid diet of film, dance, art, opera, literature, and television, weaving through the high- and pop-culture landscapes with sure-footed authority. Looks from the Isaac Mizrahi New York years (1987–98) bear witness to his cultural and historical obsessions: Inuit seal hunters, *The Flintstones*, hieroglyphics, hip-hop street culture, topiary poodles, totem poles, TV Westerns . . . the list goes on. All are irreverently and humorously part of the design tool kit.

He quotes from WASP culture and appropriates Jewish symbols. Current political events and art-world references are all fair game. There is, of course, a tongue-in-cheek tone to all these borrowings, but they refer to familiar archetypes that let the audience in on the designer's sly jokes. Through rigorous tailoring and exacting refinement of his designs—as well as judicious measures of beads, embroidery, and sequins—Mizrahi makes each reference his own. "Here's my process," he says in the 1995 film *Unzipped*. "I get inspired, somehow, somewhere; from the ballet, from dance, from a movie, from something. I get this gesture in my head, and then I think, 'Is this worthy of doing a whole collection?' Usually it is. . . . And from there I just do all these millions of sketches about that one gesture."

In *Unzipped*, fashion and theater unite without reservation. Fully complicit, Mizrahi invites the documentary filmmakers into his studio, his fitting rooms, and his bedroom to witness the origin story of his now-celebrated fall 1994 collection. The movie exults in the outsized personality and loquacious charm of its subject and star, yet it also unpacks how Mizrahi mines his enthusiasms as well as his exhaustive command of film classics to fuel his creations. He embodies the part of frenzied, hyperactive design genius as he acts out the drama of making the collection, sharing confidences with friends from Sandra Bernhard to Eartha Kitt, and dressing the supermodels Naomi Campbell, Linda Evangelista, and Kate Moss, among others. His innate sense of timing and Woody Allen-esque brand of neurotic New York Jewish humor are played to the hilt; it's a part Mizrahi can happily and authentically embrace.

Mismatched silver flats, 2006, take inspiration from Tibor Kalman's famous dictum that graphic design should not be too slick or too perfect, but "just, *exactly*, not quite right!" The shoe subversion was subtle, but once spotted, it was just, *exactly*, not quite right.

Humor is not just key to his persona in film and onstage; it's core to the Mizrahi sensibility. The acclaimed product designer Hella Jongerius has said, "Without play, there can be no design. Without foolishness and fun, there can be no imagination." That syncs with Mizrahi. One of his early mentors was the graphic designer Tibor Kalman, a provocateur and disruptor of the slick, commercial side of his industry. (For an article on race in Benetton's multicultural *Colors* magazine, for example, Kalman manipulated photographs of Queen Elizabeth and Arnold Schwarzenegger so that they appeared to be black.) Mizrahi echoes this irreverent spirit—for example, by sending a pair of mismatched shoes down the runway in 2006, silver ballet flats with one pointy toe and one round. Kalman and Mizrahi share an impatience with designers taking themselves too seriously and believe, as Kalman once said, that good design should be "unexpected and untried." Interesting clothes, Mizrahi suggests, are the ones that "look slightly mistaken, or very, very surprising."

In addition to many vibrant examples of wit, this volume reveals Mizrahi's groundbreaking preoccupations with color, print, gesture, and surface. Color, a linchpin of his design, is manipulated as if it were a material. His dazzling palette, often from the fiery end of the spectrum, is deployed in understated matte textiles to maximum effect. Print offers a platform for bold graphics, frequently animated on diaphanous gowns. Gesture, for Mizrahi, is a statement made through construction and form. In some of his sparest, most ingenious inventions, he uses the infrastructure of the body to partner with the garment to secure it to the wearer. And surface is his laboratory for research and development. Here Mizrahi develops new materials, reimagining beads, sequins, and embroidery in elevated applications, or appropriating the quilting techniques from moving blankets or elevator pads. These visionary approaches place Mizrahi's work in the avant-garde of modern design.

Over the years, Mizrahi has dressed many actors on the world stage, from politicians to Hollywood stars—an indication of the versatility of his clothes. Meryl Streep, Sarah Jessica Parker, Sandra Bernhard, Julia Roberts, Natalie Portman, Oprah Winfrey, and innumerable others in the public eye have turned to him for a special-occasion wardrobe, knowing he can bridge the tension between high glamour and real life. They will look good and still be able to walk. For his great chanteuse pals Liza Minnelli, Eartha Kitt, and RuPaul, he has provided attire with a suitably higher degree of diva bling. Two First Ladies (of the Democratic persuasion) are warm admirers, recognizing something easy, confident, and inherently American in his style. Hillary Clinton wore a floor-length shirtwaist gown at the *Glamour* Women of the Year Awards ceremony in 2008; Michelle Obama has worn several of his ensembles, including most notably an aubergine dress of matelassé, with a stretch jersey top, at her husband's first State of the Union address. Mizrahi, remarking that the First Lady looked "exquisitely beautiful," felt he had walked a political tightrope: "Not left, not right, it was kind of like a bipartisan dress. She was in a kind of purple-y color, which is a blend of red and blue!"

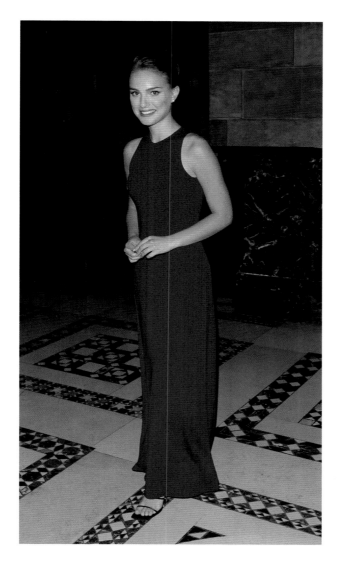

Clockwise from left:

Natalie Portman in Mizrahi, 2002.

Sandra Bernhard in Mizrahi on *Late Night with David Letterman*, 1989.

Liza Minnelli in Mizrahi, 1991.

Sarah Jessica Parker in Mizrahi at the opening of *The Producers* on Broadway, 2001.

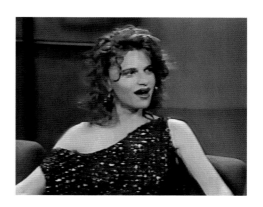

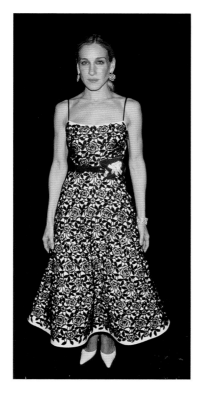

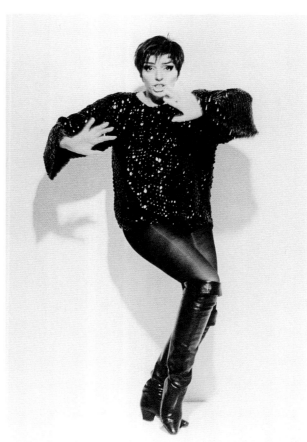

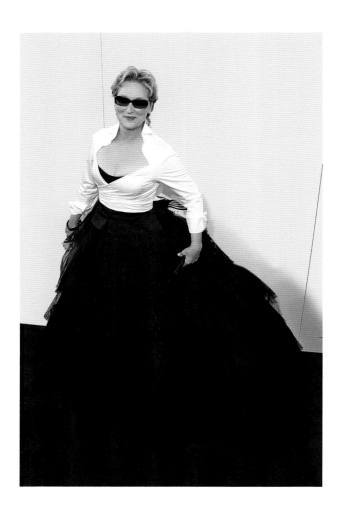

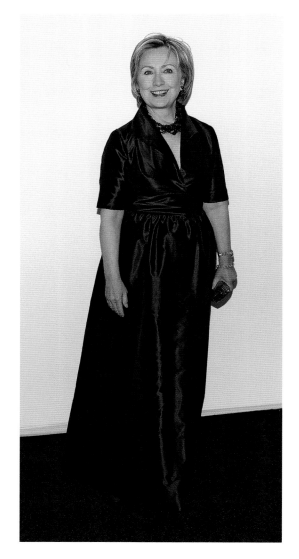

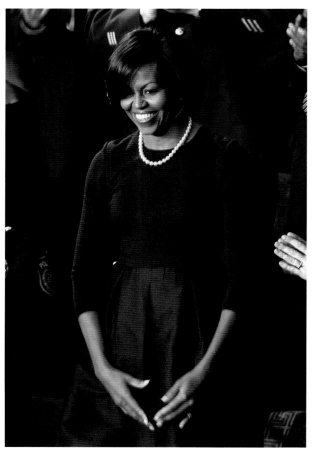

Clockwise from top:

Meryl Streep in Mizrahi at the American Film Institute Awards, 2004.

First Ladies in Mizrahi: Hillary Clinton in a floor-length Mizrahi shirtwaist gown at the *Glamour* Women of the Year Awards ceremony, 2008 ("I love dressing Mrs. Clinton; she's a doll and she's so appreciative"); Michelle Obama at President Barack Obama's first State of the Union address, 2010.

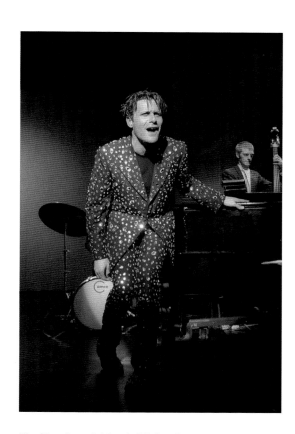

Mizrahi performs in his solo Off-Broadway cabaret act, *Les MIZrahi*, 2000. The autobiographical show, produced by the Drama Department, was a mix of monologues, onstage sketching, sewing, and songs. Richard Move directed, and the musical backup was by the Ben Waltzer Trio.

In 1998, under financial pressure from his backers, the designer shut down his Isaac Mizrahi New York brand. Mizrahi's followers were crushed. Liz Tilberis, then editor in chief of *Harper's Bazaar*, told the *New York Times*, "A smile has gone out of the fashion industry. But the saddest part is that we are headed toward a kind of mediocrity." Mizrahi himself was crestfallen, but hardly undone. "I didn't understand the repercussions. I just thought I'd go do something else," he recalls. Alternative creative passions were already stirring. He spent a year writing lyrics and a script, tuned up his voice, and crafted stage costumes for a one-man Off-Broadway show, *Les MIZrahi*. The autobiographical cabaret peeled back themes about the strains of a life as a superstar brand. "So ironic—the most silly profession is also the most nerve-wracking profession in the world," he sang to an upbeat samba. "Given up clothes to go on the stage / Now the victims of fashion are all in a rage," he crooned in a slower ballad. The show drew upon his native talent for performance and his easy effervescence, but also touched on deeper issues of the price of celebrity culture and the rigid confinement of a single-track identity. Mizrahi could now break down the silos into which his creativity had been forced; on this stage he performed and sang while sewing a coat from muslin on the sewing machine that his father had given him. Performance and narrative shed light on a career in fashion and vice versa.

The inflection point that saw the loss of his company did not signal the end of his fashion career, but broadened its scope. In short order Mizrahi signed a landmark agreement with Target as its first marquee fashion designer and developed the IM for Target line for the mass-market retailer. Meanwhile, Bergdorf Goodman quietly stepped in to revive his Isaac Mizrahi New York semi-couture, made-to-order label (produced from 2002 to 2011). Mizrahi seized the opportunity to interweave these two opposing story lines (not without a certain irony), and concocted his now-famous fall 2004 High/Low collection. At the time, to mix an inexpensive cotton T-shirt with a silk ball skirt, or a mass-market top with trousers that sold for several thousand dollars, was nearly unimaginable. Today this careless elegance is the norm.

Mizrahi's embrace of the mass market with Target, and more recently with his license for clothing, accessories, and home décor for Xcel Brands, speaks to his ease with wandering up and down economic sectors. He considers this a kind of design democracy—not just making good design accessible to the public, but provoking great designers to bring their skills to a less elite audience. For Mizrahi, there is an unruly freedom to his diverse activities: the freedom to direct a Mozart opera by day and sell his cheerful mass-market line live on QVC at night.

Of his fall 2007 collection Mizrahi said he was happy with the dresses because "they challenge the wearer to create new contexts. She can't go to the same old places. She's going to have to figure out fabulous new places to go." Wise advice that Mizrahi himself has always adhered to. Like the women he designs for, Mizrahi is on the move, filming a treatment for a new television series, publishing a memoir, developing a documentary, setting the stage for his next creative invention.

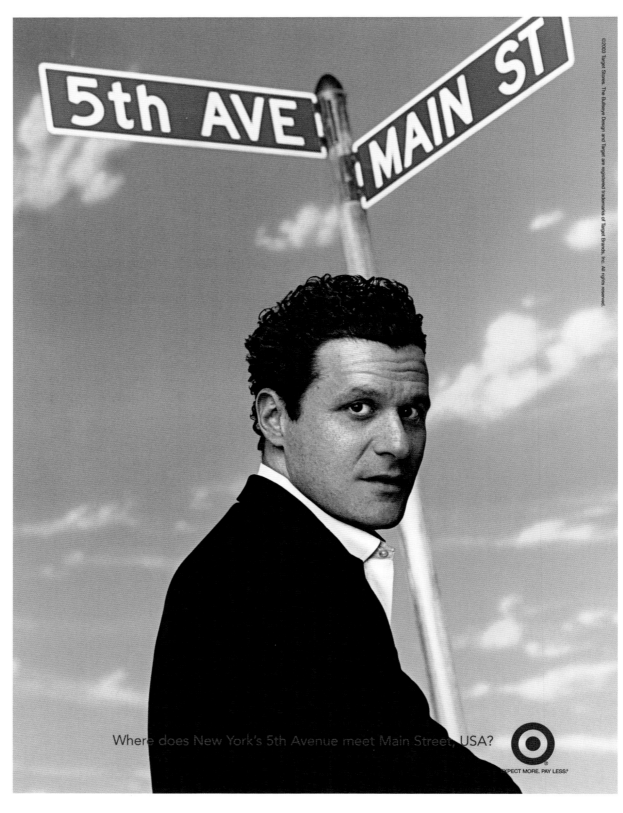

Where does New York's 5th Avenue meet Main Street, USA?

EXPECT MORE. PAY LESS.®

High/Low: a 2003 ad for IM for Target made
the point.

# interview

In spring 2015 the curator Chee Pearlman sat down
with the designer Isaac Mizrahi.

**CHEE PEARLMAN: Tell me about your childhood and growing up in Brooklyn.**

**ISAAC MIZRAHI:** I was in the wrong environment. But in my case that experience
helped me a great deal, because somehow it brought me to an understanding of
my feelings. I went to Yeshivah of Flatbush, the wrongest school imaginable. It was
a very lonely time, and I was hugely fat. I was hopelessly bullied. In those days it
wasn't even called x bullying, it was just called society. Yet somehow I knew that
*they* were wrong. And that taught me about following my own perspective, my
own dream.

**Were there glimmers of your future career as a fashion designer in those years?**

I started making puppets when I was quite young, and they were glamorous. Lots
of glitter, lots of color. I would spend hours and hours on these shows. When I
was ten or eleven, I went to see *Follies* with my mother, the Stephen Sondheim
musical, and the costumes were out of this world. So I made a puppet *Follies* of
my own, with a row of dancing girls in glittery costumes.

**And you produced your own show?**

I built an elaborate theater. I used to go into my parents' bedroom on my way
to school, and they'd be asleep and I would take money off my dad's dresser.
I always assumed he knew about it, so I couldn't consider it stealing, but those
coins were what supported my early creativity. After school, I would go down the
block to M&J Trimmings, where they sold fabric and notions, and I would buy felt
and ribbon and thread and fabric to make costumes.

**Did you perform in these shows?**

Yes, by the time I was about thirteen I'd created a whole hand-puppet theater—a
portable affair that I could bring from house to house and assemble. I created
a musical called *Daffodil in Yum-Yum Land*. It was a standard *Wizard of Oz*-type
story about a girl who has a fabulous dream and wakes up in the end. I performed
it for birthday parties. For money! I wrote the songs and recorded them on the
piano, and I had a little cassette player and I'd play the accompaniment while I
sang as the puppet characters. It was so multimedia; it was crazy.

**Had you already begun designing clothing?**

I was hand-sewing, saving up for my first sewing machine. My dad took me to the
Singer Center on the New Jersey shore, where we had a summer place. And there
was a brand-new machine, which I had been saving all summer for. It cost $80. My
father was in the children's-wear business and knew a lot about sewing machines.
He said, "You're *not* going to buy that new machine. It's no good." At the center
they had a collection of resale machines and he pointed out a refurbished
turn-of-the-century one, and said, "That's the one." It was small, with a strong
motor, and was easy to handle and thread. Not overly loaded with gimmicks and
gewgaws. It cost $120. He put up the rest of the money. I loved that machine—I
think I still have it today in storage.

In 1976, at age fifteen, Mizrahi started a fashion brand with Sarah Haddad Cheney, a family friend. He designed the IS New York (Isaac and Sarah) label.

A button-down blouse designed by Mizrahi around 1978 for the IS New York label was sold at high-end New York boutiques such as Charivari and Lonia.

**How did you move from puppet costumes to designing for women?**

The first thing I think I made was for my mom—a skirt, when I was about thirteen. This was way before I understood anything about draping or darts or any of those things. It was double-face wool, a beautiful rust color on one side and plaid on the other. I made her a straight skirt, just below the knee, with a shawl. I don't know how I made it fit her, but I did. I just had such focus and motivation to make this wool skirt. It was the first thing I ever made with my hands. And she wore it for the High Holidays.

**And you even designed a label?**

It was really good! It was very long and rectangular with a long vertical "I" and then "S-A-A-C."

**You launched a real label a few years later, when you met Sarah Haddad Cheney. How did that come about?**

Sarah was in her thirties when we met, and I was fourteen. My mom introduced us as though she were introducing friends. I remember just sitting in her kitchen and talking. Sarah was—I don't want to use the word "aggressive." She was I'd say *cardinal*. Like, she moved forward at all times.

I used to do sketches, and somehow she was interested in them. We would go shopping for fabrics together. Her husband had this funny nickname for me, Baby Saint Laurent. Really. Baby Saint Laurent.

Then the relationship ignited and we made this little business—the IS label, for "Isaac and Sarah." Neither of us really steered that ship. But the ship sailed from the second we met. Certain relationships are just like that, autocombustible.

**So there you were, selling your designs at cutting-edge boutiques like Charivari at age fifteen. What about your other life, at school?**

The whole thing started when I was in eighth grade at yeshiva, which I mentioned earlier was the least conducive environment imaginable for me. At that time, as I was facing options for high school, I was lucky. I had an incredible teacher. This is a crazy story, like something out of *To Sir, with Love*, some uplifting sixties movie. My English teacher, Sheila Kanowitz, gave us assignments to dramatize books and do little plays in class, which was really different from the rest of the curriculum at yeshiva. And I loved it.

She knew I was in the wrong place—she sensed the problem. She introduced the idea of my going to a school called the High School of Performing Arts, in Manhattan. She had meetings with my parents, who were very cautious. She convinced them to let me audition. She helped me with the audition. And when I made it into the school, she helped convince my parents to let me go. And they let me go. I call that . . . what's the word? Freedom. You know, freedom is a kind of gift.

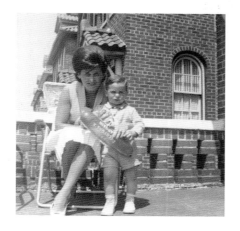

Isaac, age three, with his mother, Sarah, in Brooklyn, 1964.

Isaac at the High School of Performing Arts.

**So these two women—first your teacher in grade school, and then your business partner while you were in high school—were pushing you forward. What did your mother think of all this?**

My mom was more like my best friend. And there are bad things about that, but there are a lot of good things. Because she was loving and supportive and would say things like, "You can do this; you're brilliant," but at the same time she would challenge me and say, "Really? Is that your best? Try that again." She was the best mother an artist could have because she was aspirational herself.

**Was she stylish?**

She was the textbook definition of the word. She told me that when she was a girl, in the fifties, she would buy copies of Dior dresses. Later, she would shop at Loehmann's, the off-price clothing store, which was renowned in New York. She was very good at manipulating things to make them look more expensive than they were. She altered things. Wore things back-to-front. Wore men's pajamas on the beach. Found gorgeous things at Loehmann's. So for the most part, when I was growing up, the idea of being truly stylish was somehow more akin to scavenging, reinventing, than it was to luxury and spending loads of money. I think the most stylish person is a kind of scavenger who doesn't rely on expensive clothes. Someone who gets things here and there and puts it all together. And I will never give that up. Never.

**Performing Arts is the school the movie *Fame* is based on. A lot of the graduates go into theater, music, film. Were you on track to do that?**

For a while I thought of myself as an actor. I studied to be an actor and also played piano for many years. I was musical. But somehow I got sidetracked by fashion. I guess I saw it as an easier way to support myself. I was desperate to get out of my parents' house, as any teenager is. And it seemed easier to get a job as a sketcher or an assistant than it would be to get a job in Hollywood or on Broadway. Auditions scared me. I just thought of theater as a road to nowhere, even though it was my first passion.

**After Performing Arts, you went to Parsons School of Design—one of the main feeder schools for the New York fashion industry. What was the most important thing you learned there?**

I learned a lot at Parsons. Not merely how to sketch and make patterns; I learned what it was all about. It was at Parsons that the whole thing came together. At some point in my junior year there I got the point. I got the object of the game. It manifested itself clearly: the idea of how to create things that were relevant, irreverent, chic. Something about the exposure there and the history we were taught. The future became apparent.

**And you were working in other designers' studios during and right after college, right? Perry Ellis, Jeffrey Banks, Calvin Klein. What was the New York fashion scene like at the time, from your apprentice perspective?**

More than anything it was a social thing. The fashion scene in New York is really a closed circle. And those people run the whole social thing globally. They run the clubs and the dinner parties and galas. It makes sense, when you think about it. The club scene was and still is the center of the world of style. It's what people

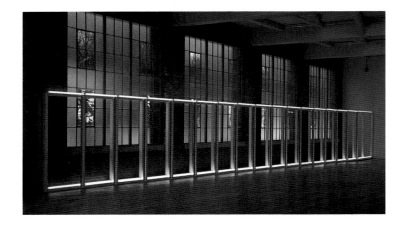

Dan Flavin, untitled installation, 1970,
Dia:Beacon, New York. When Mizrahi
designed the *Kitchen Sink Pink* dress
(page 176), he was in part responding
to the many shades of pink found in
Flavin's Minimalist light installations.
"To see a Flavin in natural light," he
recalls, "made any kind of nature seem
sickly by comparison."

look like when they have no other agenda but to be stylish. So working at Perry Ellis at the age of seventeen was fabulous, 'cause I got to see all that firsthand. One of the first tasks I had was dressing Mariel Hemingway for the 1983 Costume Institute gala at the Metropolitan Museum. She was accompanying Mr. Ellis, and I met her at her hotel and oversaw her styling for the night. The work in those days was never-ending. It felt like what a doctor would go through in an internship: always on call. We worked from morning to night. But more than that was being included, brought into society. The best thing was that, on occasion after a long day of work, Perry Ellis would take us to dinner, to somewhere fabulous like Mr. Chow or Elio's . . . just the idea of seeing things and being seen. It was the best lesson of all.

**You started your own company in 1987. What was the message of your work?**

I was trying to do a smart version of something over the top. There was always something crazy about my shows, but then I would pull it back to a point where the woman I was designing for was in control—in control of the story of her life. So if a look had sixteen different shades of orange, there was always something that grounded the piece and made it work. Maybe she was in hush puppies and wasn't wearing any makeup. There are a million ways to balance things. I make clothes for smart people who don't think too much about fashion. They can get carried away, but never by trendy things. I like the clothes I make to look like they've existed for decades, like something classic. The clothes I've made that I like the best are subtle. Things that make you think, "Could that actually not have been made before?" Like the earth itself came up with it.

**Why did a dazzling color palette become one of your trademarks?**

Color was important from the beginning. In my first show, in 1988, I started with passages—groups of looks—that used a lot of gray and camel and brown. And then, all of a sudden, after about twenty passages, I took off the brakes and went to color, and the audience went crazy. At that moment the show came alive; everybody was going, "What, what, what, what?" The rest of the show was about sixty passages of bright, crazy colors. And I thought it was smart, psychologically. If you're planning a fashion show, you have to ask, "What is the best way to present color?" The best way is to show what gray looks like first, and then show what color looks like. I always thought of color as the most fun part of clothing. And if a color is good, you have the whole thing. I think that too about costumes. If you get the color right, you will add to the concentration of the audience. If you get it wrong, there's a big distraction. It's emotional. It's the biggest luxury there is. It affects you on such a deep level, and most people don't think about it. It's like a flavor of food that you either like or dislike.

**But your work isn't always about color.**

That's right. From that point on, everybody kind of overly associated me with color—which I like, because it's a big part of what I do. But I also like the plainness of black, or gray, or camel. And sometimes if you're stressing the design of something, the seams, the construction, the invention, it's best to show it in gray or black so as not to change the subject.

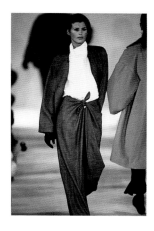

*Pants in a Knot,* fall 1992, a design twist on the *Sack Pants* (page 63).

*Prayer Jacket,* spring 1994.

**And color isn't just decorative in your designs; it has all kinds of resonances and references. What makes your use of color specific to Mizrahi?**

I think it's like a political affiliation. If the color is right, you vote all the way down the ticket. If it's wrong, it's wrong. So if you walk into a room full of terrible colors, you will be ill. If the colors and the light are right, you'll feel wonderful. That's not my idea—it's the classic idea about color and light.

**You've talked about how the chicest clothes often have the least construction—your *Pants in a Knot* and *Prayer Jacket* are iconic examples. What inspires these designs?**

A gentleman I worked with had given me a French Foreign Legion jacket that I loved. I reimagined it slightly and decided it would be my classic, the way Chanel had her classic bouclé dressmaker jacket. I made the *Prayer Jacket* (1994) as an alternative: not as structured as a man-tailored jacket yet not as unstructured as a shirt jacket—something a man or woman could wear to work. I still wear it more than anything else I own. Another idea like this is *Pants in a Knot* (1992), which is like a kerchief with legs. I'd seen a dancer wearing sweats that were too big, so she knotted them. It inspired me to do away with zippers, buttons, and drawstrings and instead make the closure integral to the construction.

**Who was the woman you imagined designing for?**

I always had real women in mind, not fantasies. There is a dark side to the fashion industry—the marketing and advertising of beautiful models can make millions of women feel inadequate. The industry feeds on a woman's insecurity in order to sell her things. I find that unconscionable and cruel. And plastic surgery: to do that kind of work to your body, I find misogynistic. It's much more interesting to see people age naturally. Something that's really beautiful is something that's real.

I was insistent that I was designing for an American woman, because I was trying to make a statement about American clothes, about the American love of clothes, the love of fashion, the love of style. The progression of style from something musty and European. At the time, that was the opposite of what we were supposed to be doing, which was to interpret someone else's love of clothes and style. American designers were supposed to look to European designers like Christian Lacroix and say, "Oh, our version of Lacroix is this, our version of Saint Laurent was that." I mean, if you look at other American designers who came before me, that's all they were allowed to do. But in truth, if you look at all the best European designers, their clothes reflect this American ideal. This fast, postmodern thought, which is American. The idea of ball gowns with combat boots is not a very European thought. The pendulum swings both ways.

**What do you think sets you apart from your contemporaries, designers like Marc Jacobs and Michael Kors?**

I think humor sets me apart. I thrive on self-mockery. A lot of designers out there have to take it all really seriously. It's one thing, I think, that stands in the way of my own immediate progress. Most times, when I see people on the worst-dressed list I think they look great—and vice versa. It's a tough line to hold, a delicate line to walk. I remember when Sarah Jessica Parker would show up in crazy-looking things and look amazing and get voted worst dressed. And now it's de rigueur.

The logo for Isaac Mizrahi New York was designed by Tibor Kalman.

**Yes! There are fabulous examples of your sense of humor in these pages. From the Tee Pee collection to the *Beast Coats*, the *Tote Hats*—you weren't holding back.**

> I had the best time doing those collections. Those were the most exciting days of my life as a designer. I think that the ability to laugh at myself still sets me apart. I don't understand people without humor, and I just don't like certain things because they have no humor. Like when you walk into some boutiques and they feel like mausoleums, with rows of rigid black handbags.
>
> I talk a lot about being funny, being whimsical. But it's also about elegance, which is just as important to me. My idea of elegance comes more from nature than from other clothes. Women I looked up to. When I was sixteen my sister gave me the catalogue from the Metropolitan Museum's Richard Avedon show, which was going on then, and my eyes were opened. Those women were elegant because of a kind of composure. And no matter how artificial, they always referred to something natural. A natural asset. Long throat. Slim arms. Beautiful legs that were set off by wonderful shoes. And a wink. That's the humor. I think humor was in short supply in the American fashion arena. There was nobody who could be smart *and* funny.

**Earlier, you mentioned scavenging as a form of style. Part of your wit, your whimsy has to do with the way you absorb and reinvent cultural or historical ideas.**

> I start with a gesture and run with it. And as I've said before, sometimes I have no idea where the gestures come from. Sometimes it's a show I've seen, or a painting. That's the most exciting part of the process: the beginning. The first glance at something new coming out of your pencil onto the paper. I can't say more 'cause it happens on a case-by-case basis. No two collections are alike. The building, the fleshing out of ideas.

**Were your designs influenced by what was happening in the arts at the time?**

> To some extent, yes. But mostly I thought of them as things to wear while you were looking at art. Or while you were at a party surrounded by art. I never thought of my clothes as "art."

**You've said that you learned a lot from the graphic-design provocateur Tibor Kalman. What resonated with you in his work, his approach?**

> He was always one of my best critics, but also a cheerleader at the same time. He was hypercritical, weirdly smart—smarter than anybody, and a great, funny guy. He was a counter-thinker, which is something we shared. If you said black, he'd say white. It's like my dog, Harry. If you tell him to come, he goes. Tibor was full of humor too. And was fearless in that way. He demanded a high level of honesty and could see through any lie. I felt comfortable with him because I too was sensitive to bullshit.

**I was struck by your enormous archive of drawings, and how true the finished pieces are to the original sketches. You put a lot of time into these artworks.**

I love sketching. That was my favorite part of making clothes—and it was also the most horrible part. But once I got into it, I was gone. You couldn't talk to me. I was just lost in the bliss of making drawings. Sketching collections, to me, was the best part. Being alone in a room for days, mapping out this story about a woman's life and as an aside inventing all these new things she's never worn before. Once that process was over, it was all a bit boring, except for fittings. The way fabrics are transformed into designs. The lines as you create them. The lines as they relate to a body. The body as it relates to fabrics. The rest of it—the assembly of the show, the press, the salesroom stuff—that's all a huge bore to me.

**After you shut down your designer label in 1998, you chose to follow so many different paths of creativity—you're a performer, writer, musician, director. You're working in dance, theater, opera. And of course you've been a celebrated designer for Target, and now you have the *Isaac Mizrahi Live!* show on QVC. Do you miss the world of high fashion?**

Occasionally I wish I were doing that again because I'll have an idea for the most major, amazing coat or ball gown or handbag in the world. Or the craziest shoe you've ever seen. (It always starts with a shoe!) And I'll wish I were back. But you can't do that; it doesn't work that way. This industry expects you to stay on the treadmill, doing it every single day. I can't do that—to me it feels redundant.

I have been praised but also punished. And it's because I didn't necessarily see this as a labor of commerce; I saw it as a labor of love. I am a true amateur, a person who works from a position of love, which is the meaning of that word. I approach everything, all my projects, from that perspective, from the perspective of an amateur.

**And what does the amateur in you like doing most?**

I think I like writing the most. It's the most challenging.

**What about directing?**

It's also really hard work! But it's really fun, those weeks in rehearsal before anything is set. You get to create a whole universe.

**Between *A Little Night Music* in 2010 and *The Magic Flute* in 2014, you've had some major directorial successes. Where does this lead?**

I'm working on developing shows for television and writing a TV series and a memoir. And I want to create a musical show—probably not an opera, but something for musical theater.

**Would that bring you back to your roots in puppet theater?**

It's the same thought. Except now with live people!

# collection

Principal photography by Jason Frank Rothenberg

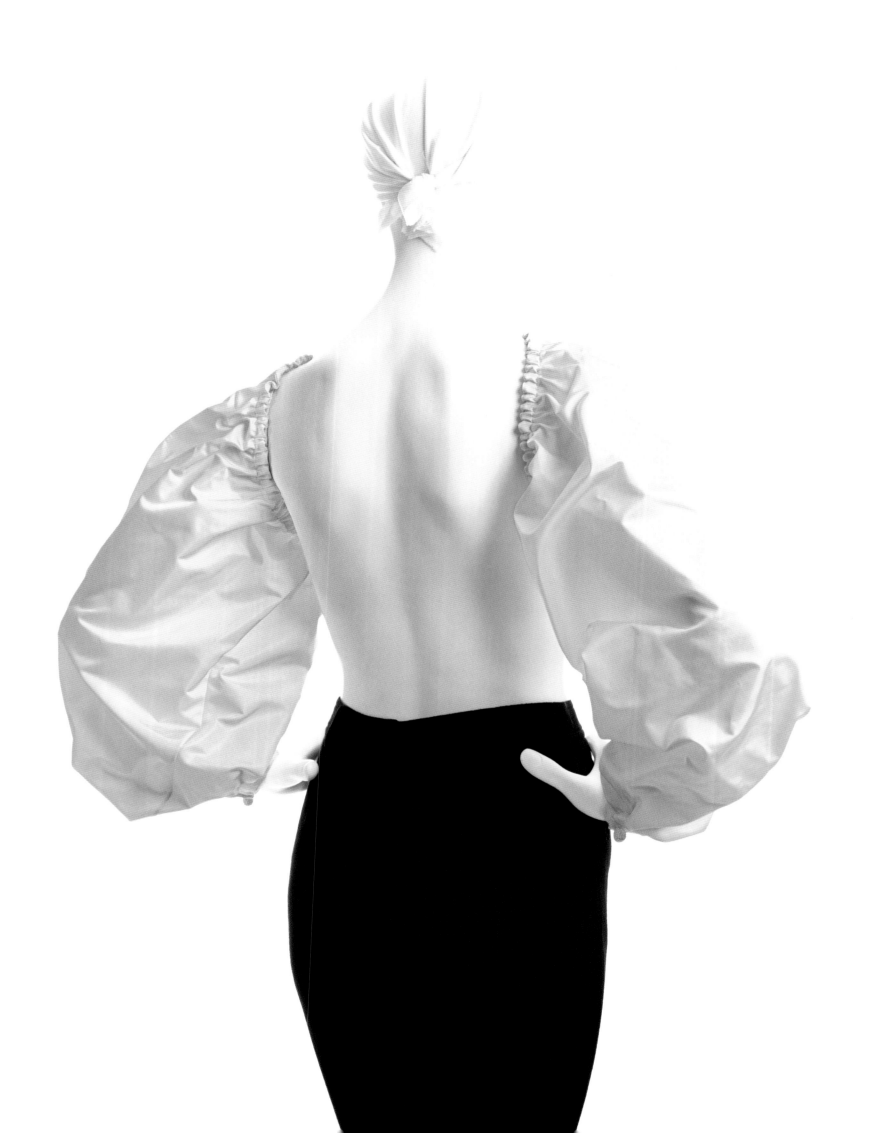

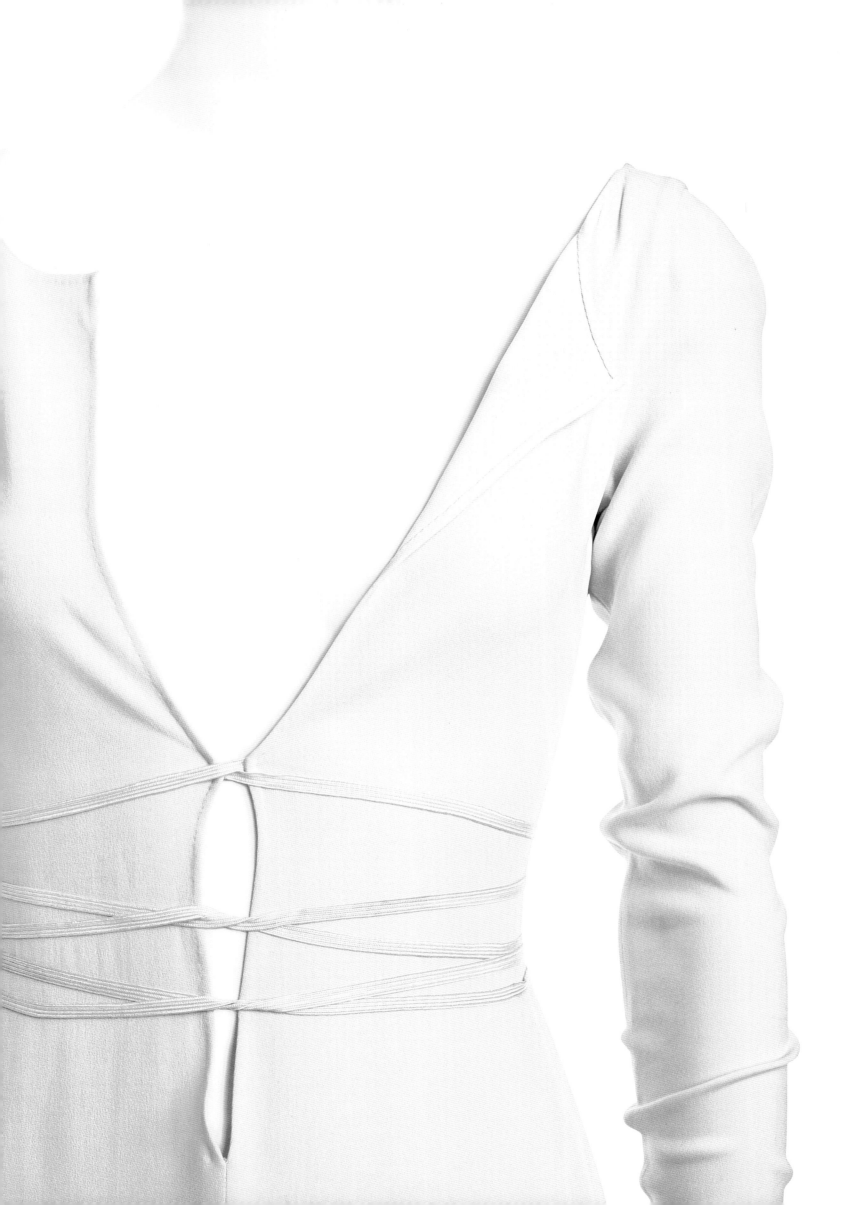

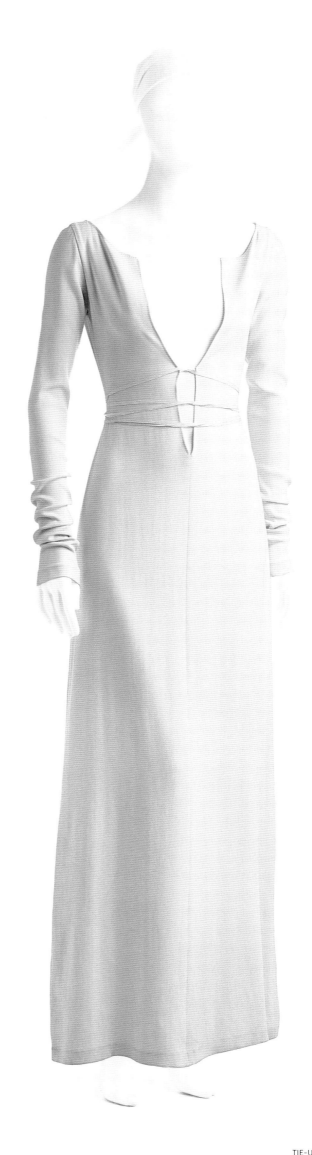

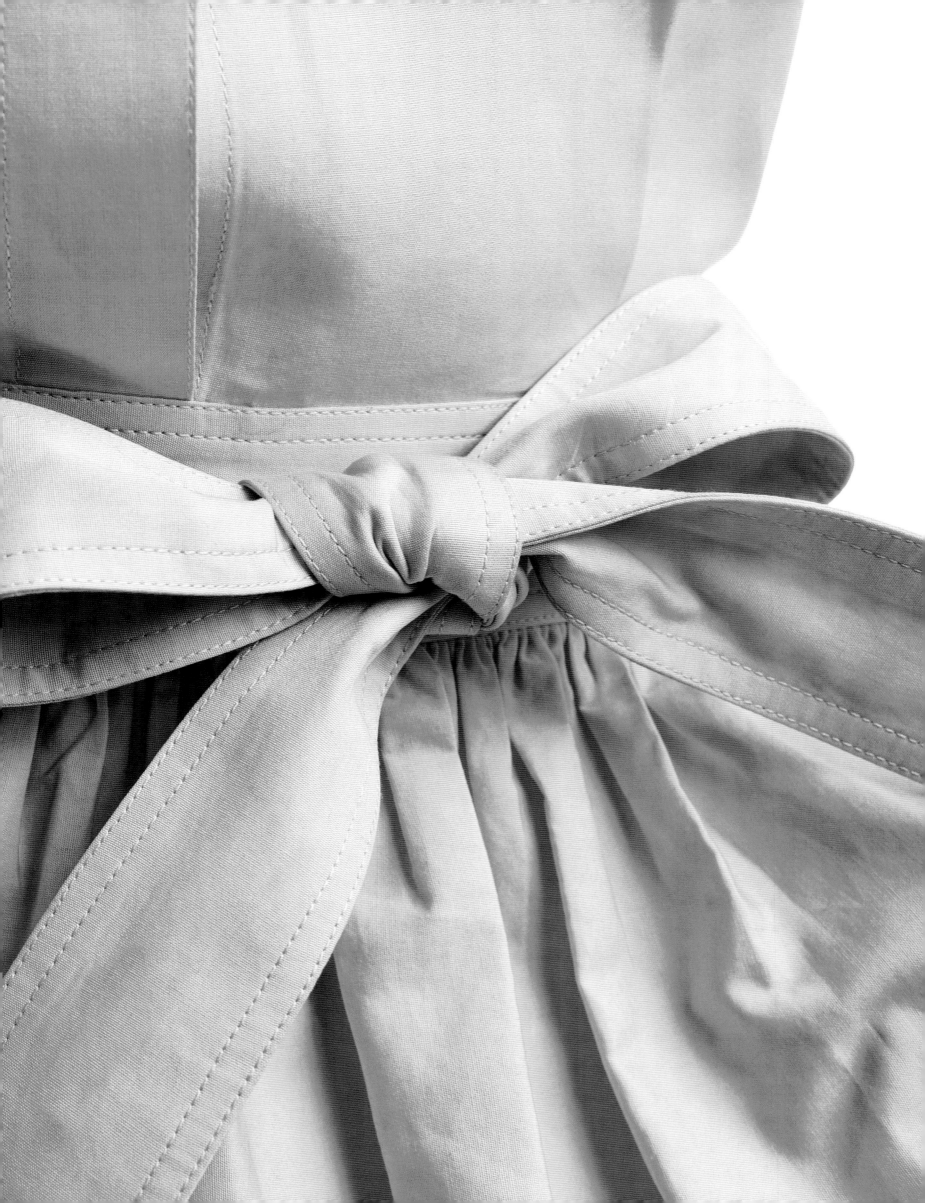

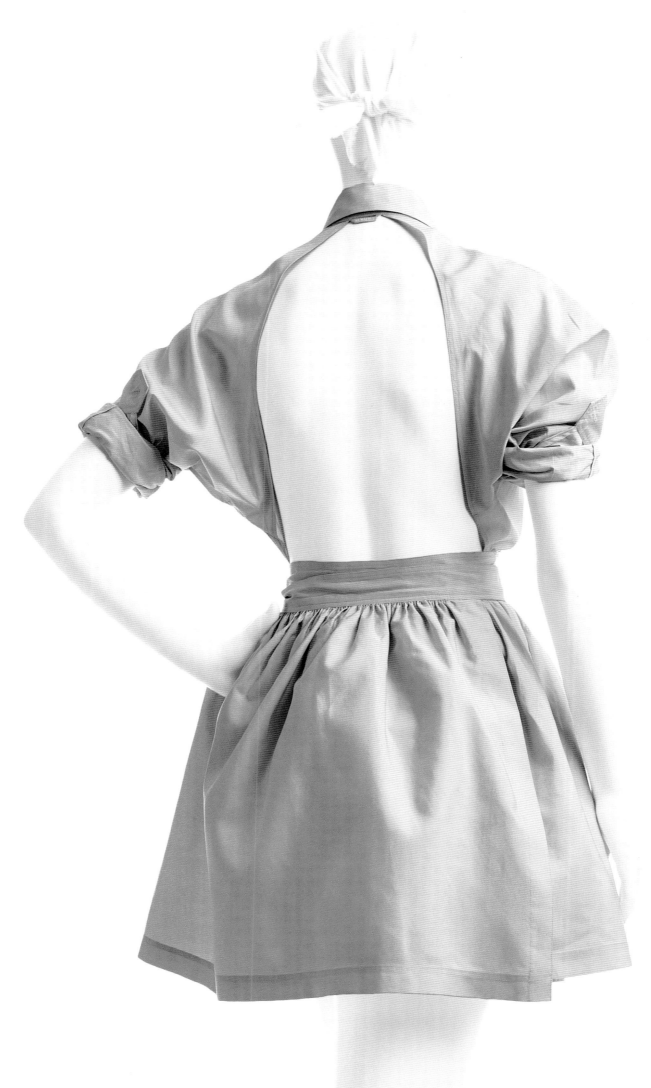

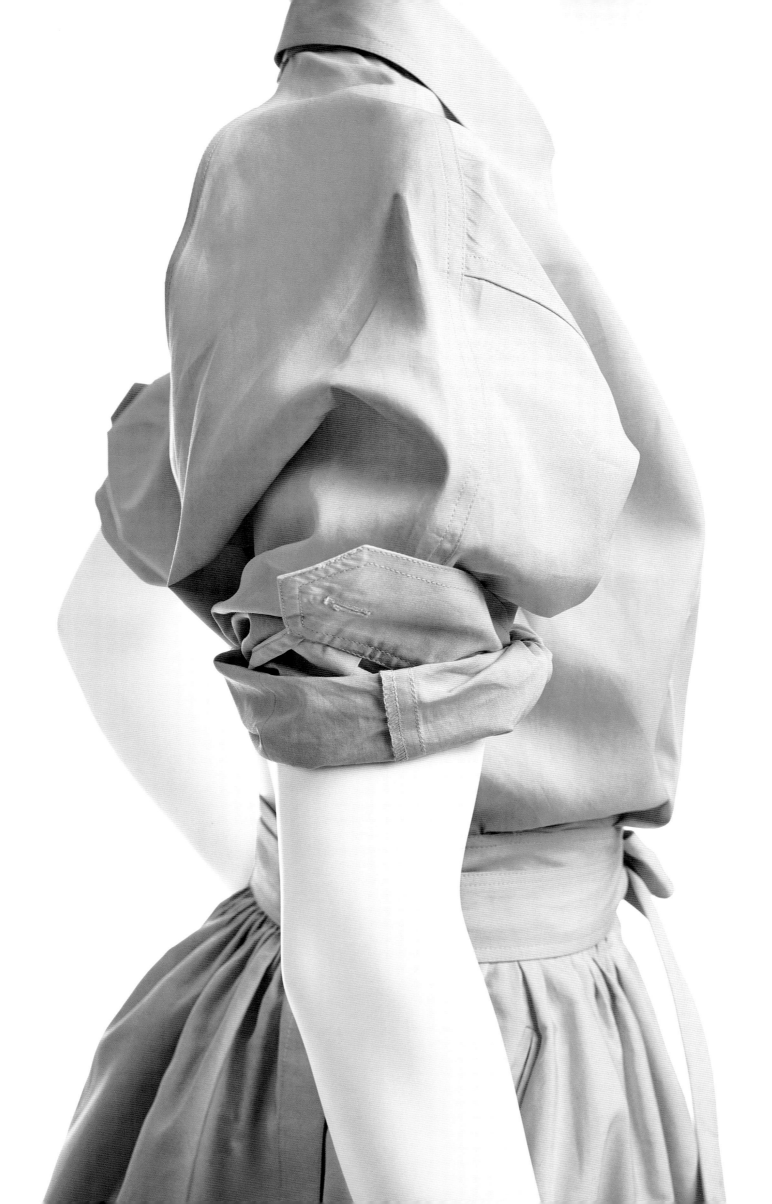

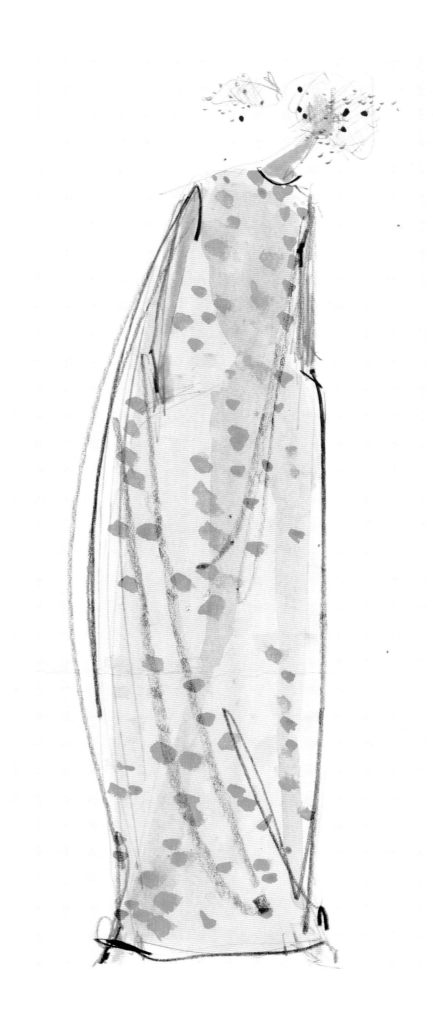

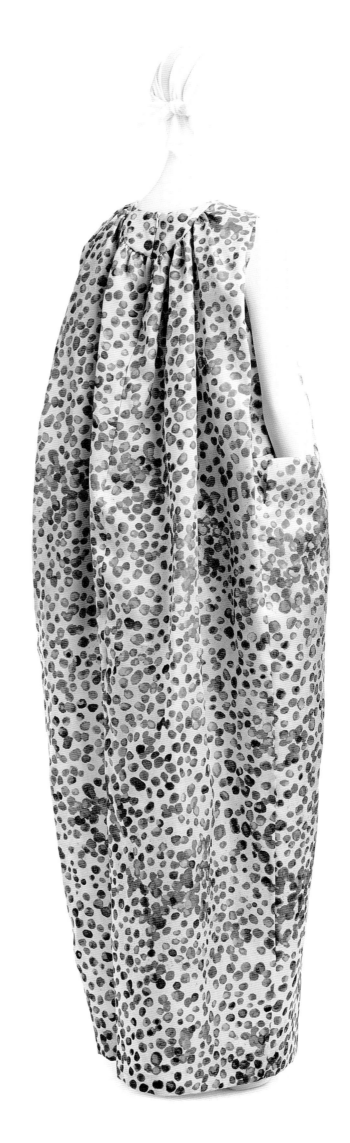

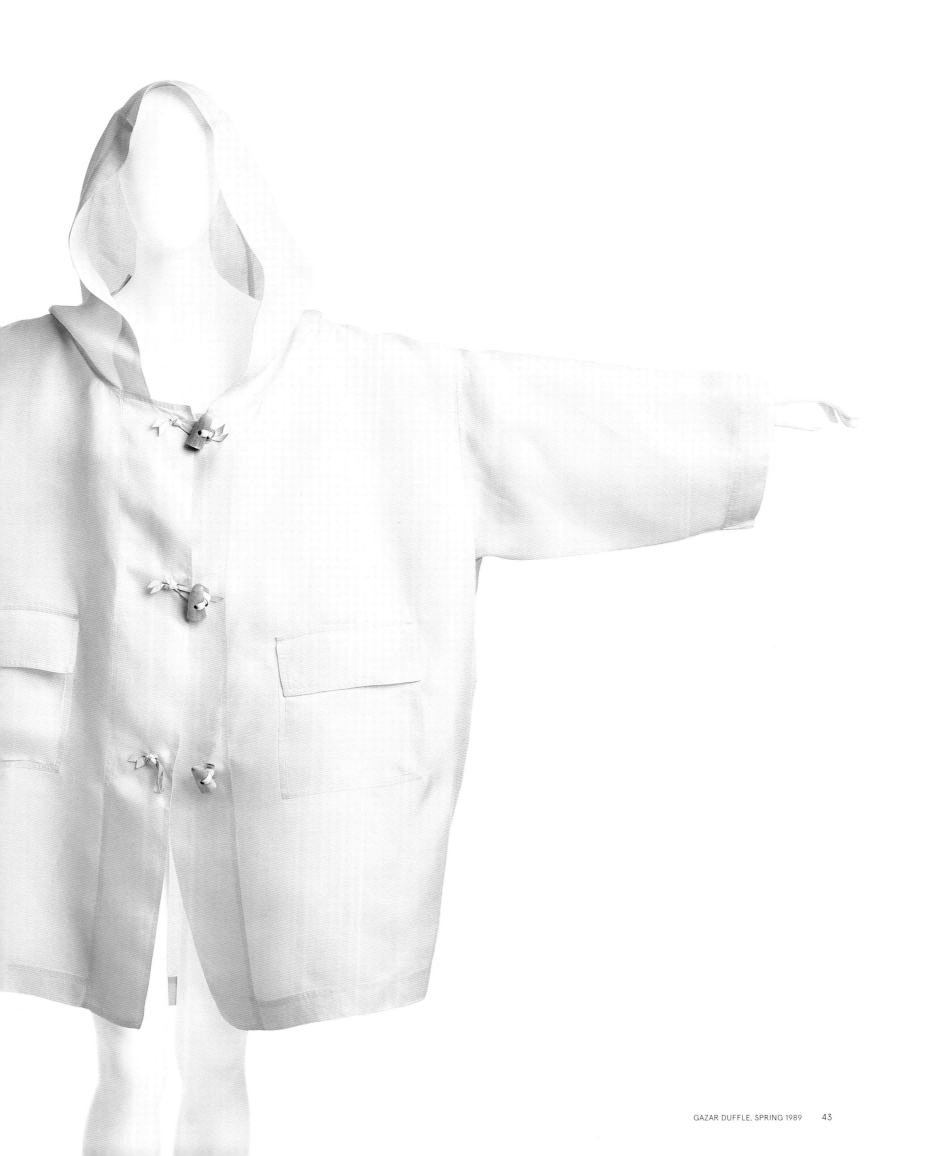

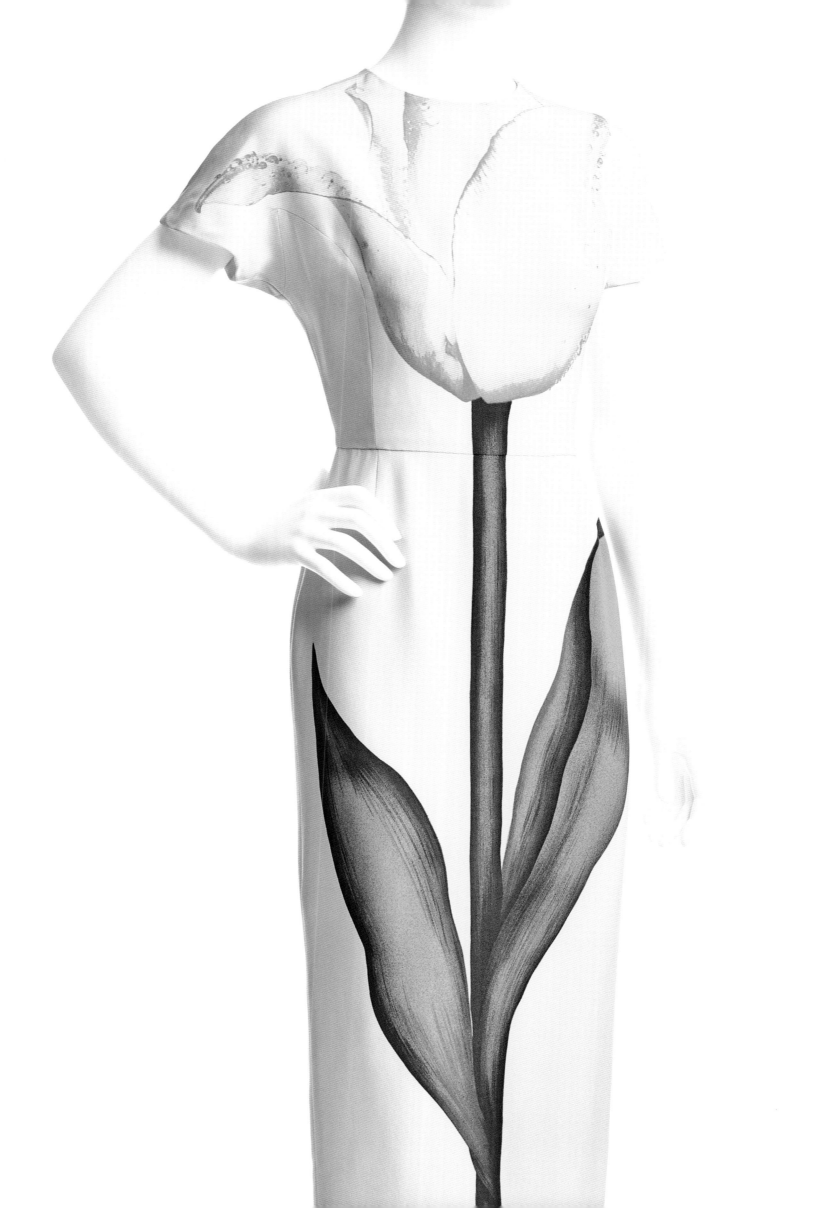

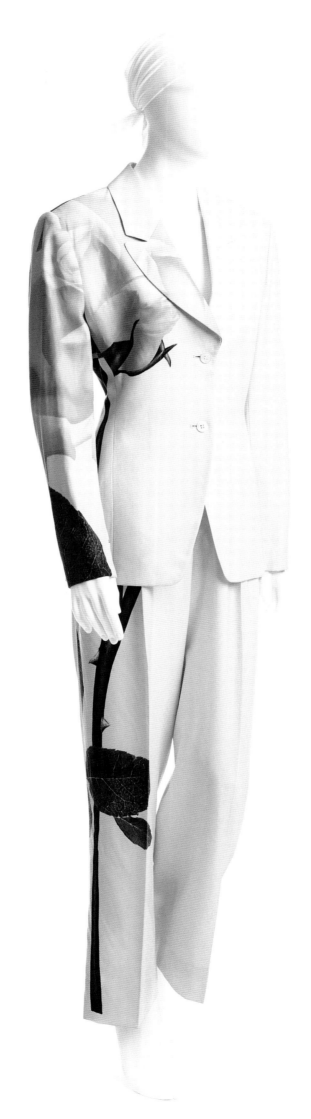

#30

*Cindy Crawford*

— Special Sunflower
Yellow
Cotton Jersey

(Jamaica)

Spring 1984
(79)

48

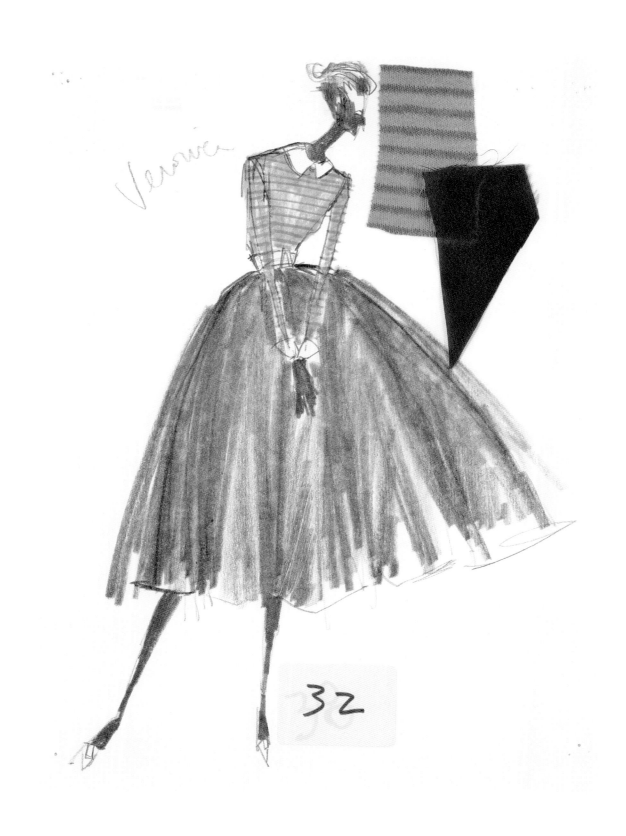

Verona

32

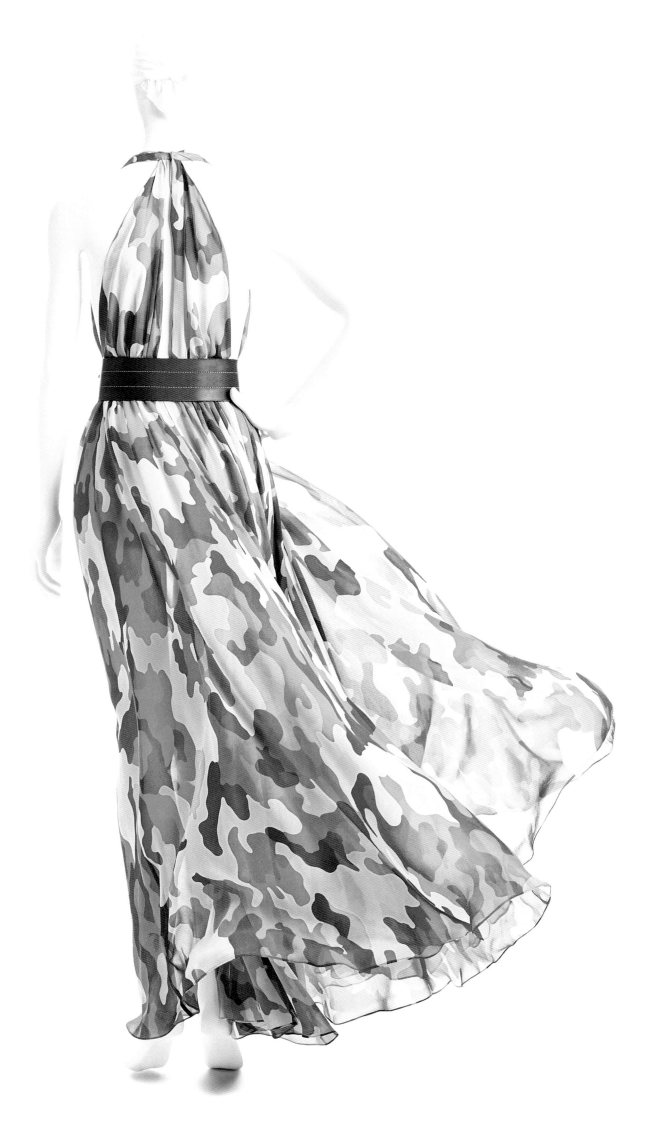

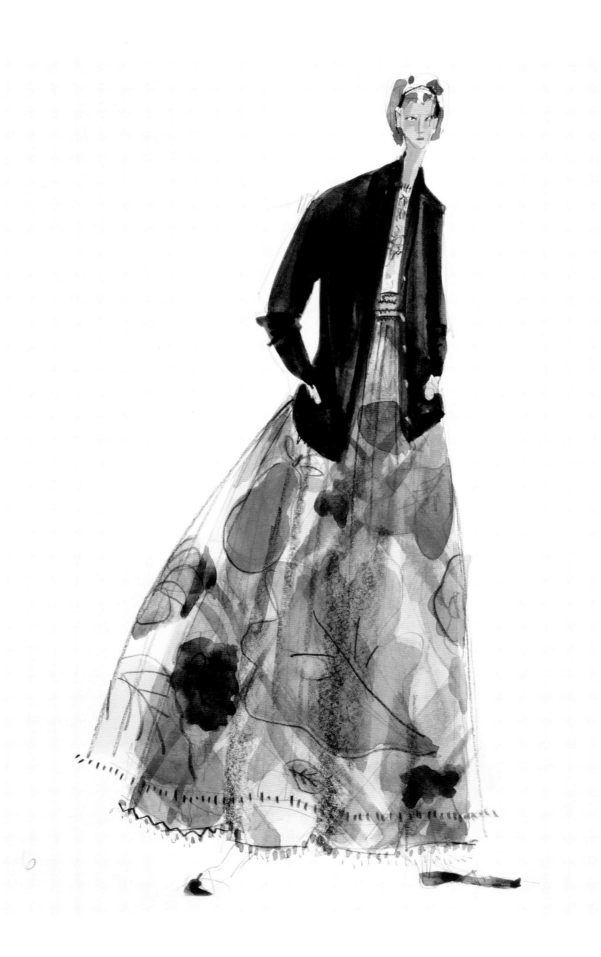

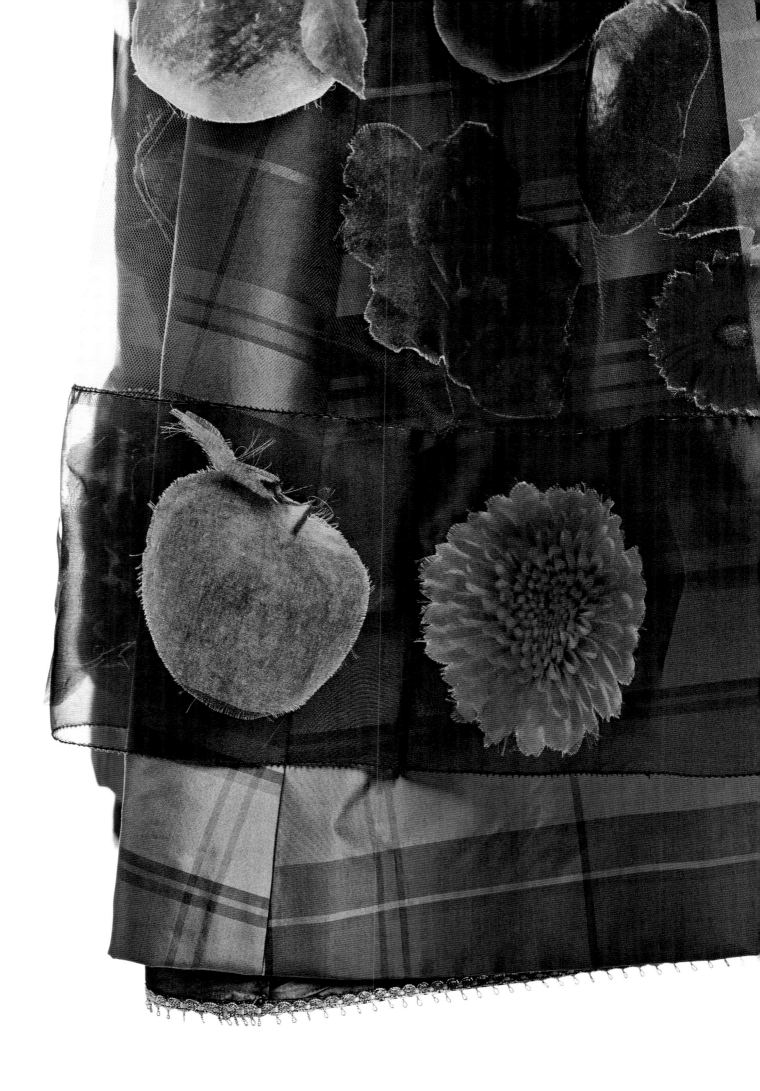

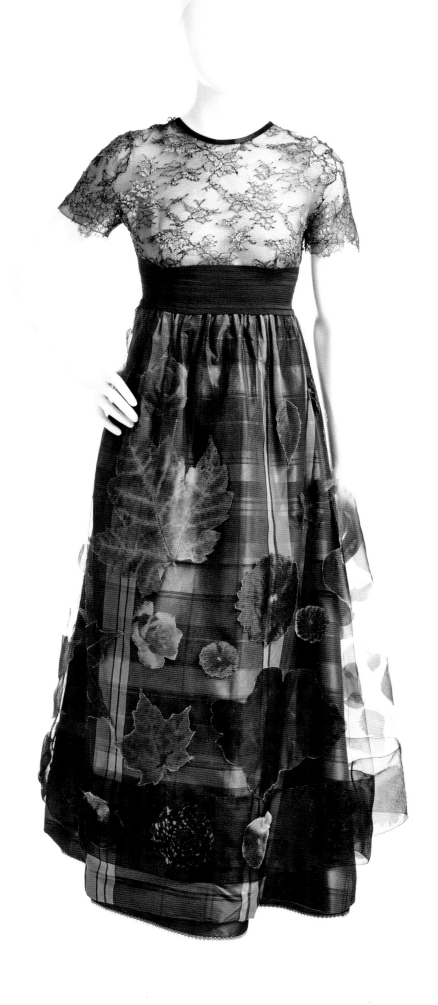

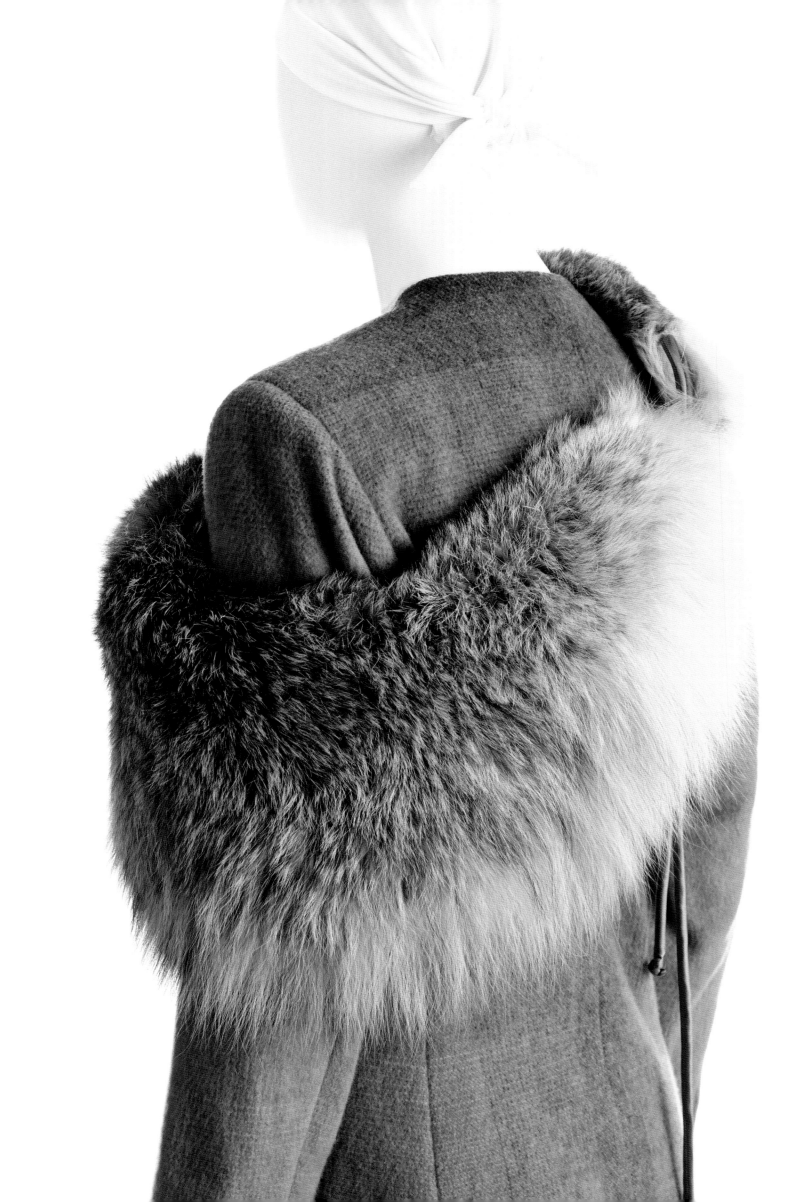

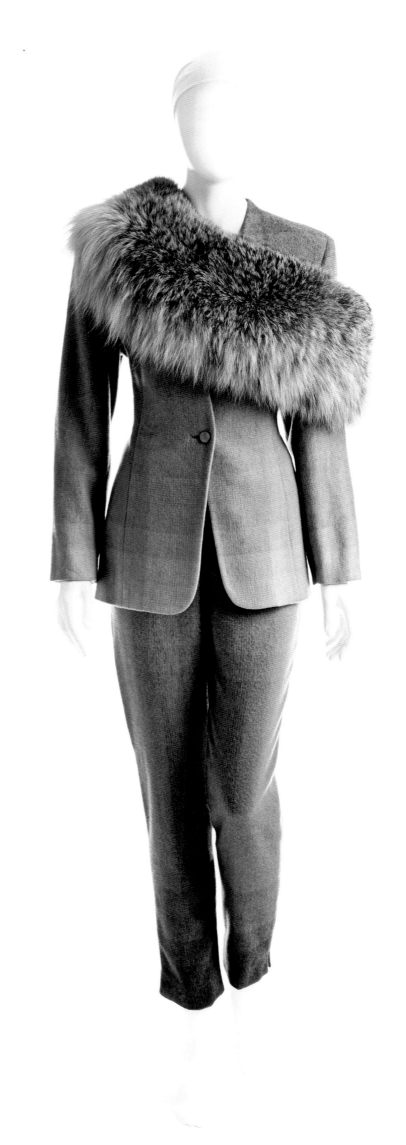

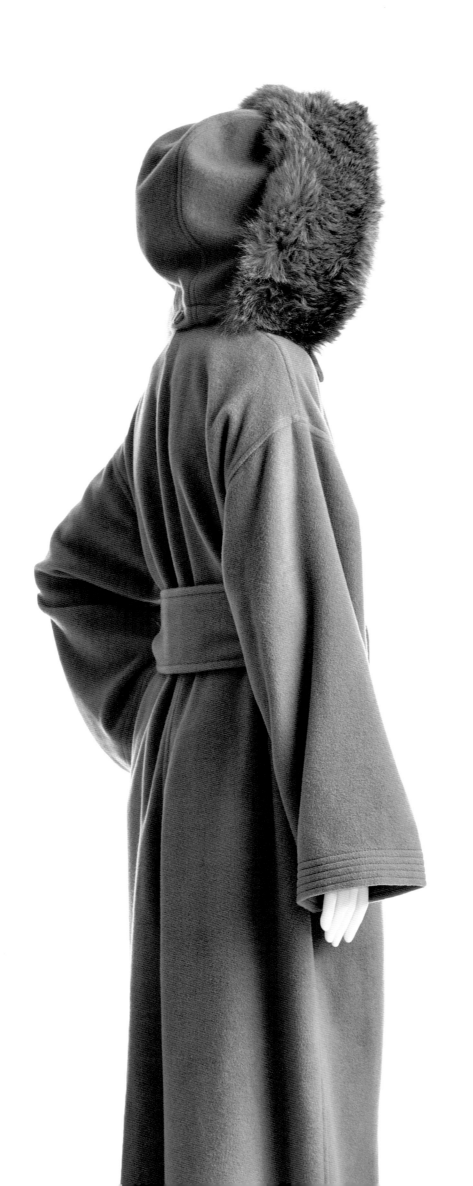

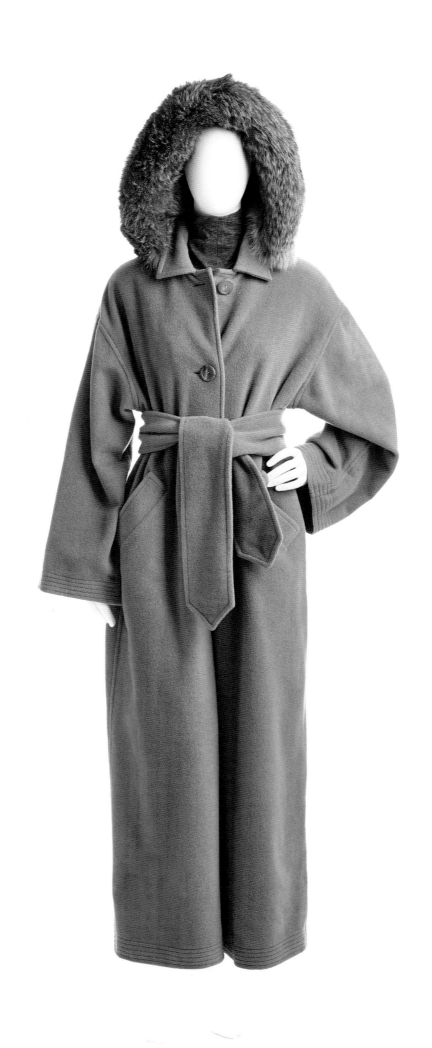

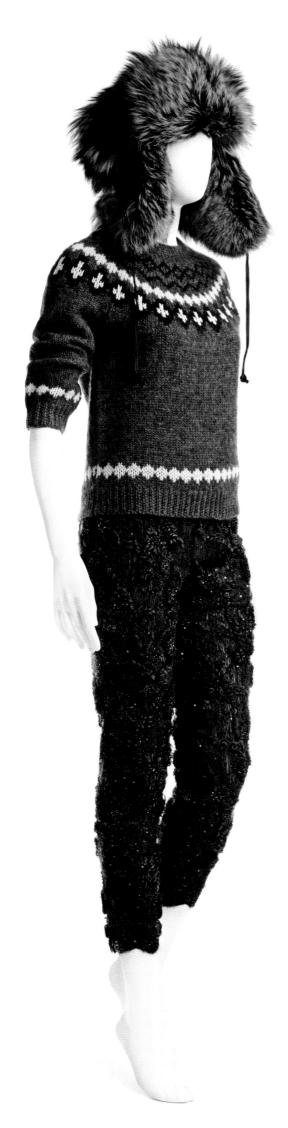

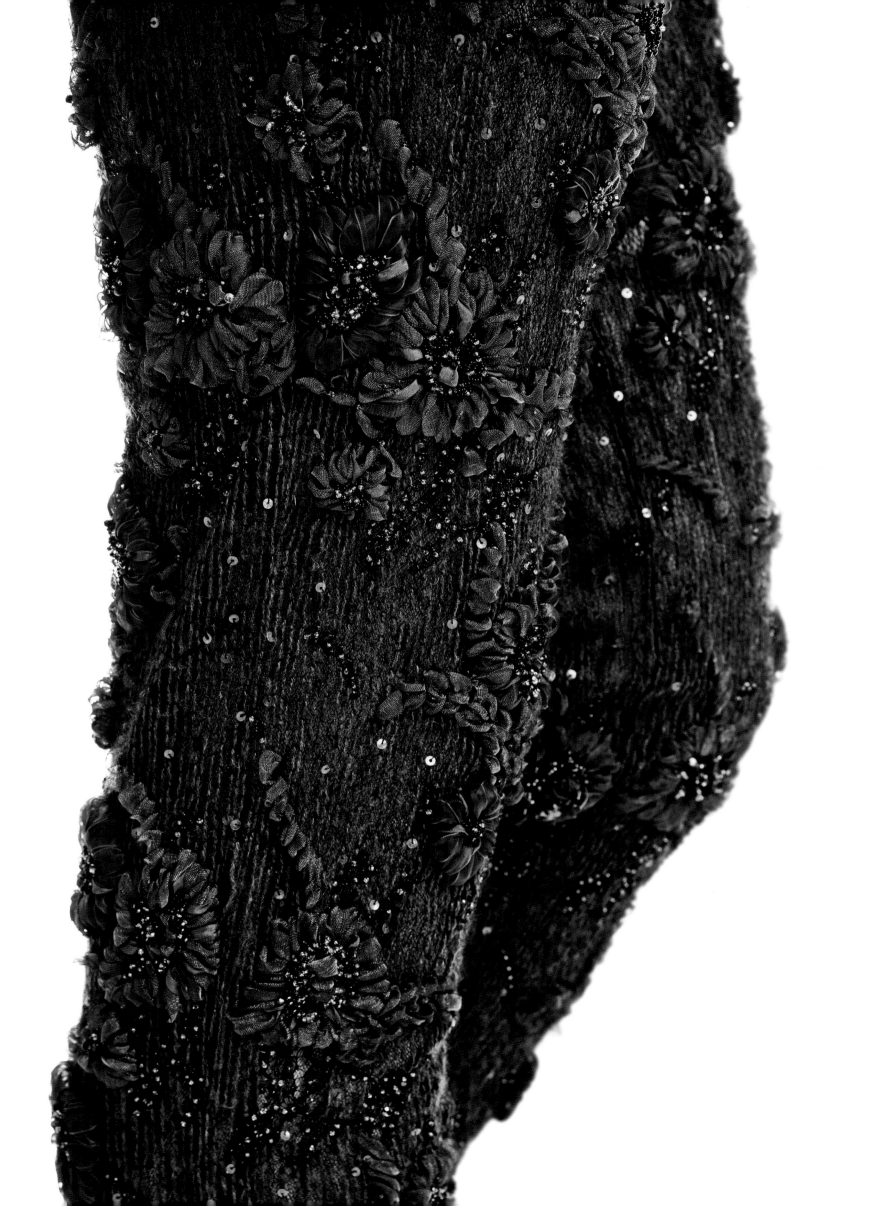

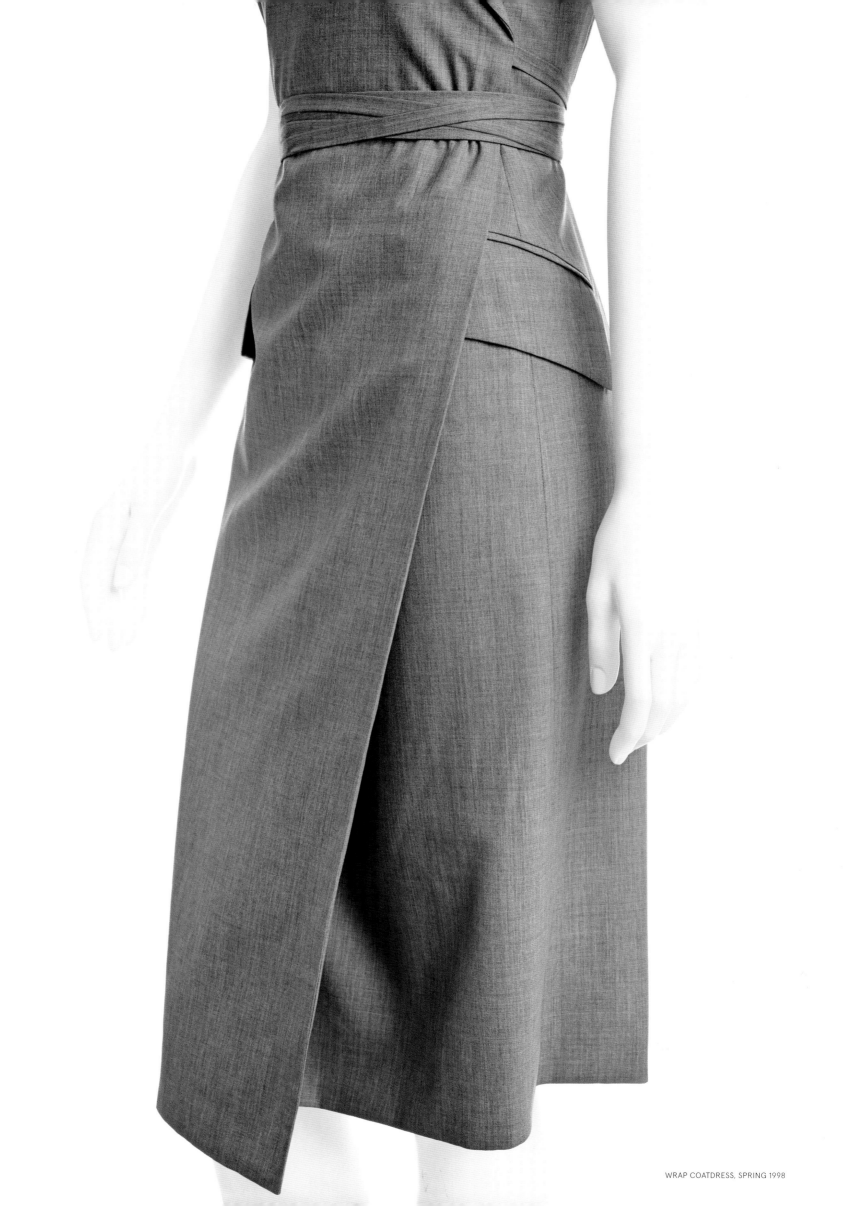

WRAP COATDRESS, SPRING 1998

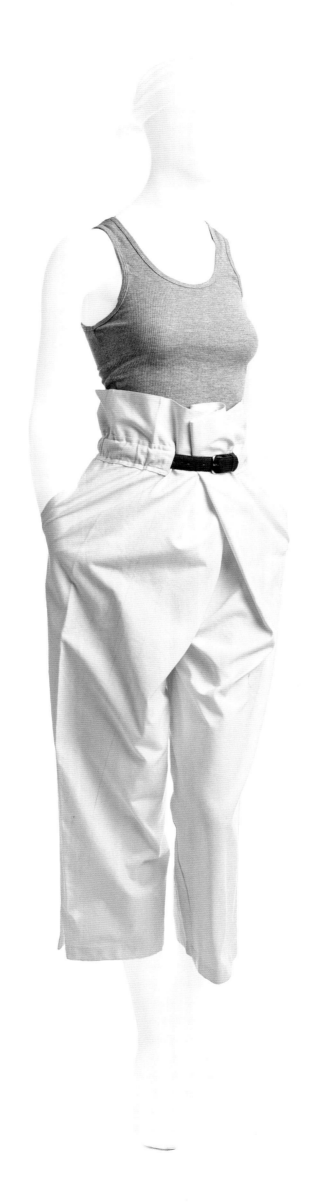

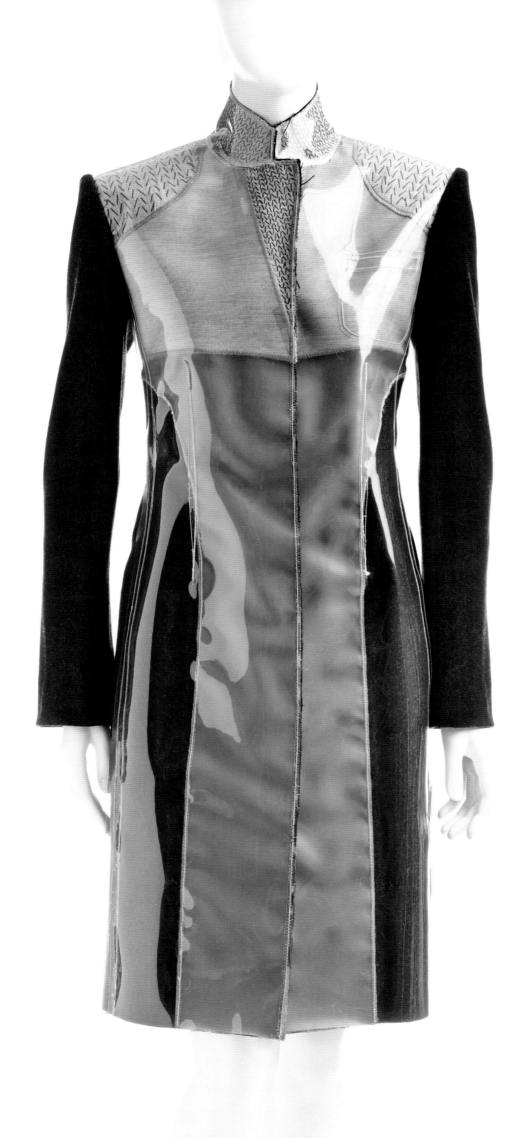

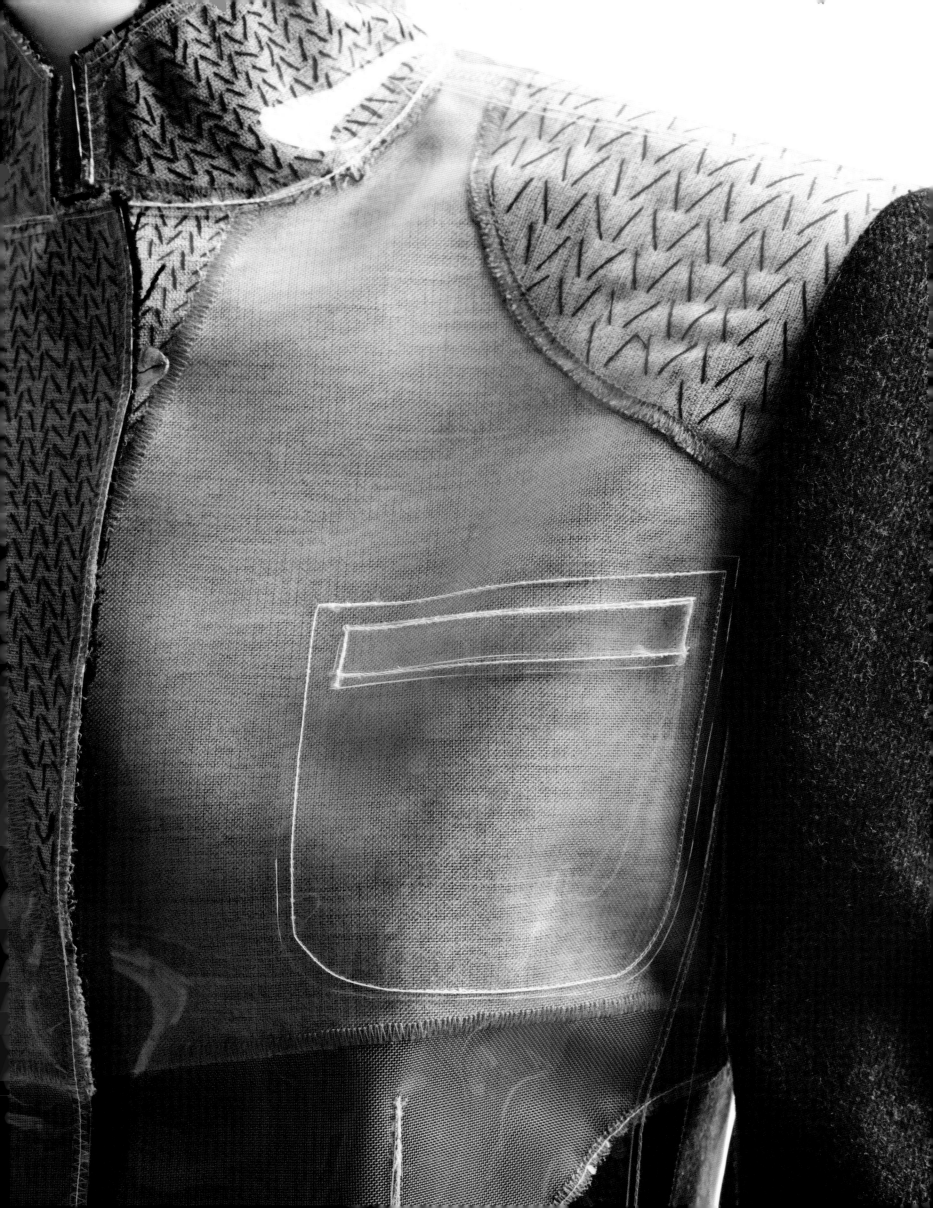

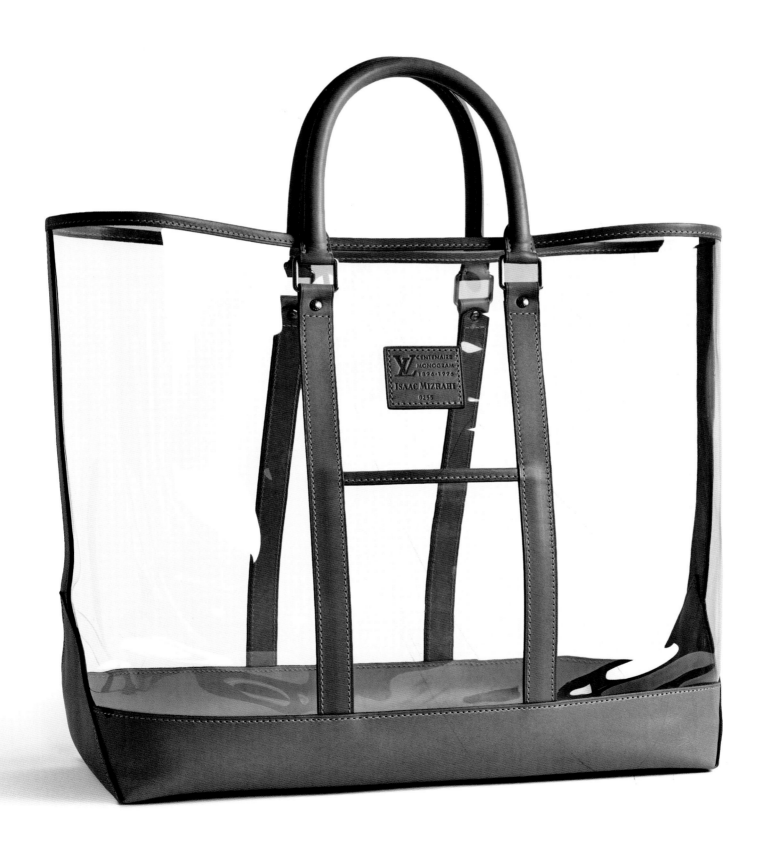

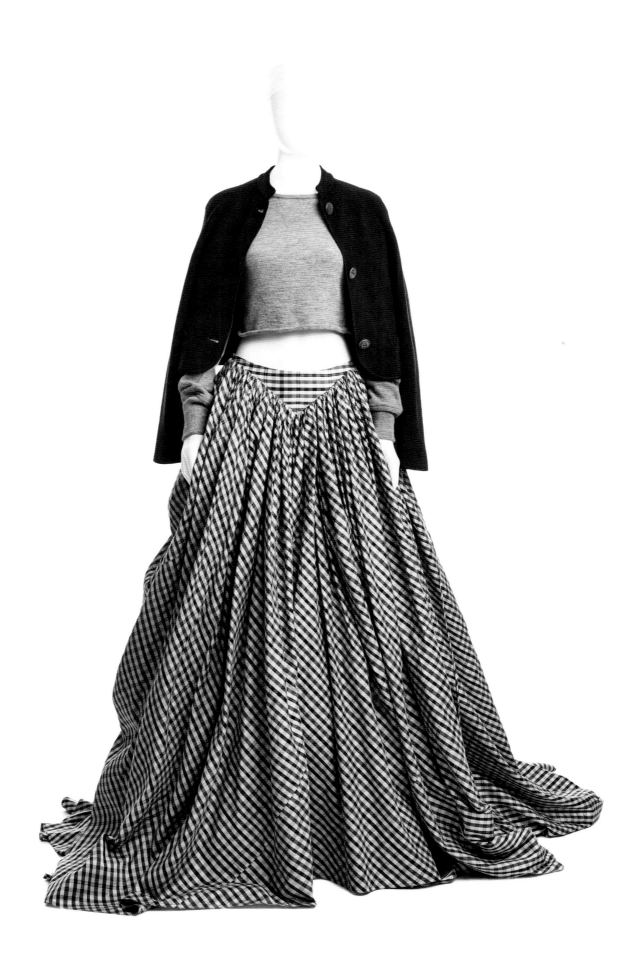

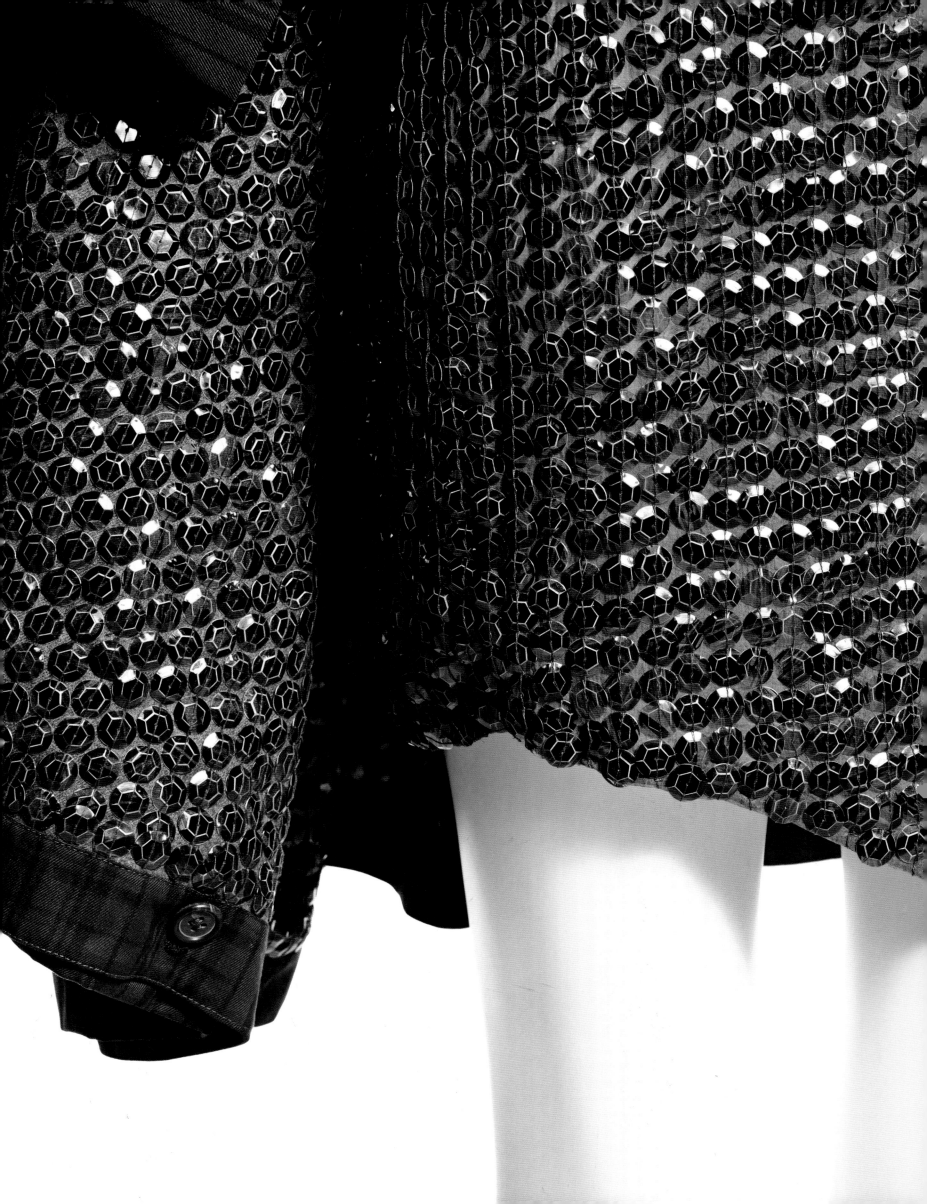

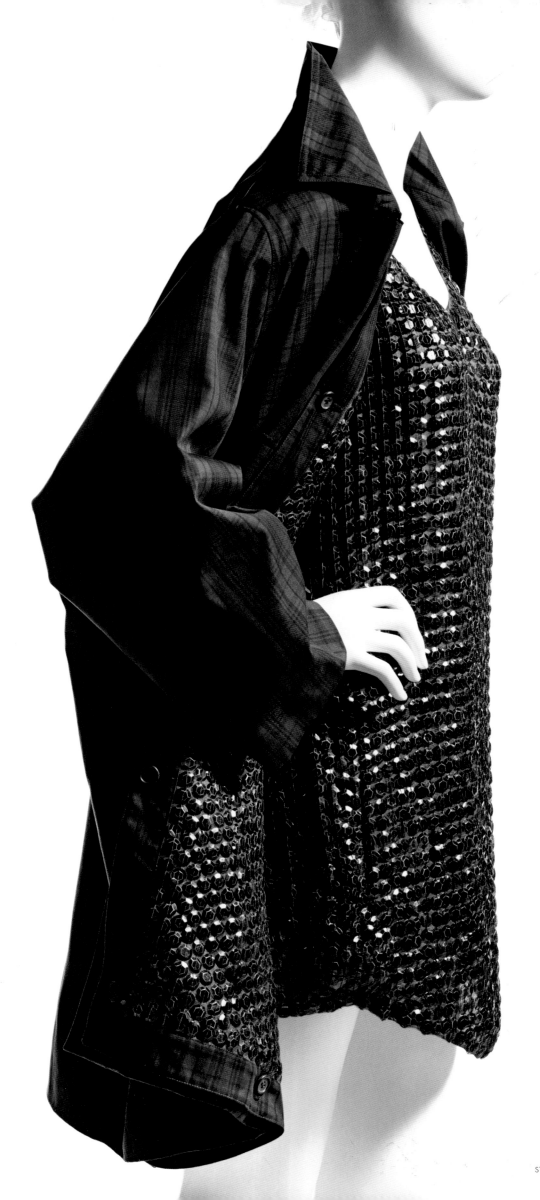

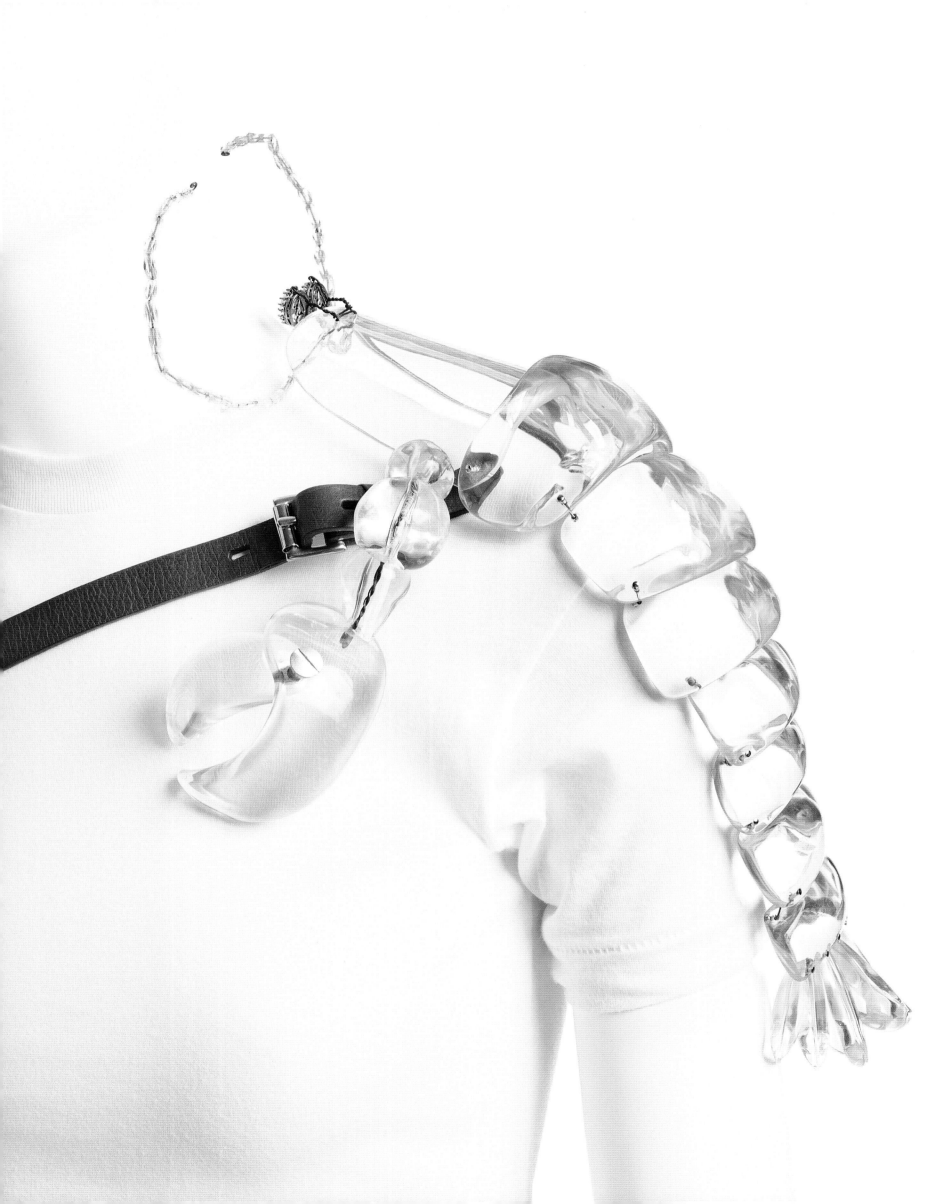

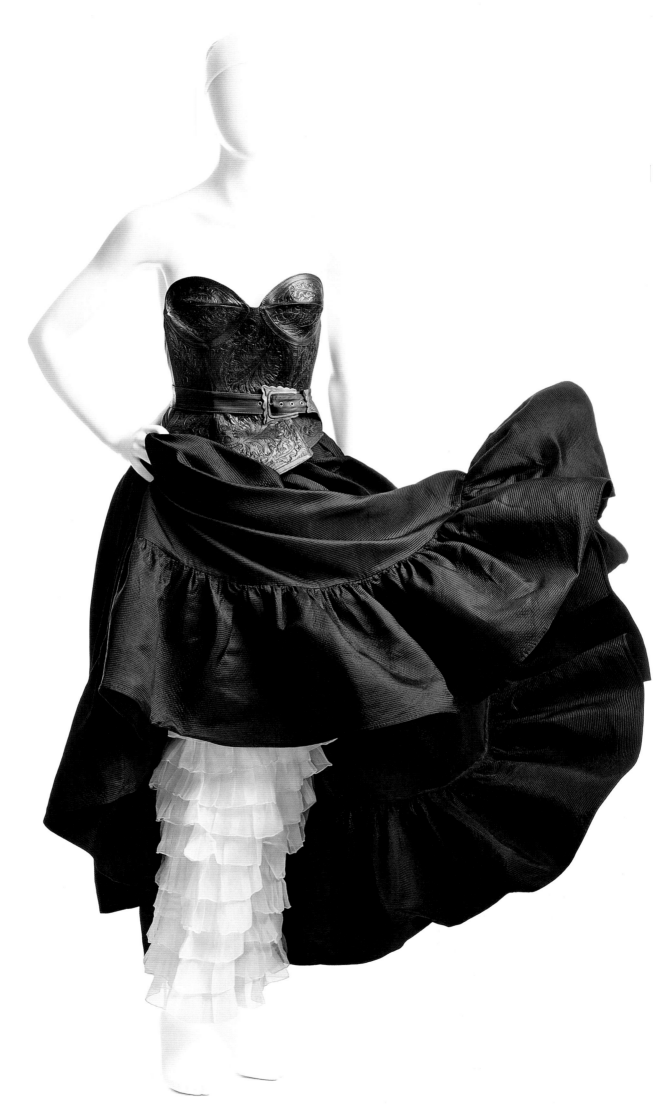

TOOLED BUSTIER-BELT, SPRING 1992

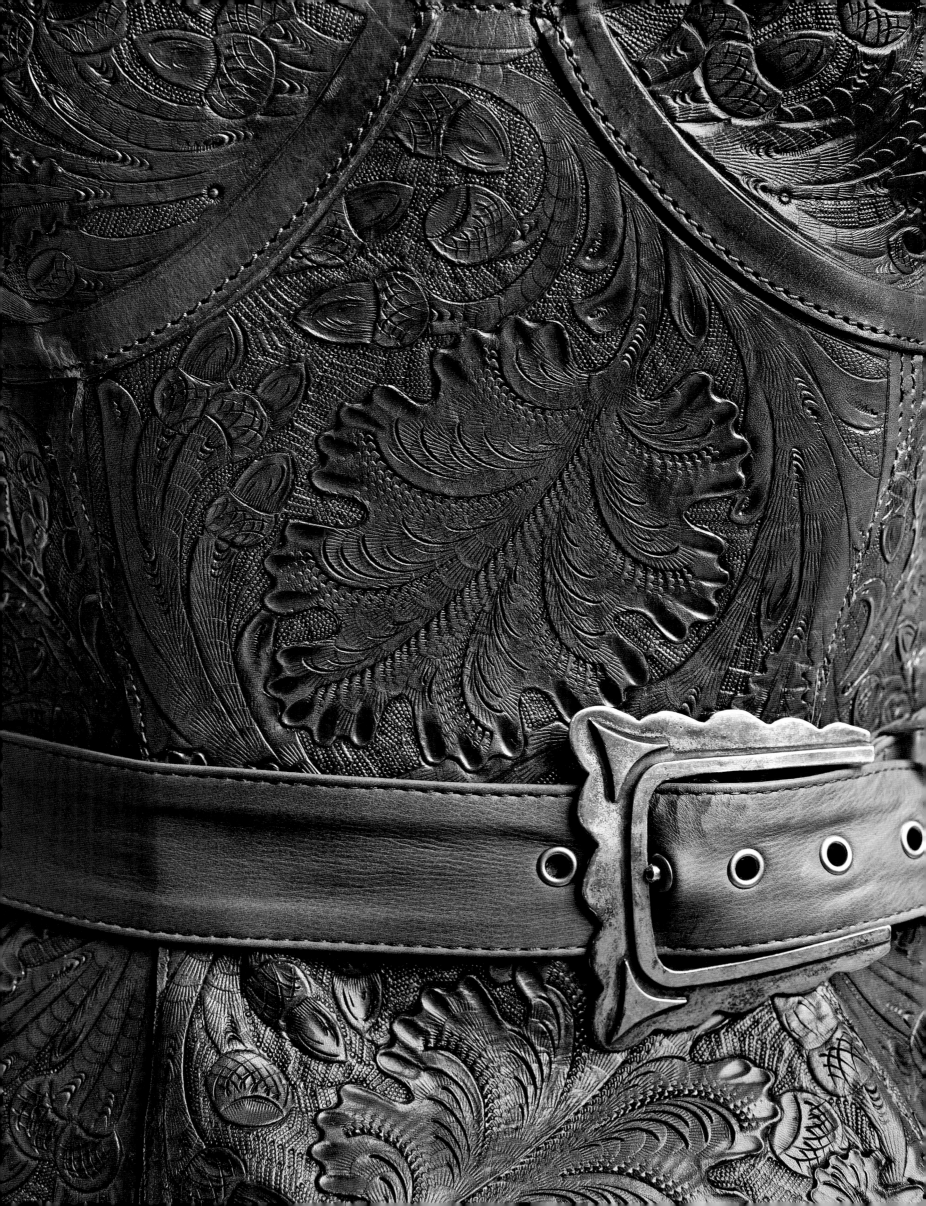

Lynx
Trimmed
with
Beast

Wool
Organ

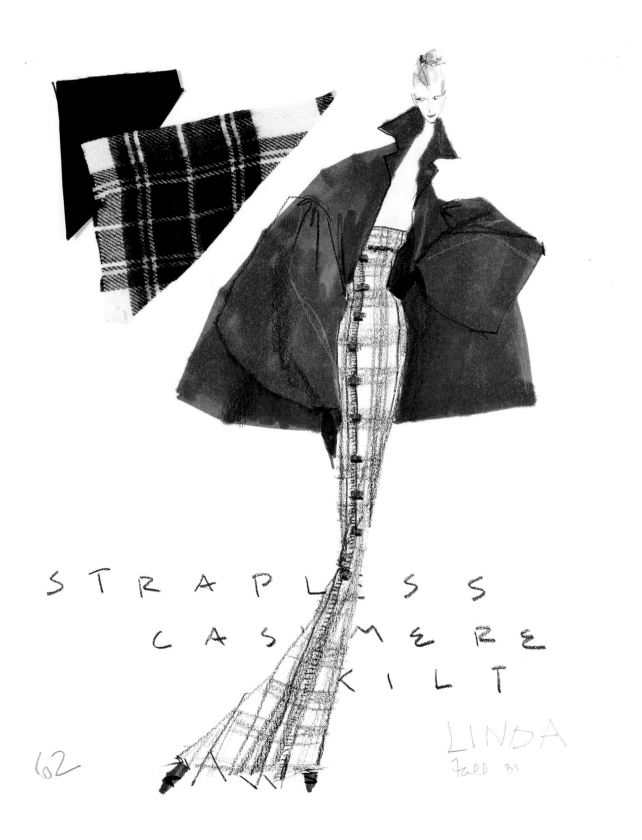

STRAPLESS
CASHMERE
KILT

62

LINDA
Fall 89

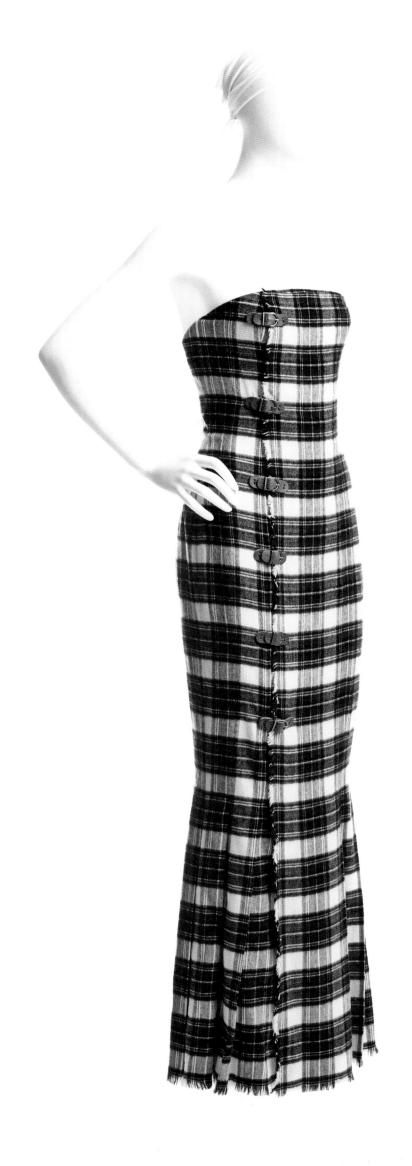

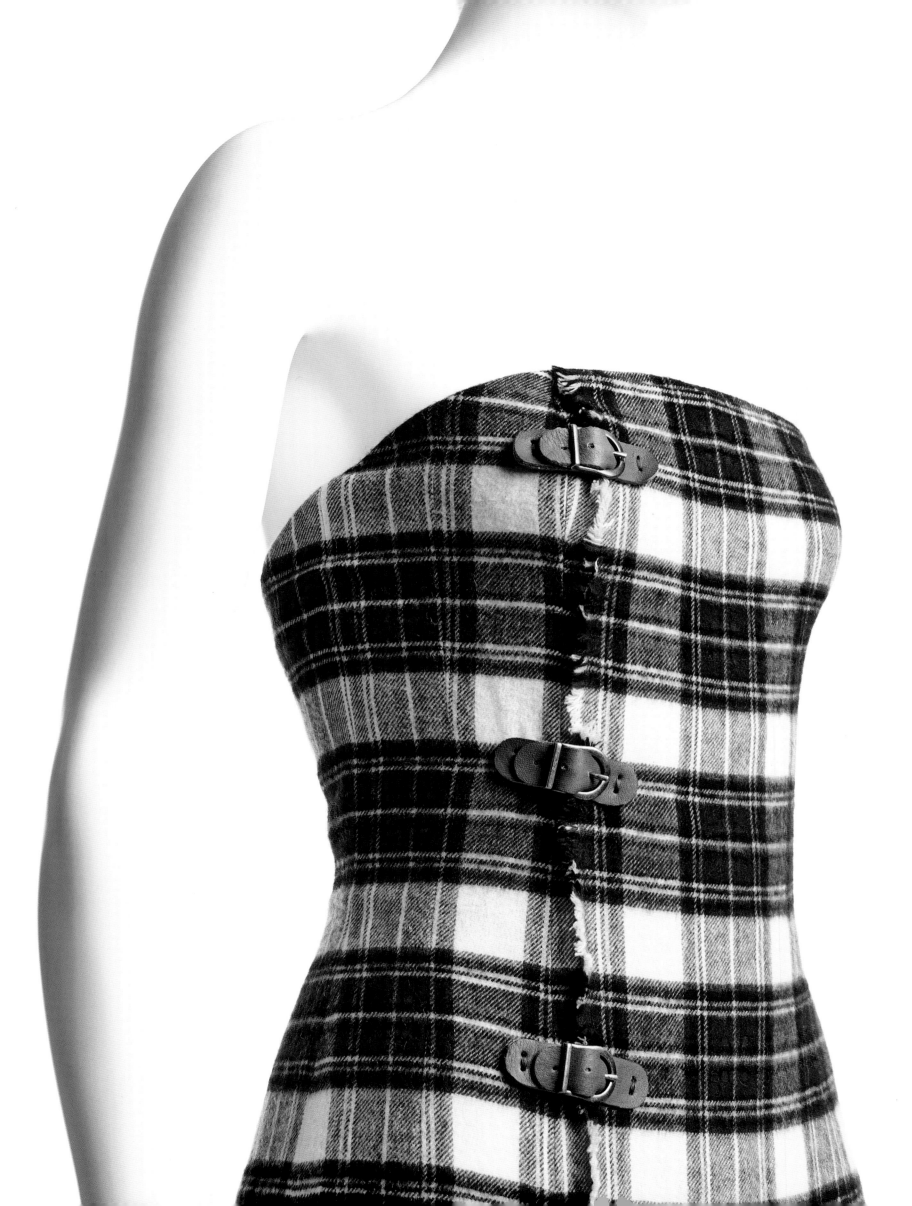

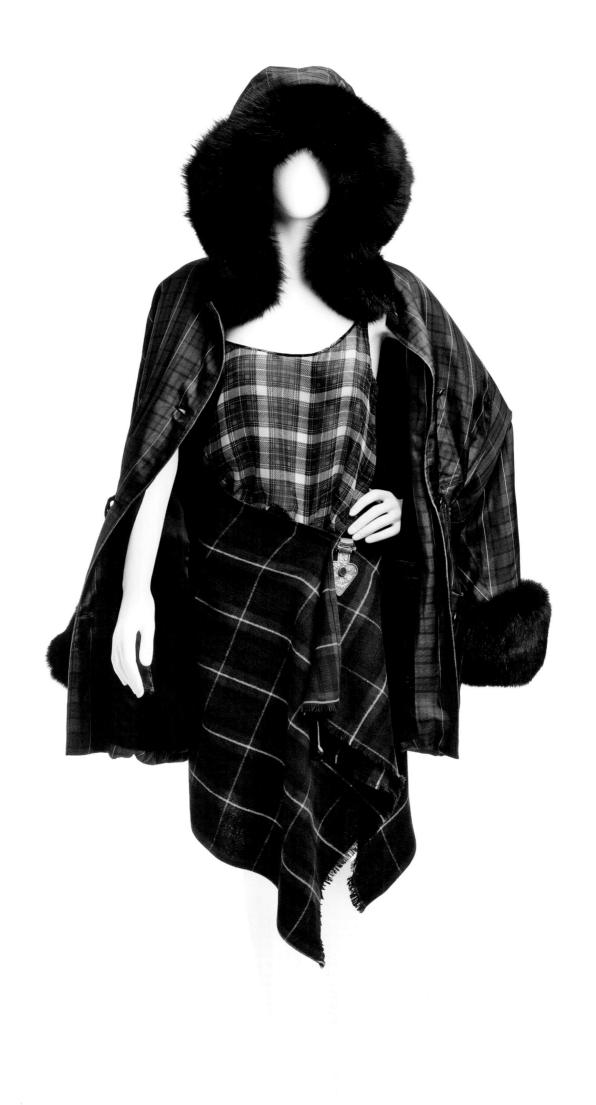

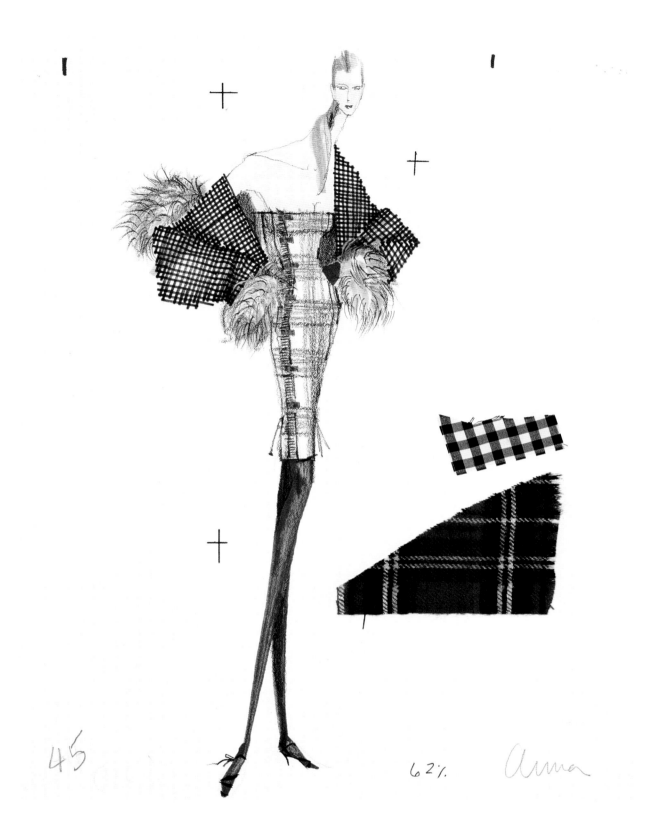

45

62%.

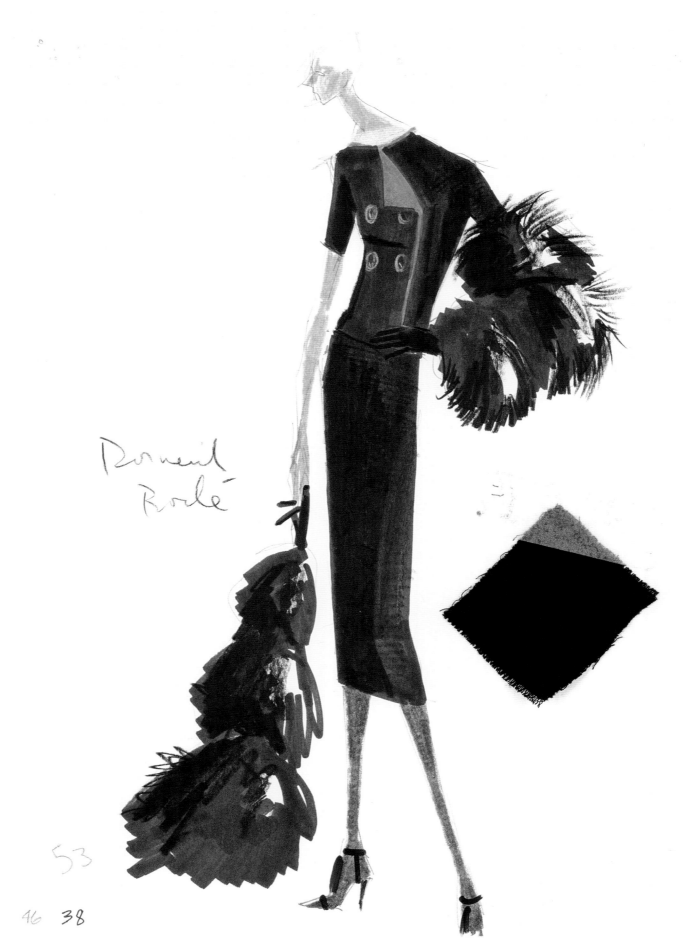

Romeil
Roché

53

46  38

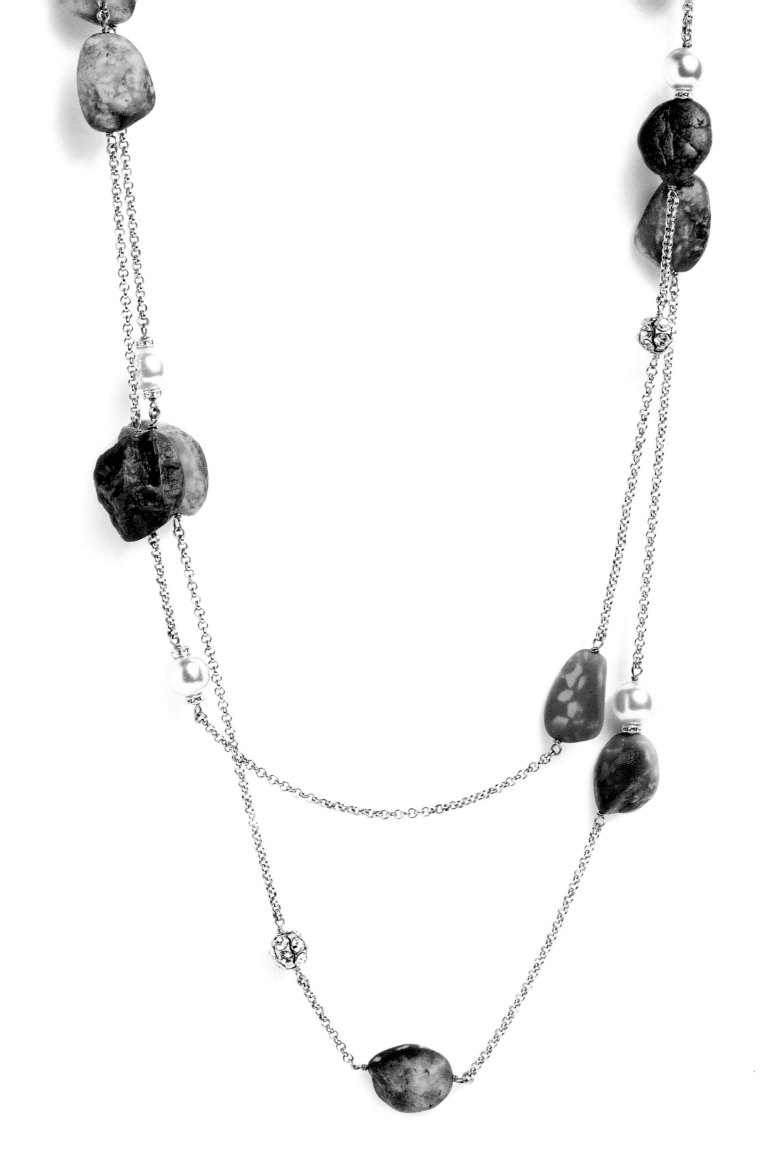

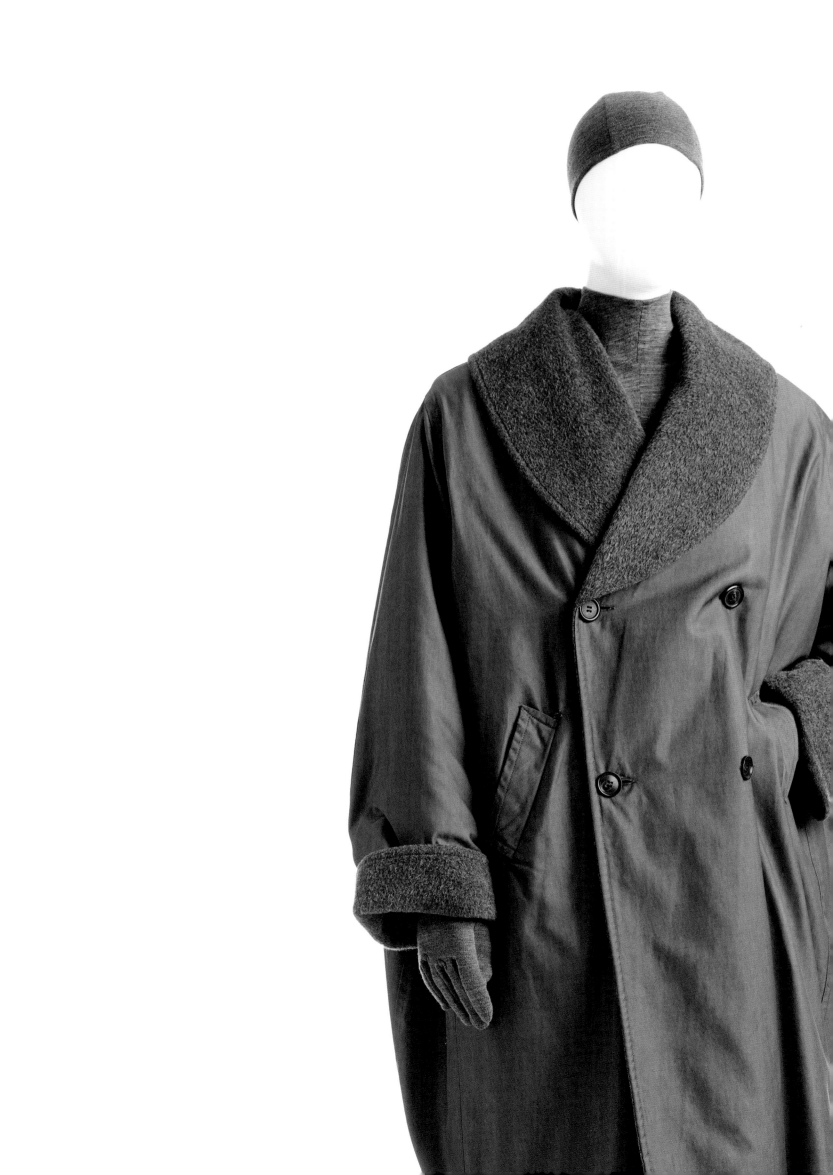

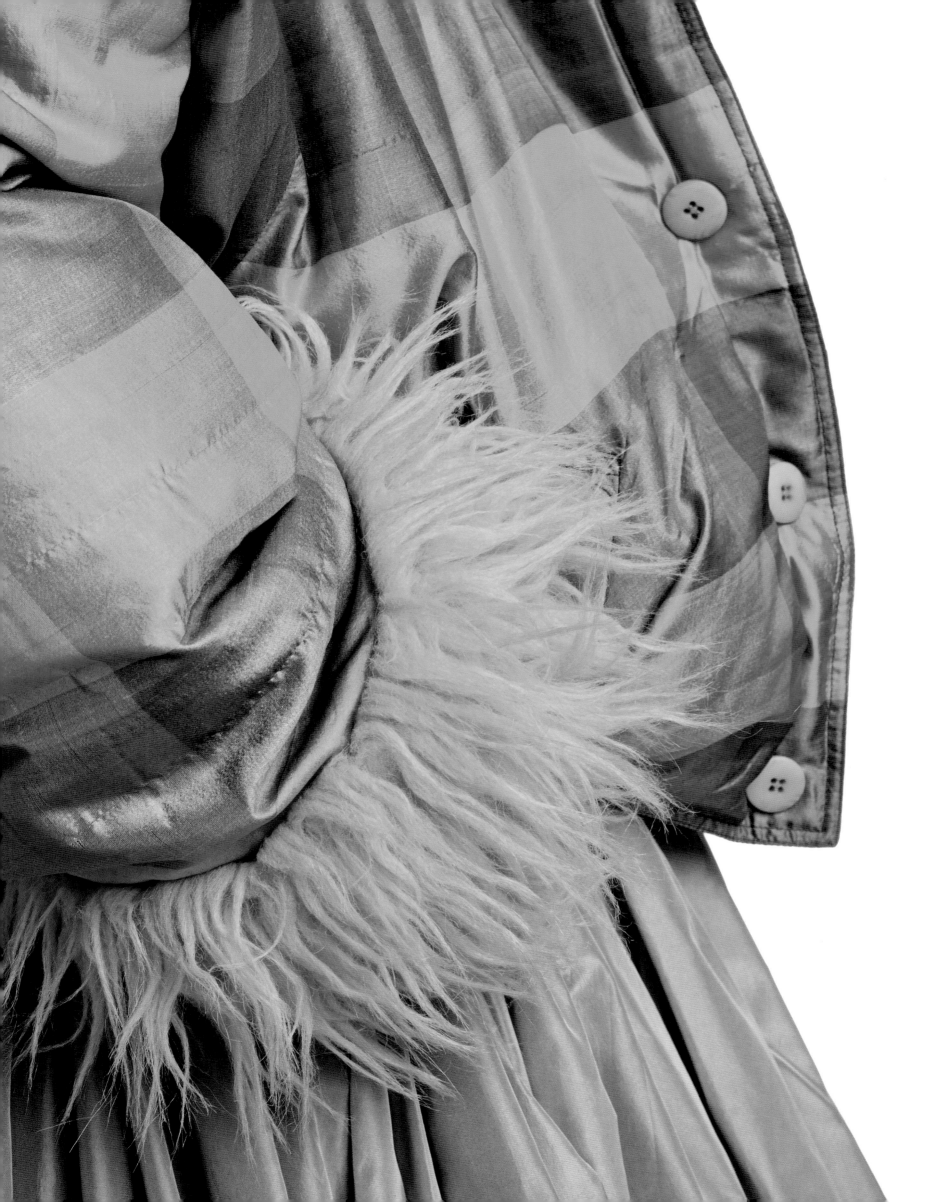

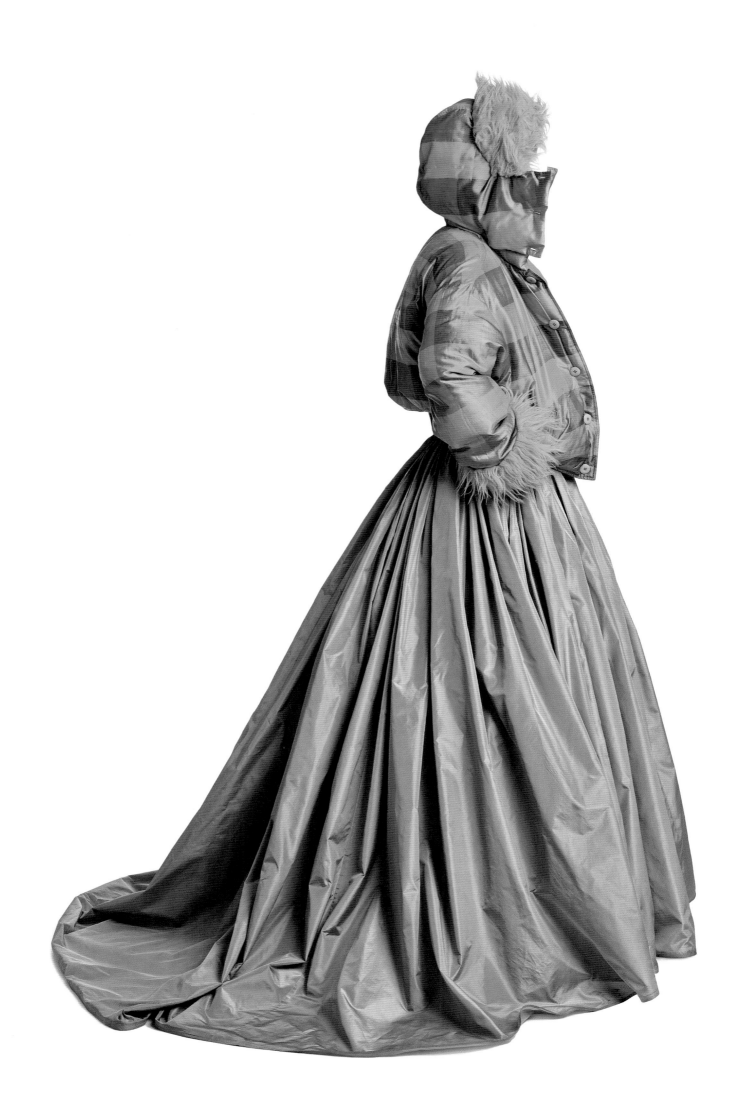

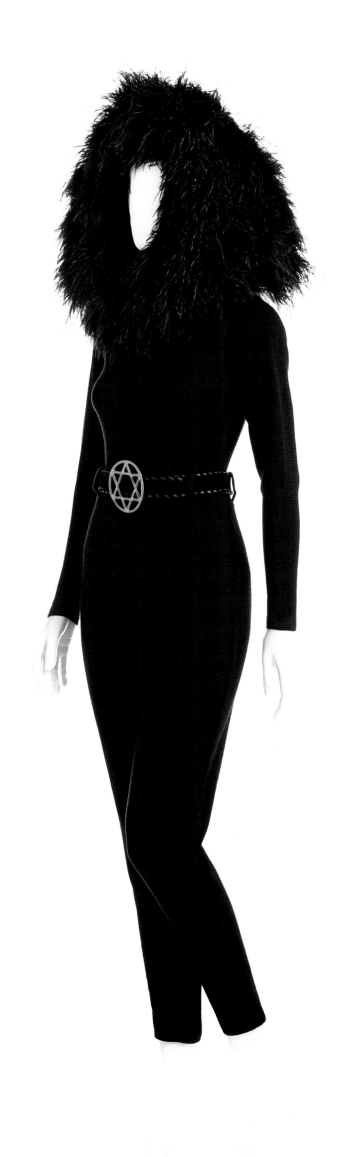

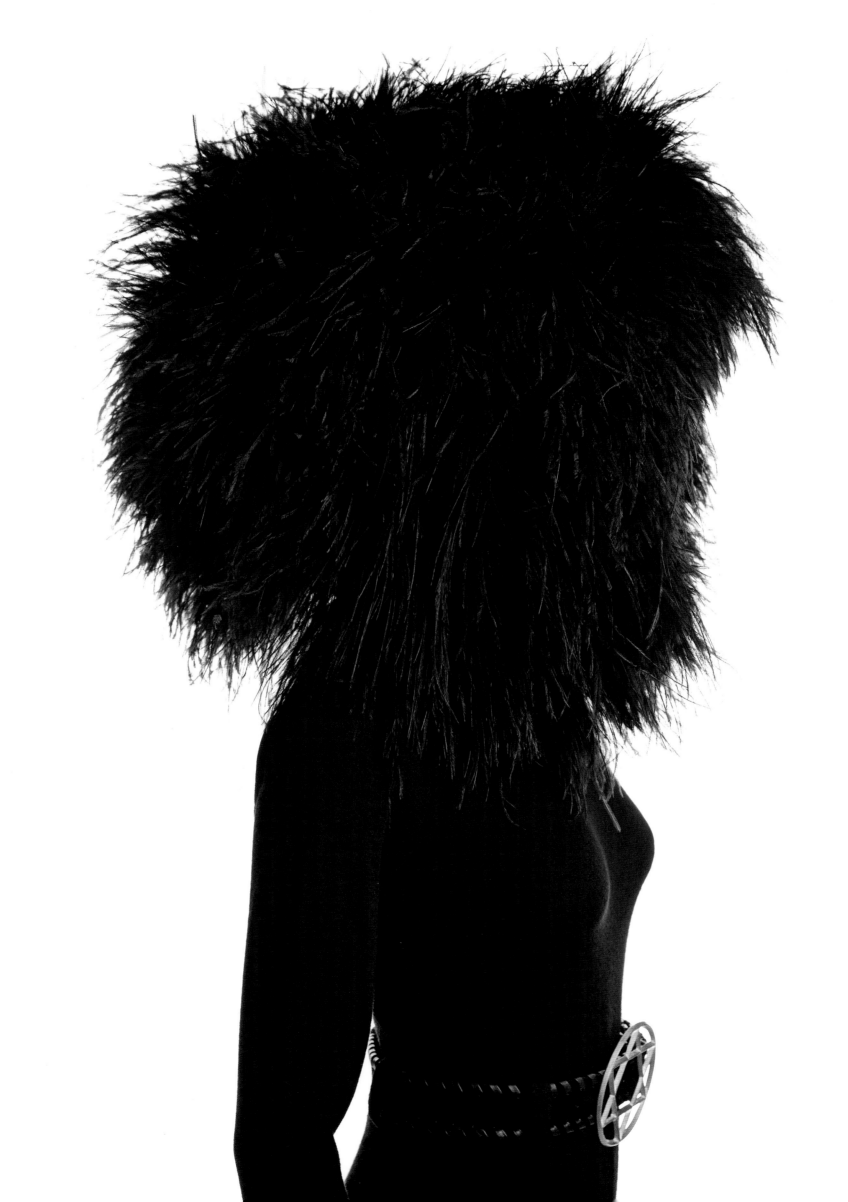

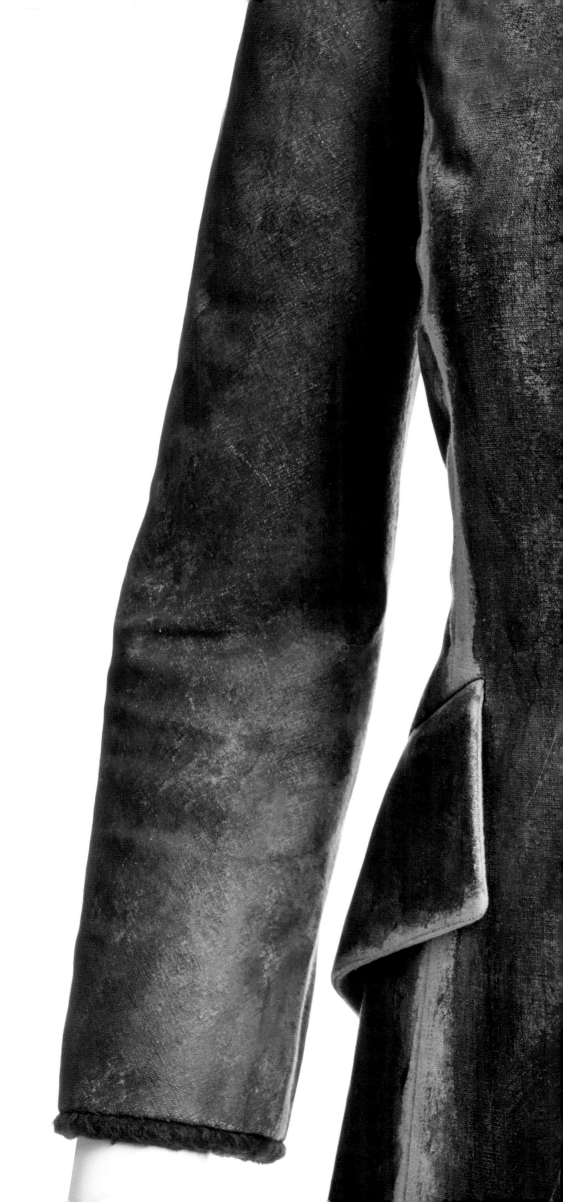

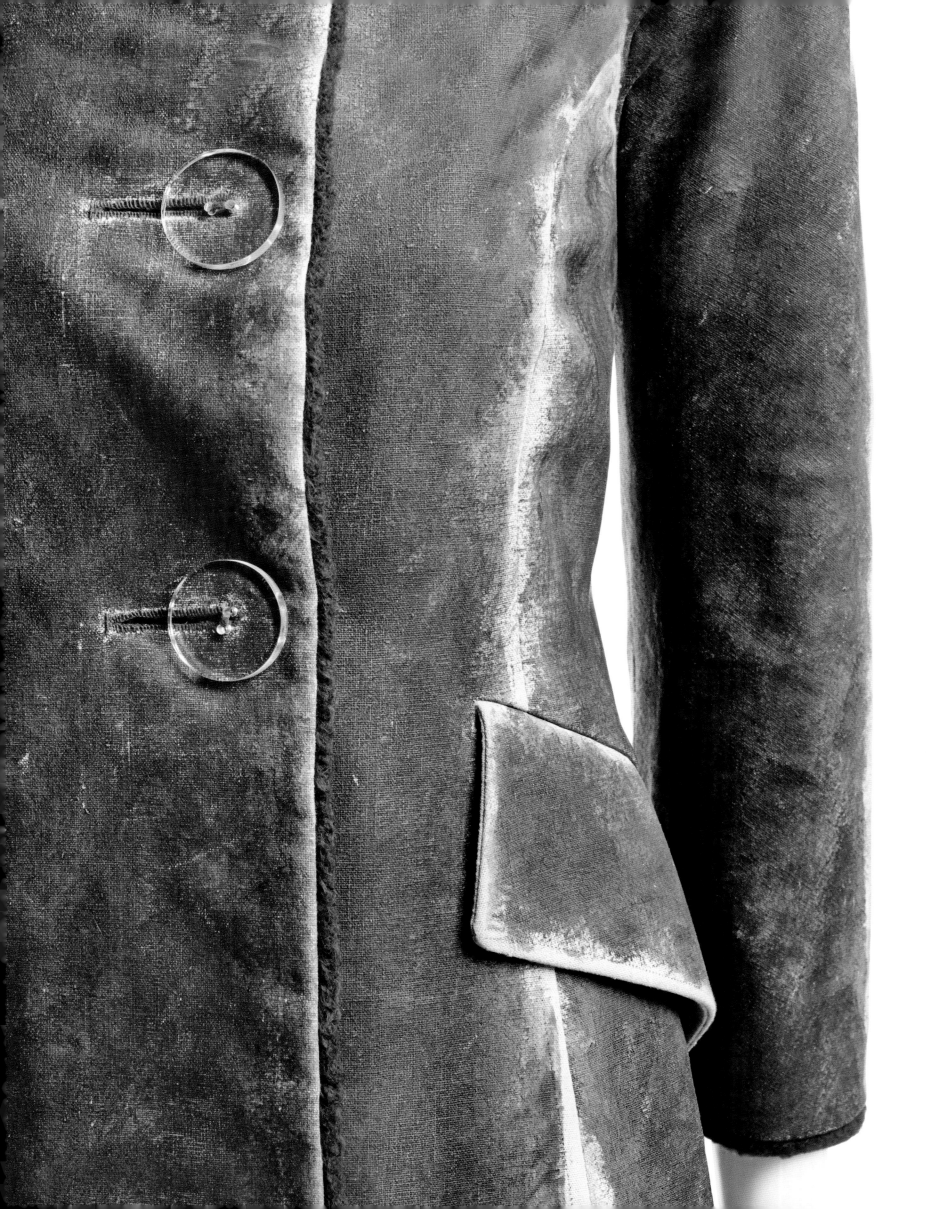

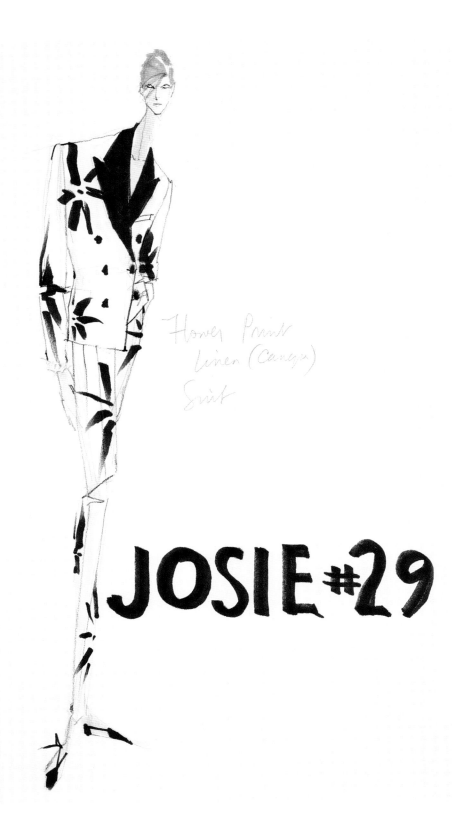

Flower Print
Linen (Canvas)
Suit

JOSIE #29

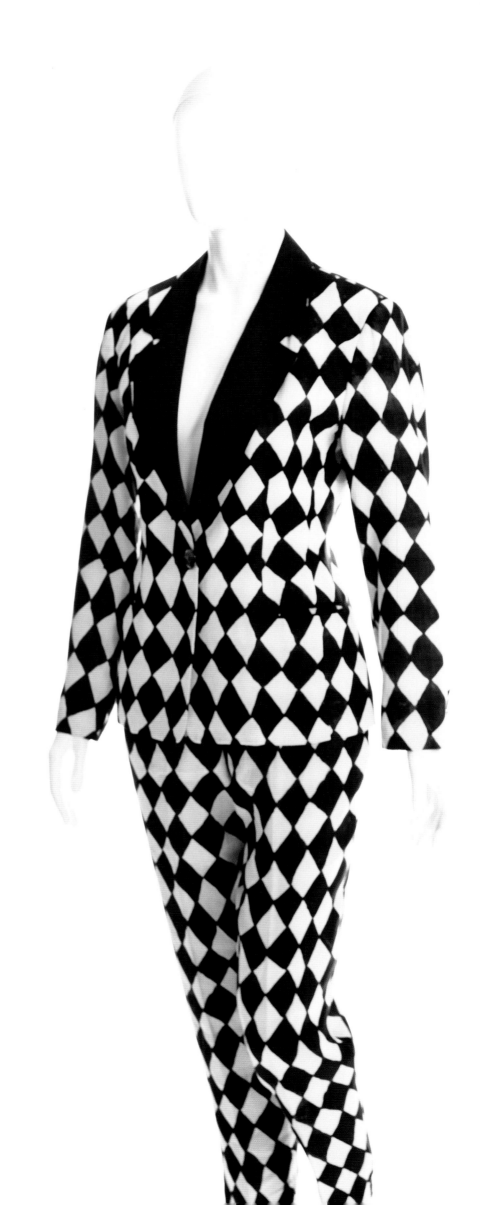

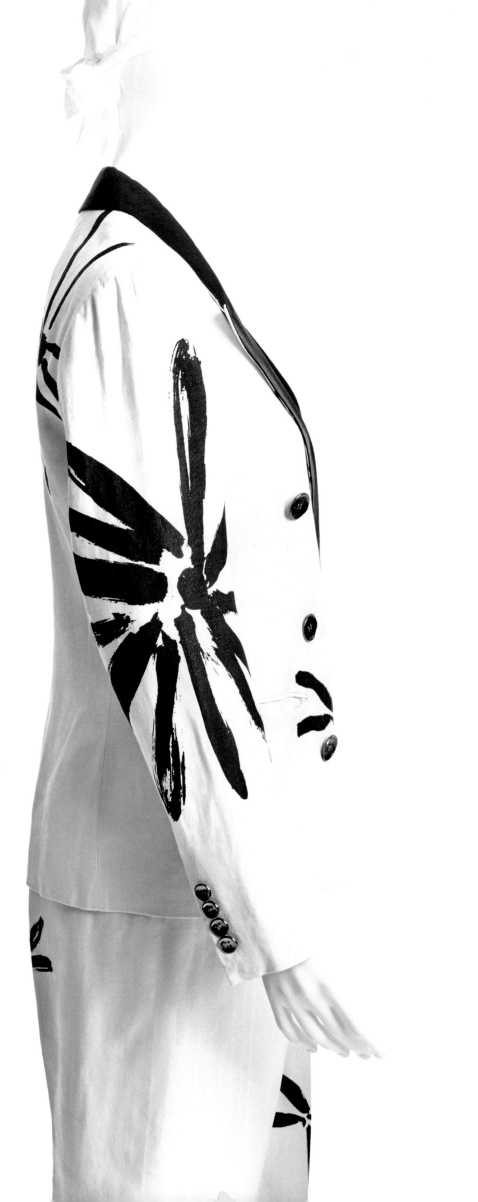

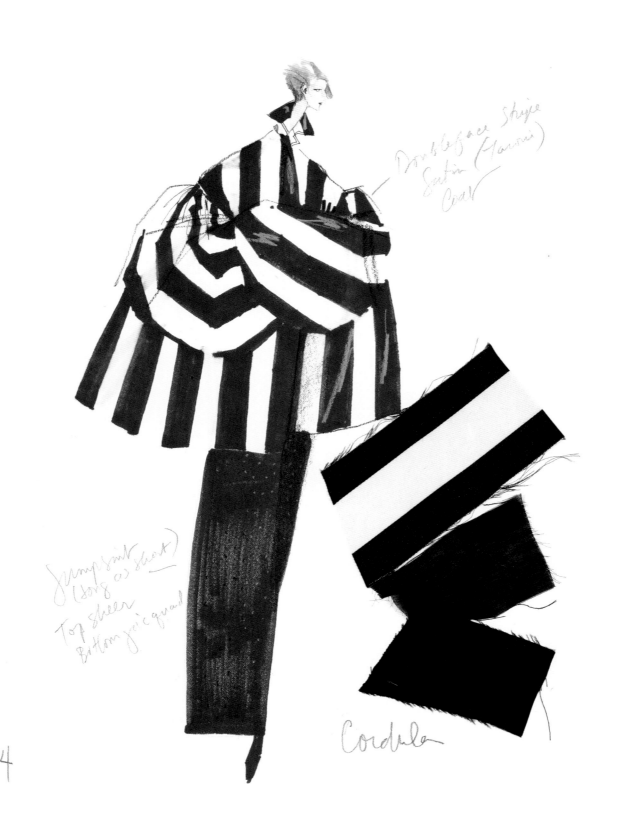

Double-face Stripe
Satin (Flannel)
Coat

Jumpsuit
(long as short)
Top sheer
Bottom jacquard

Cordula

74

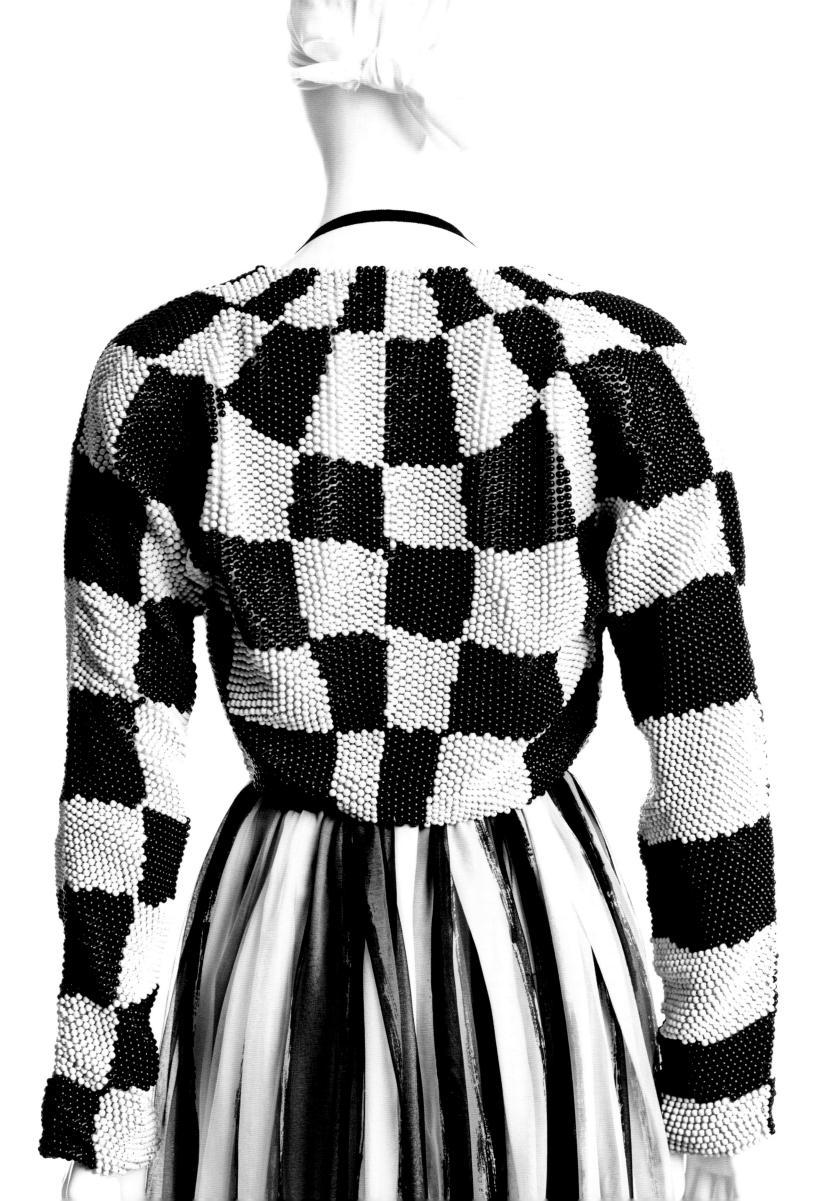

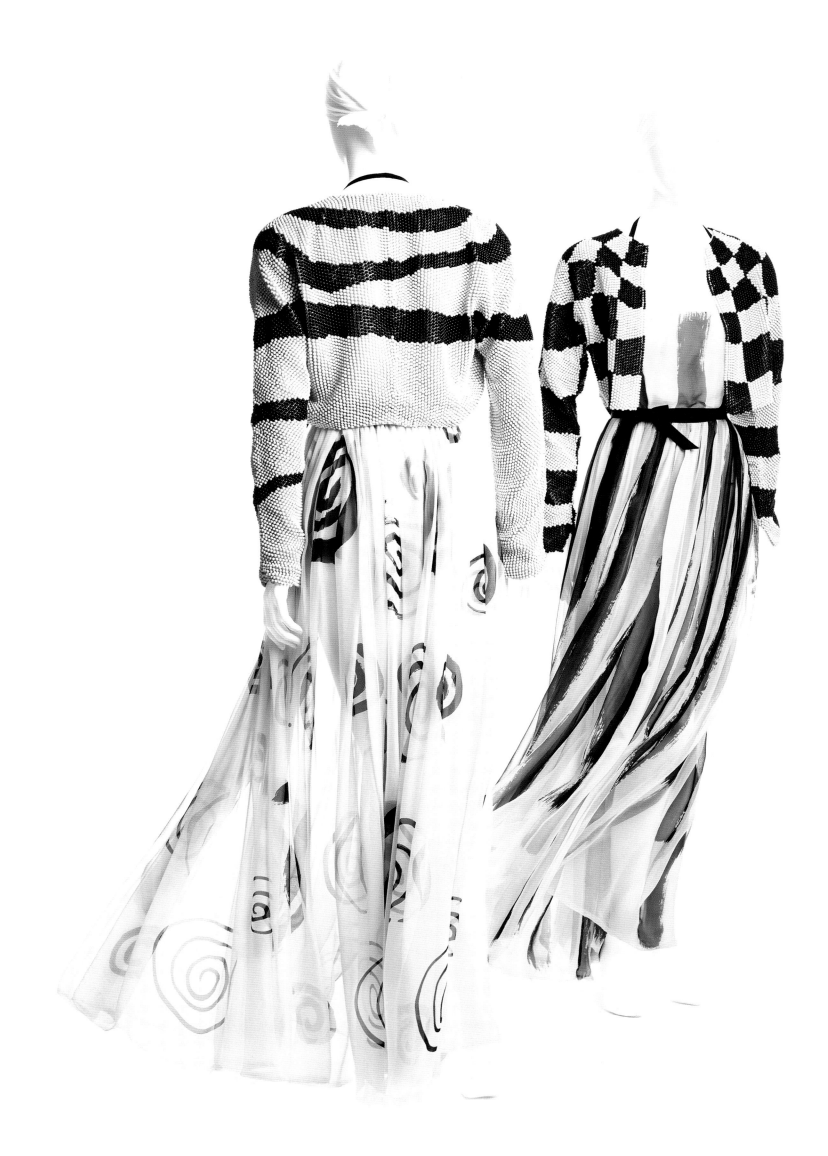

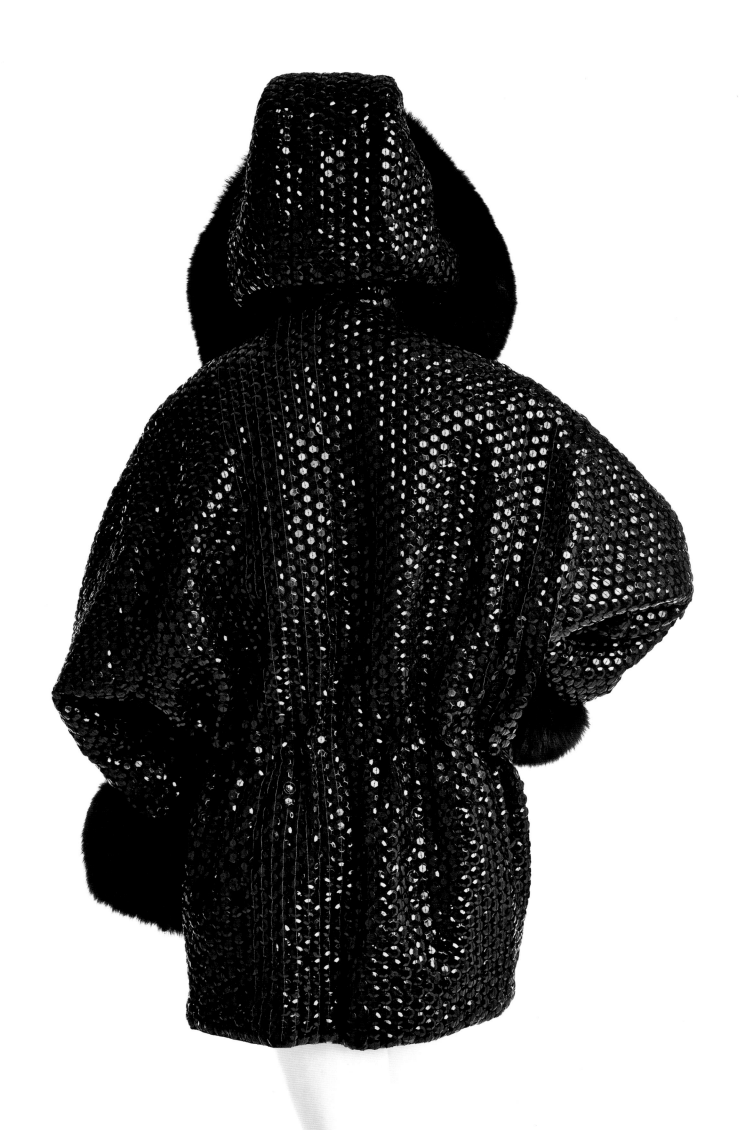

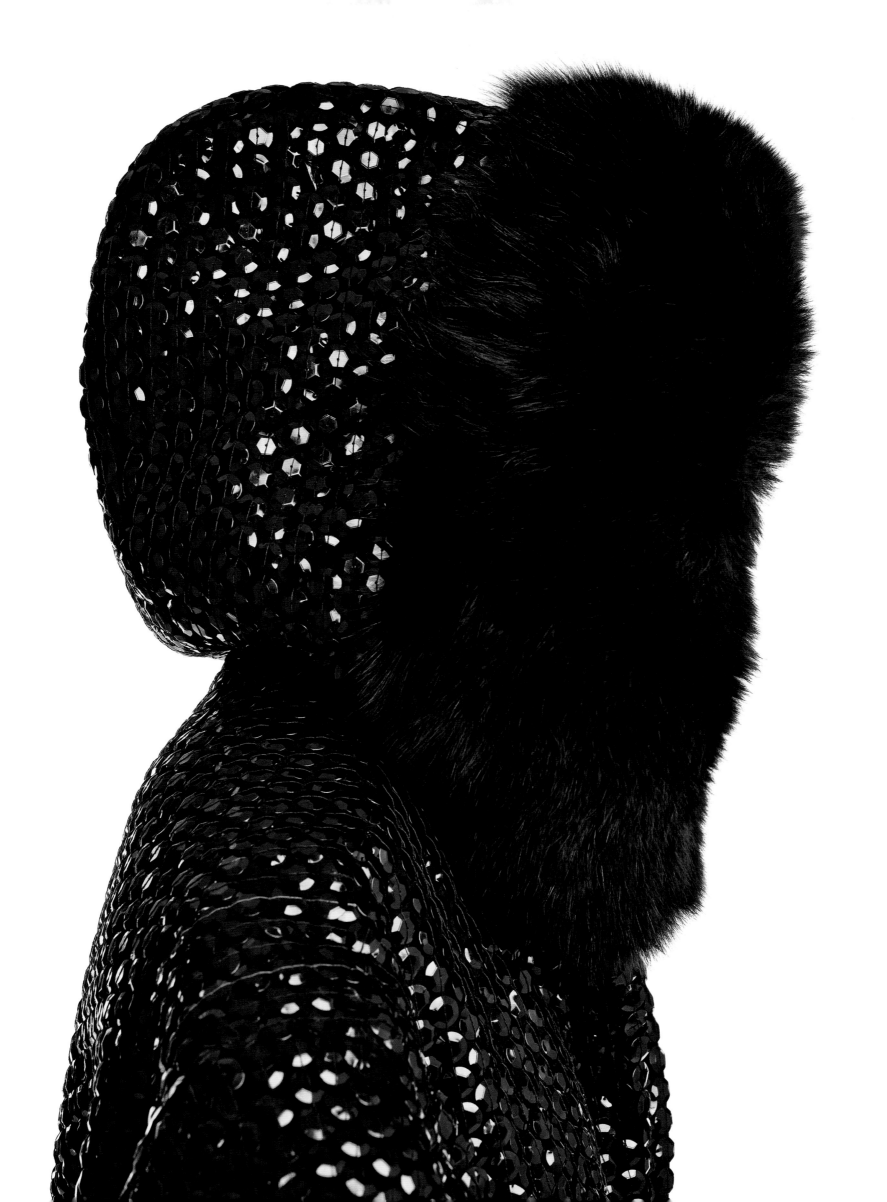

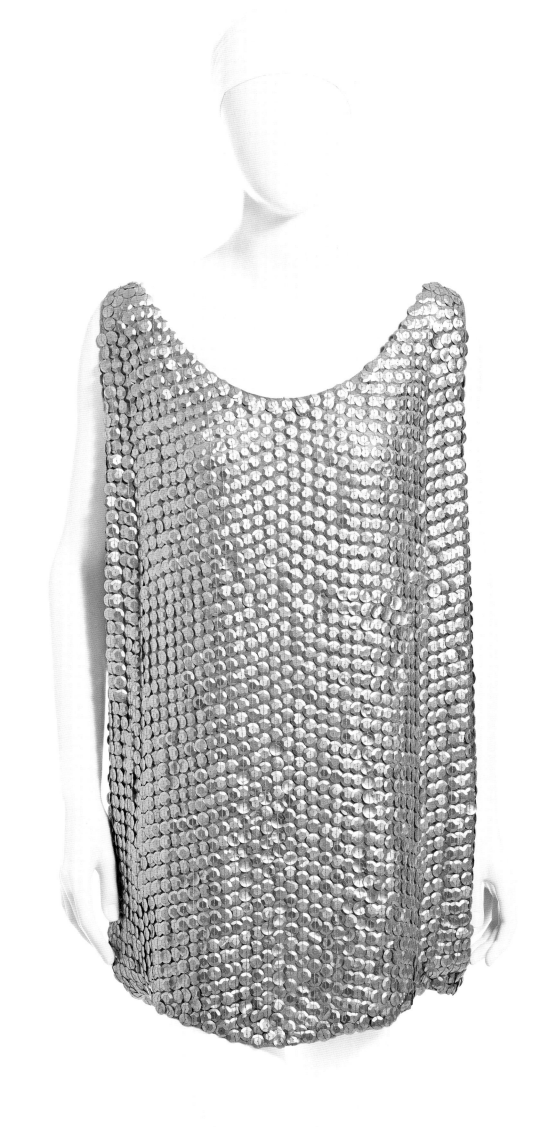

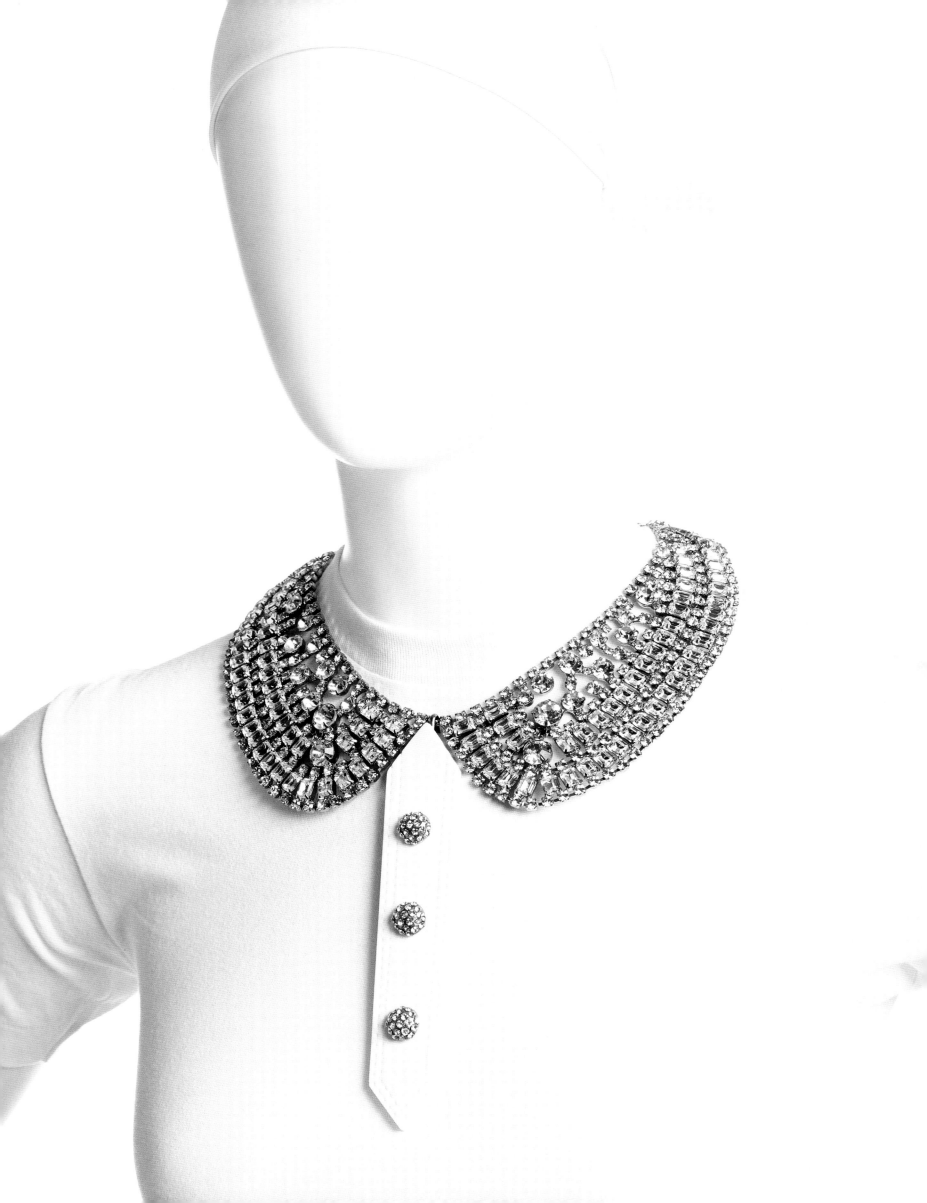

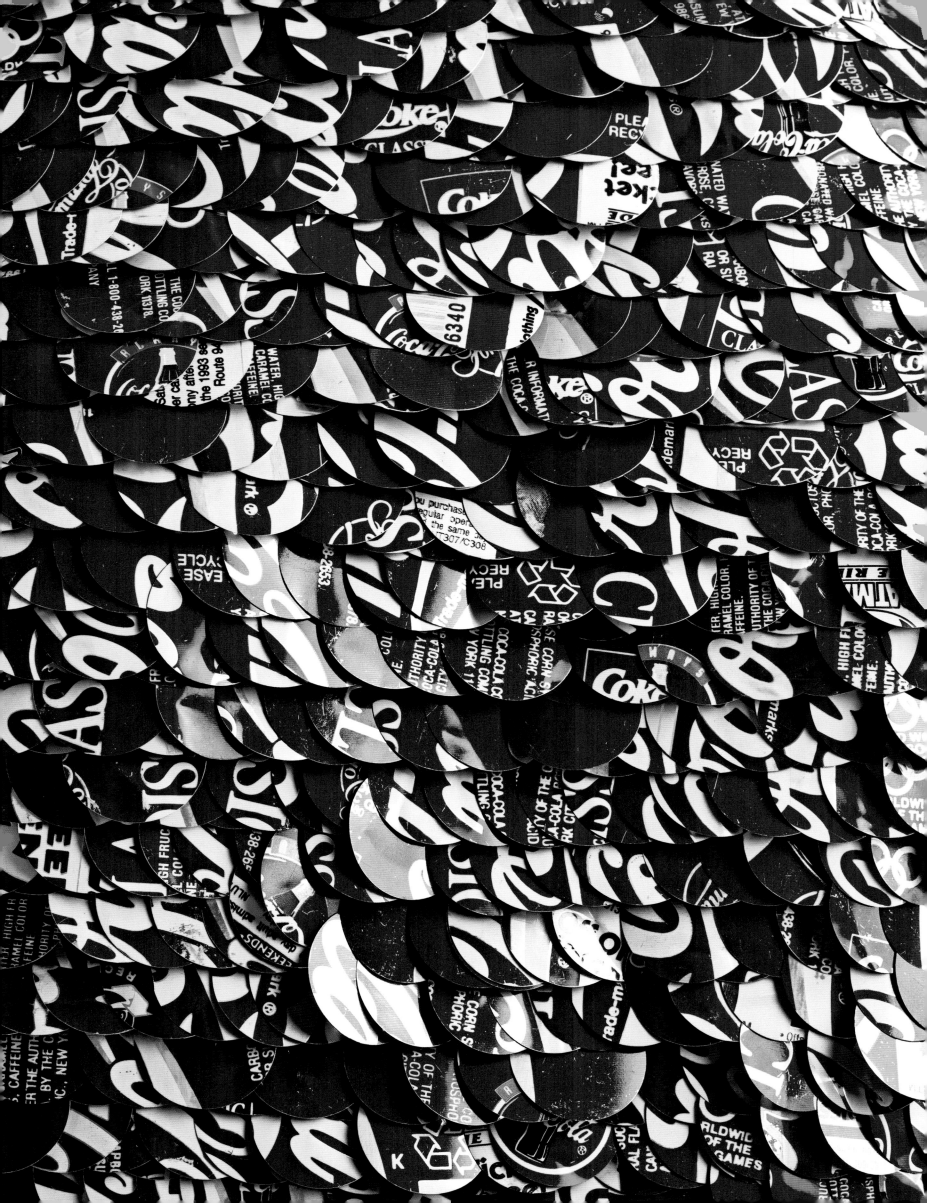

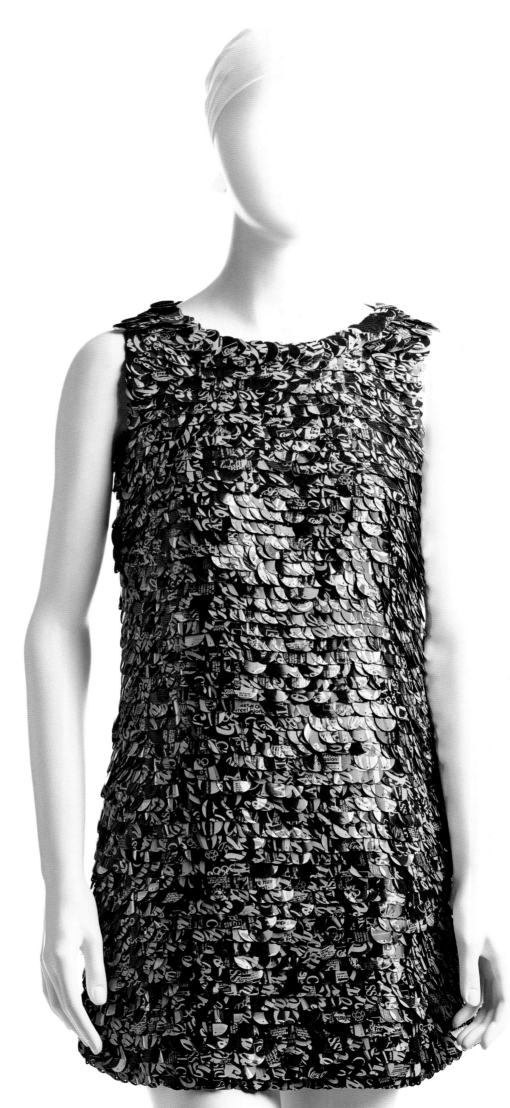

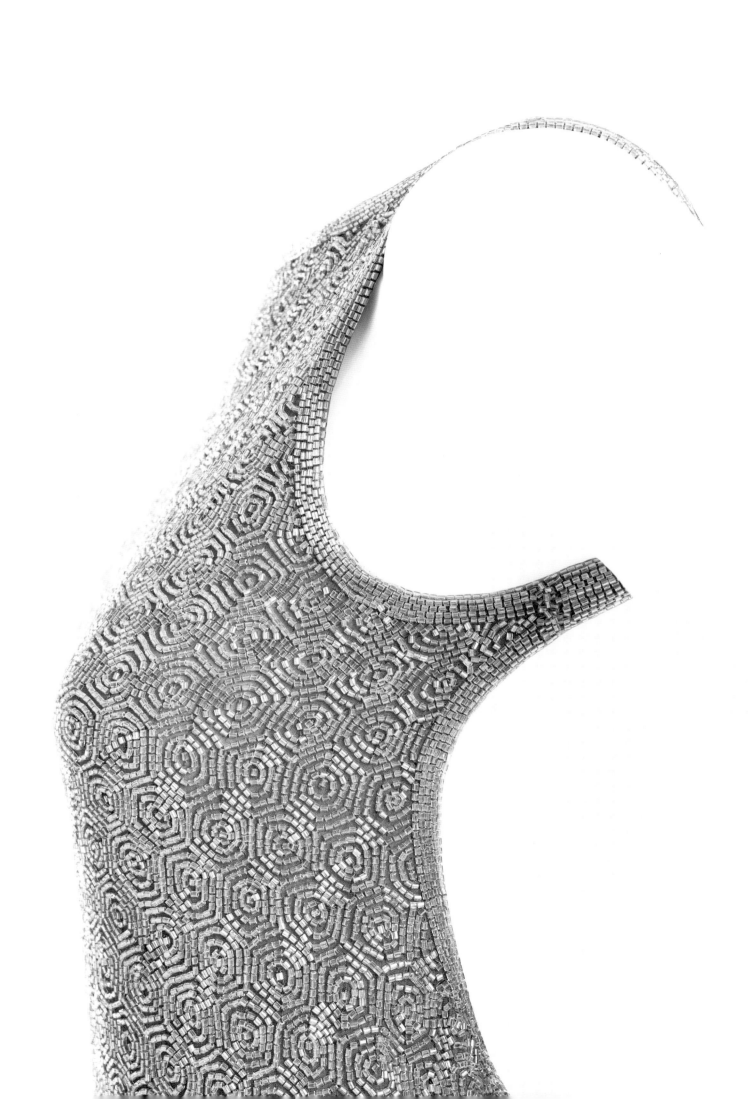

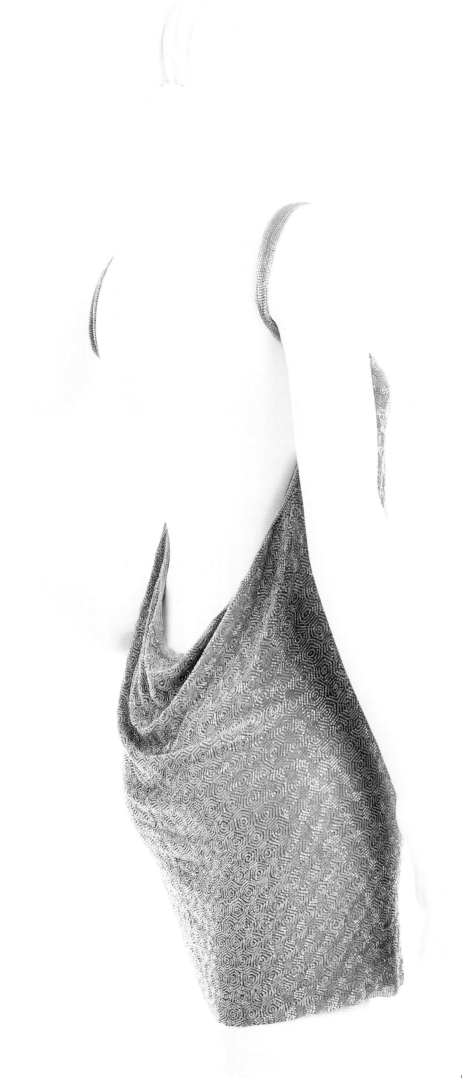

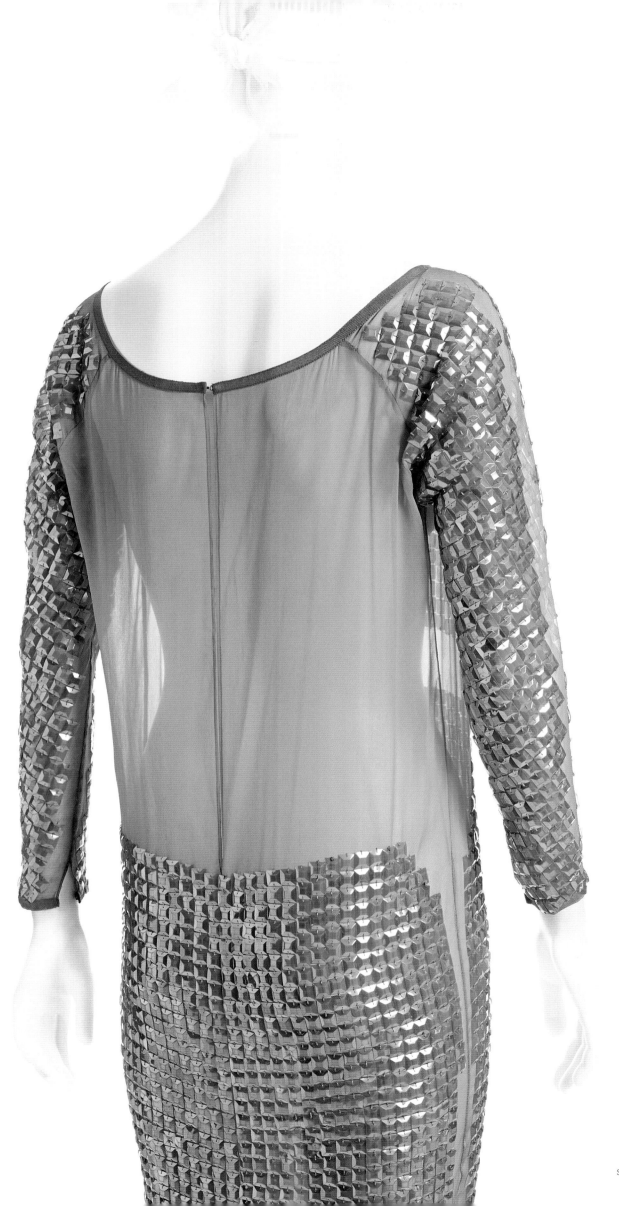

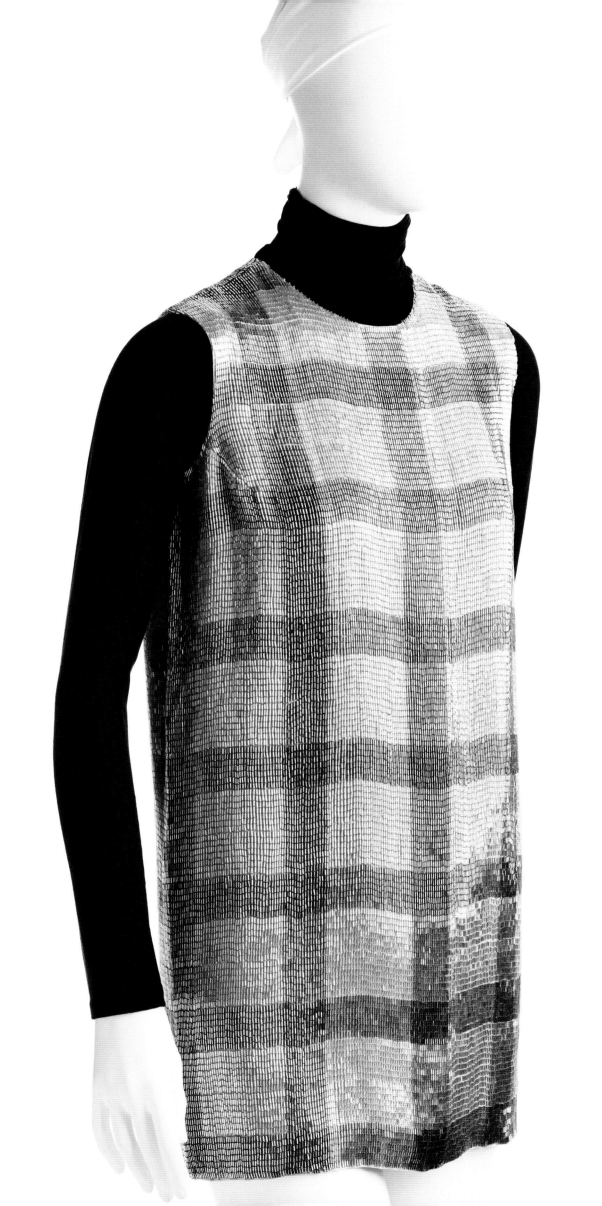

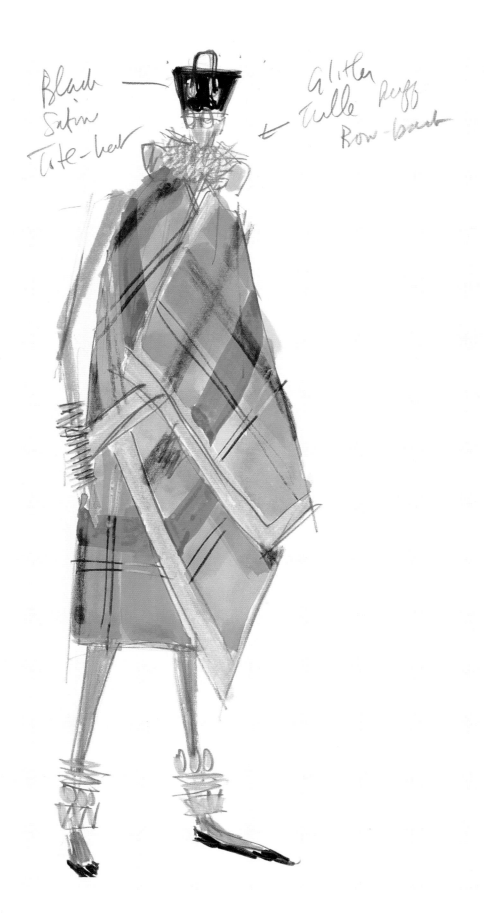

Black
Satin
Tôte-hair

Glitter
Tulle Ruff
Bow-back

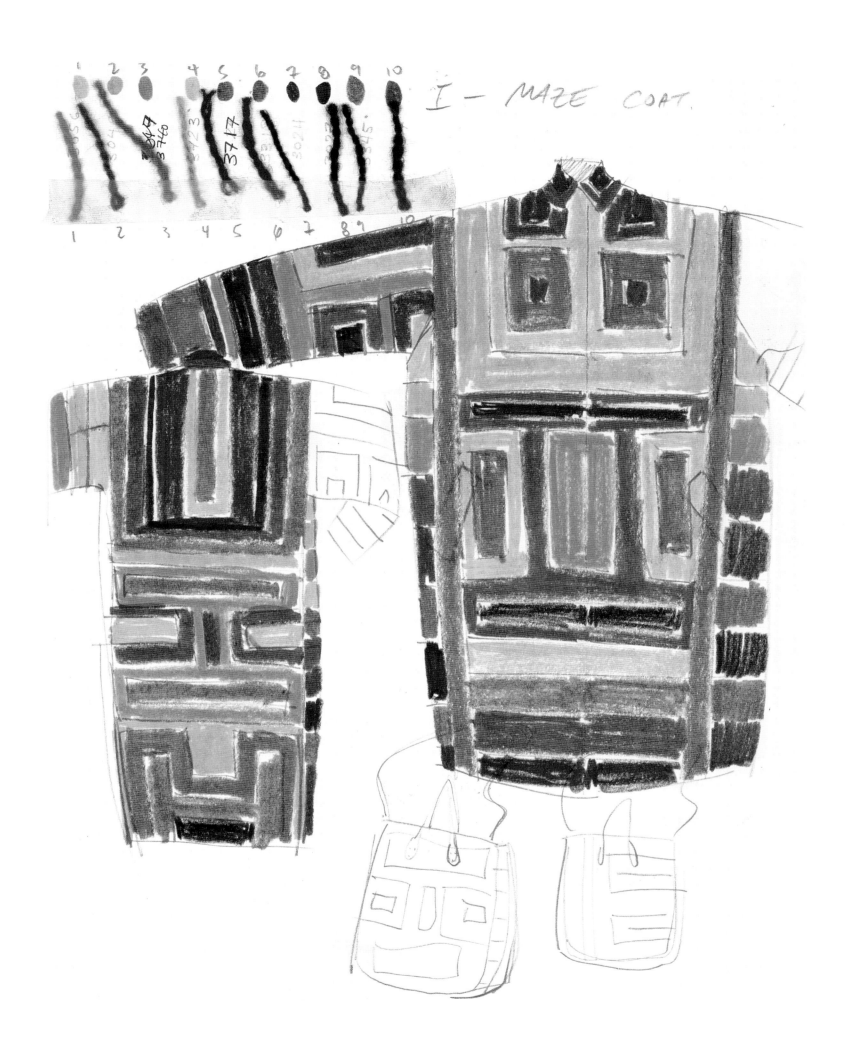

I — MAZE COAT.

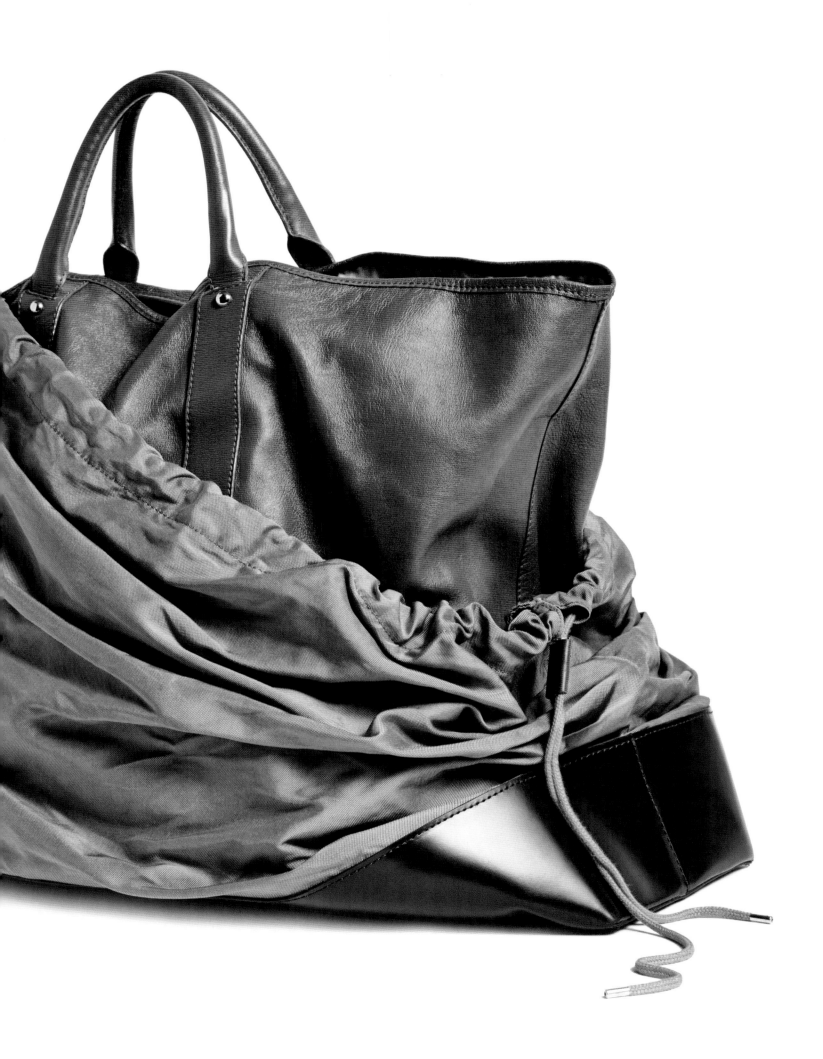

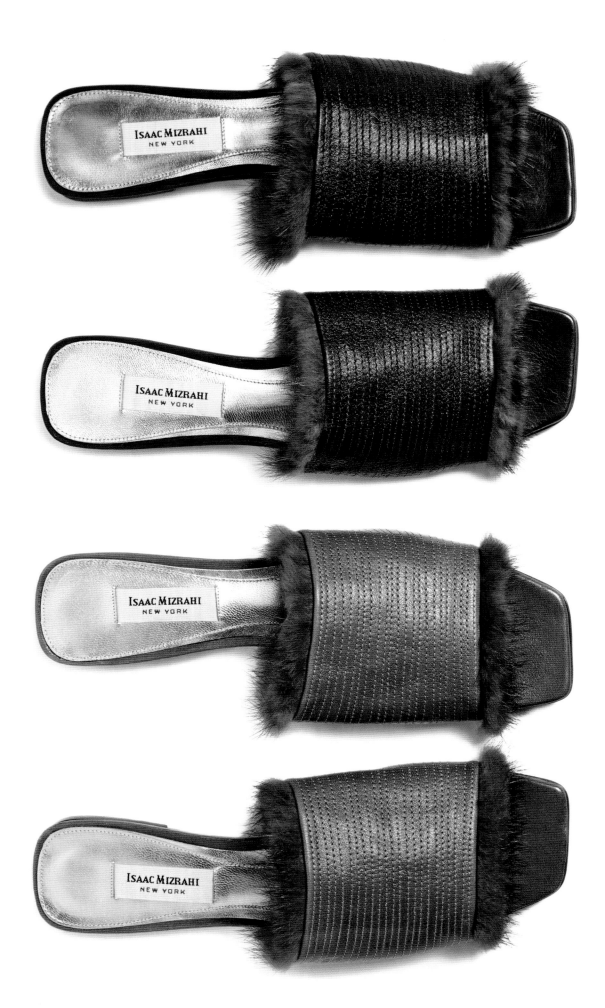

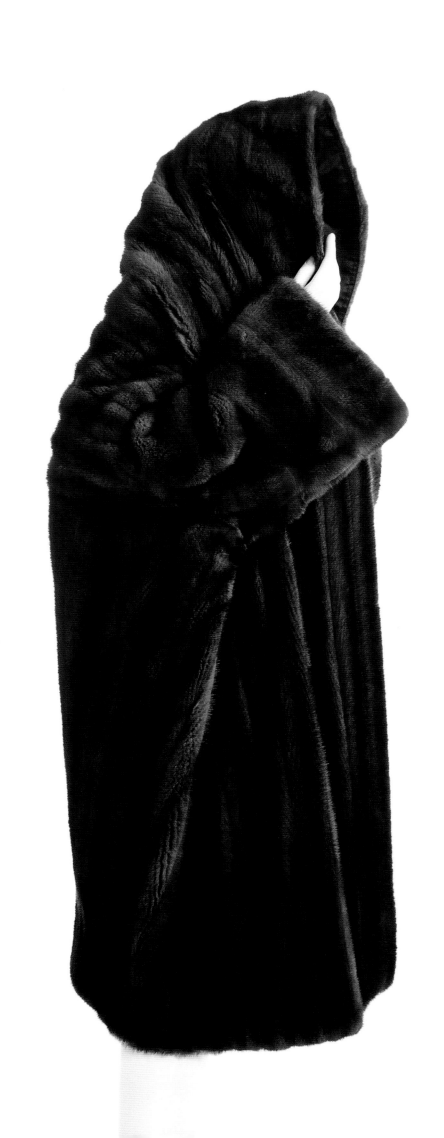

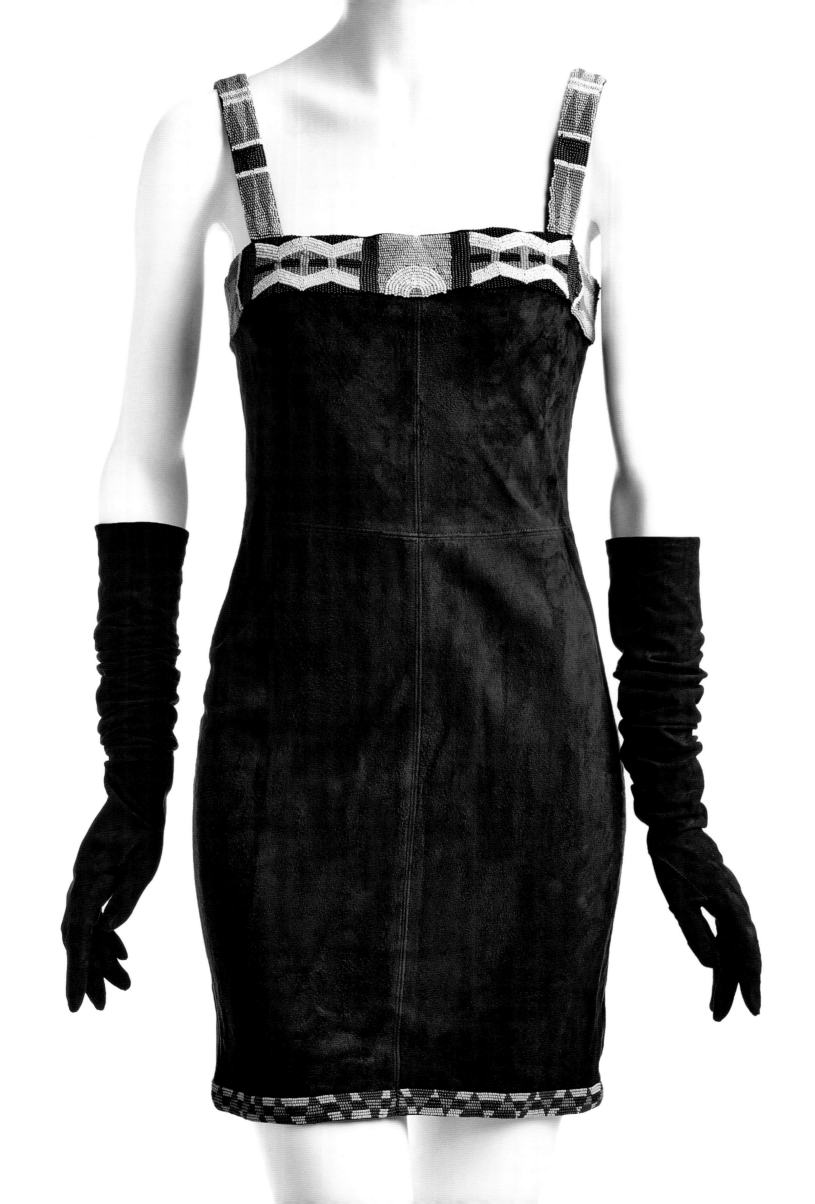

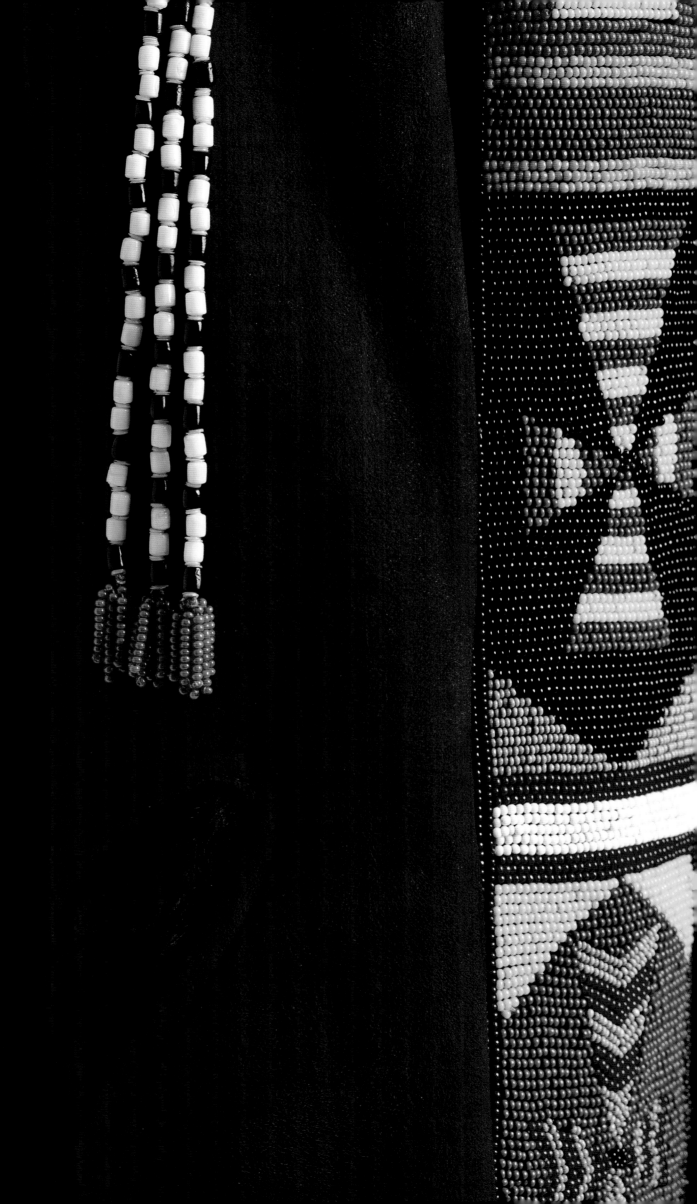

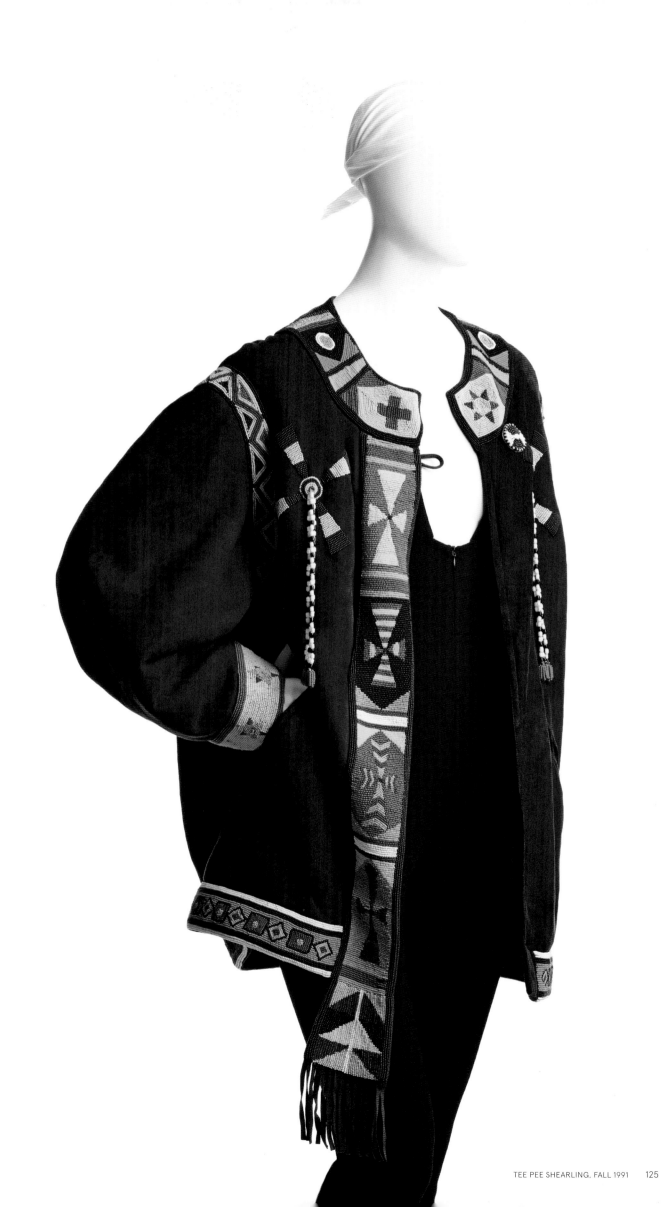

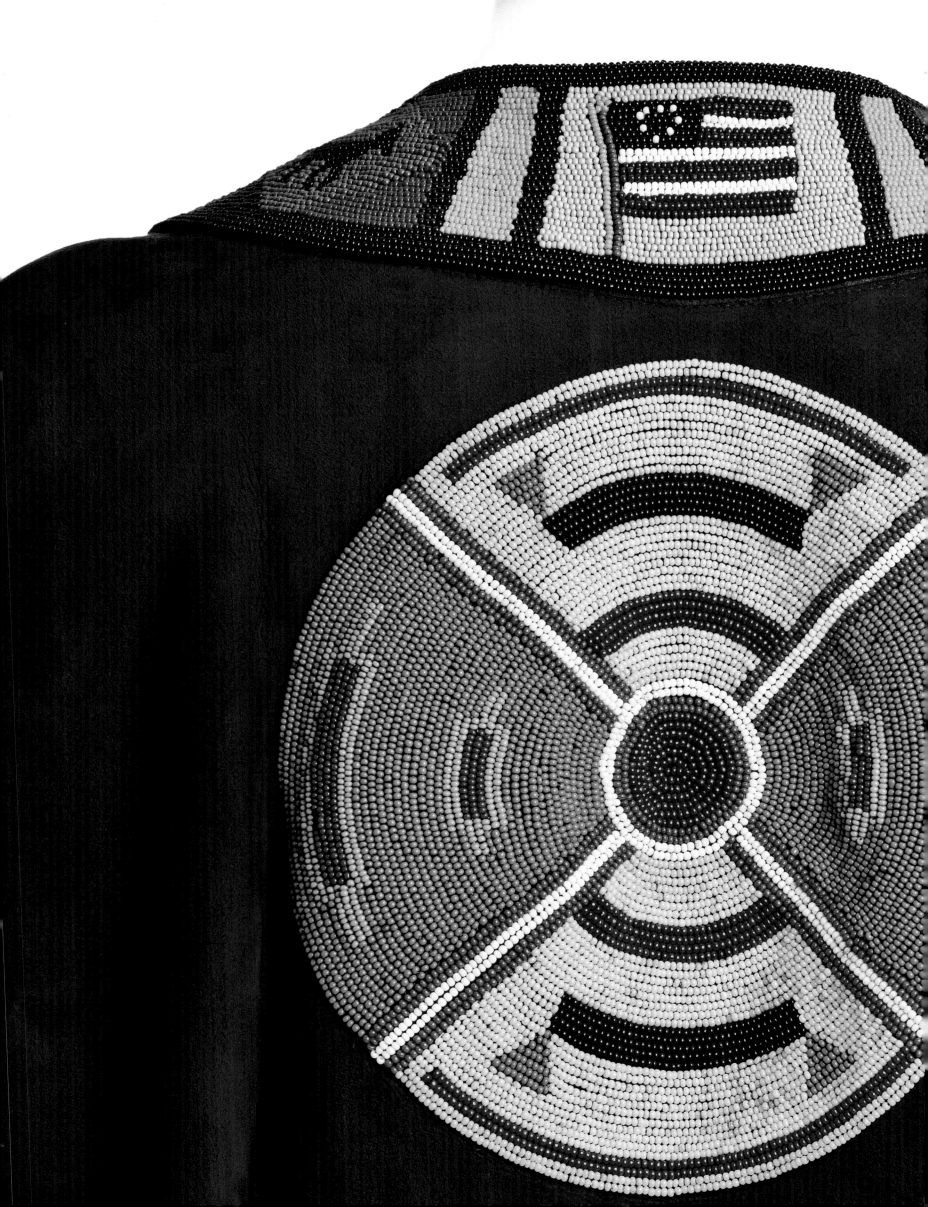

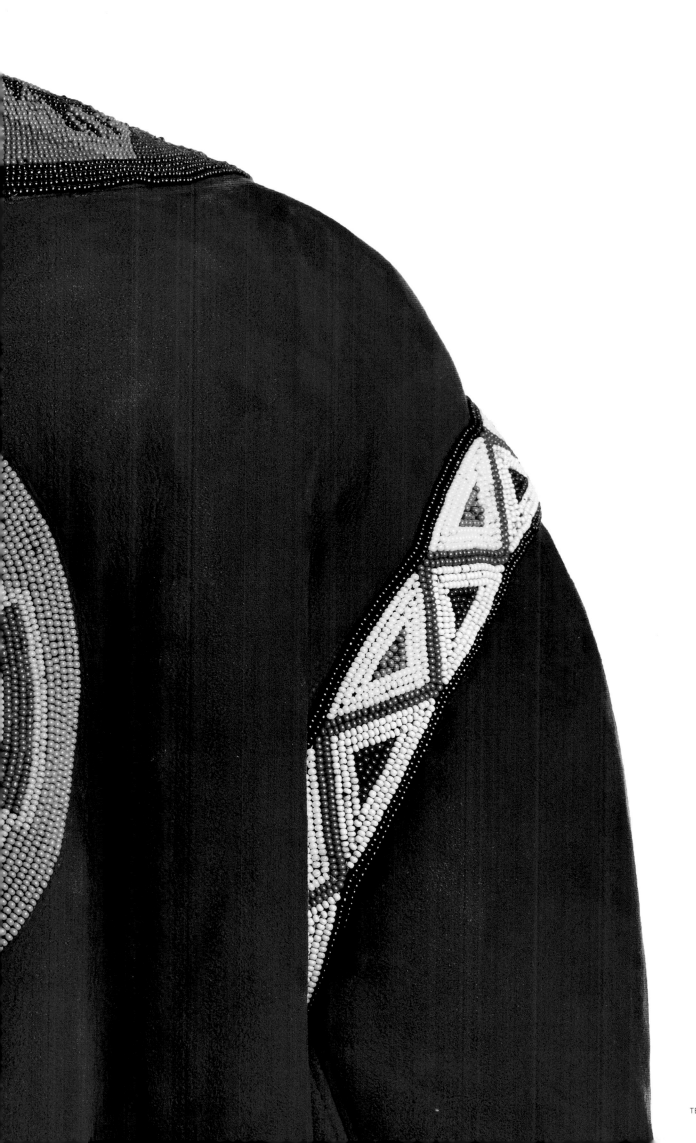

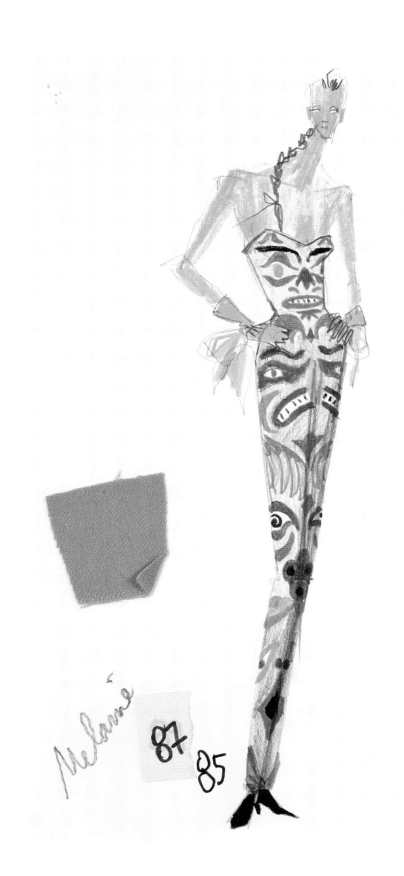

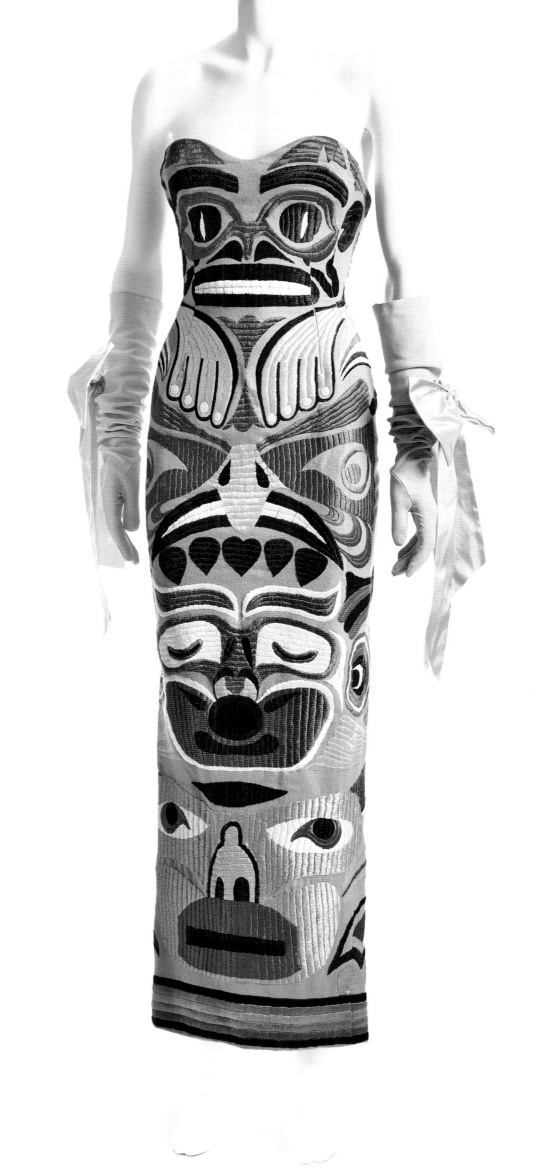

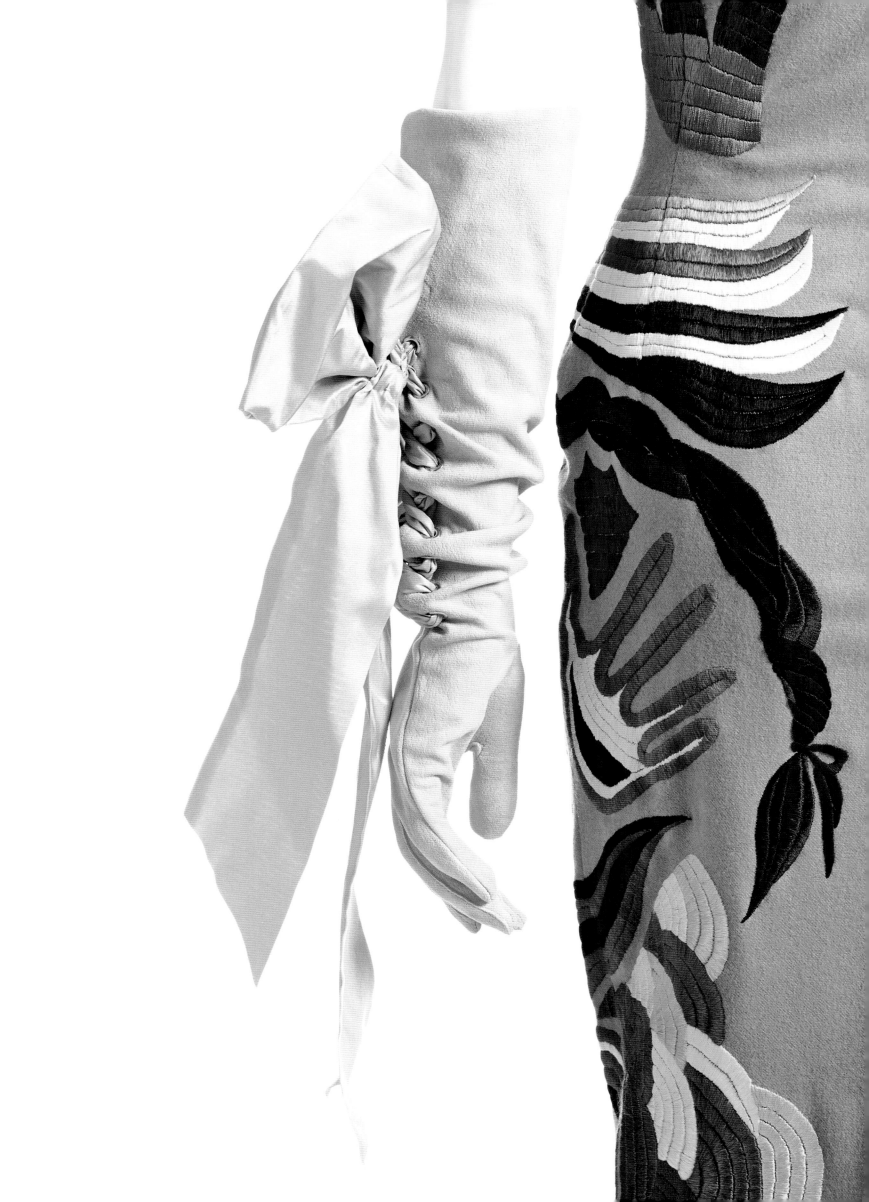

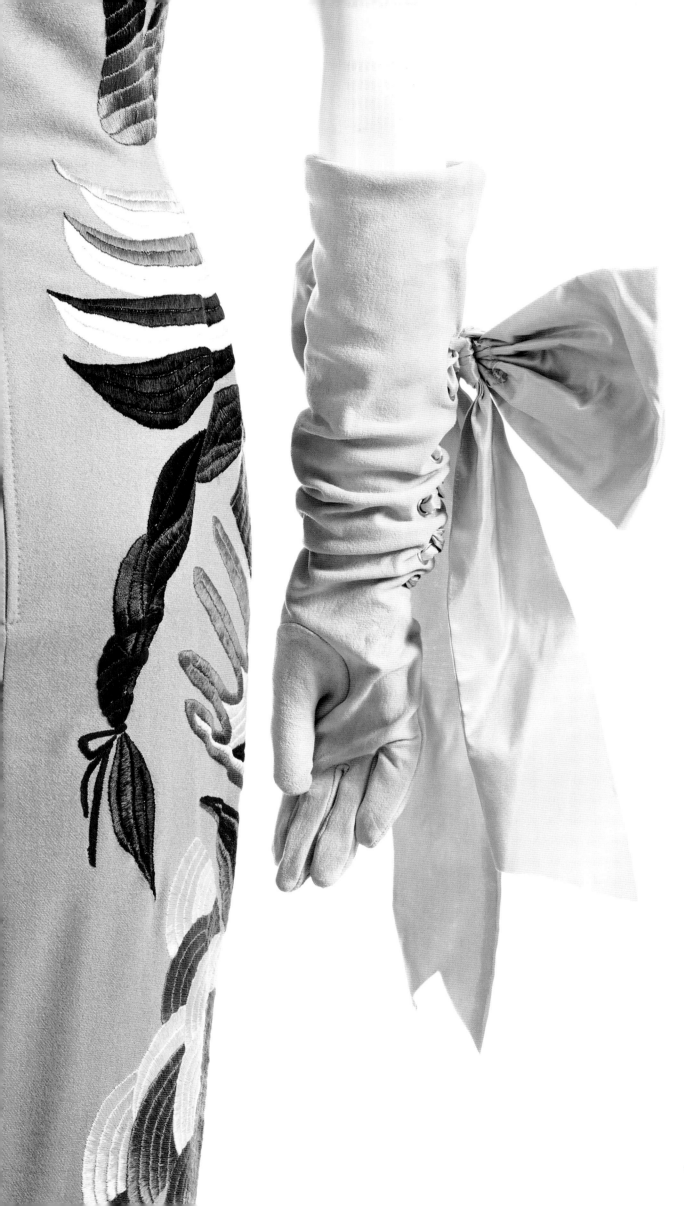

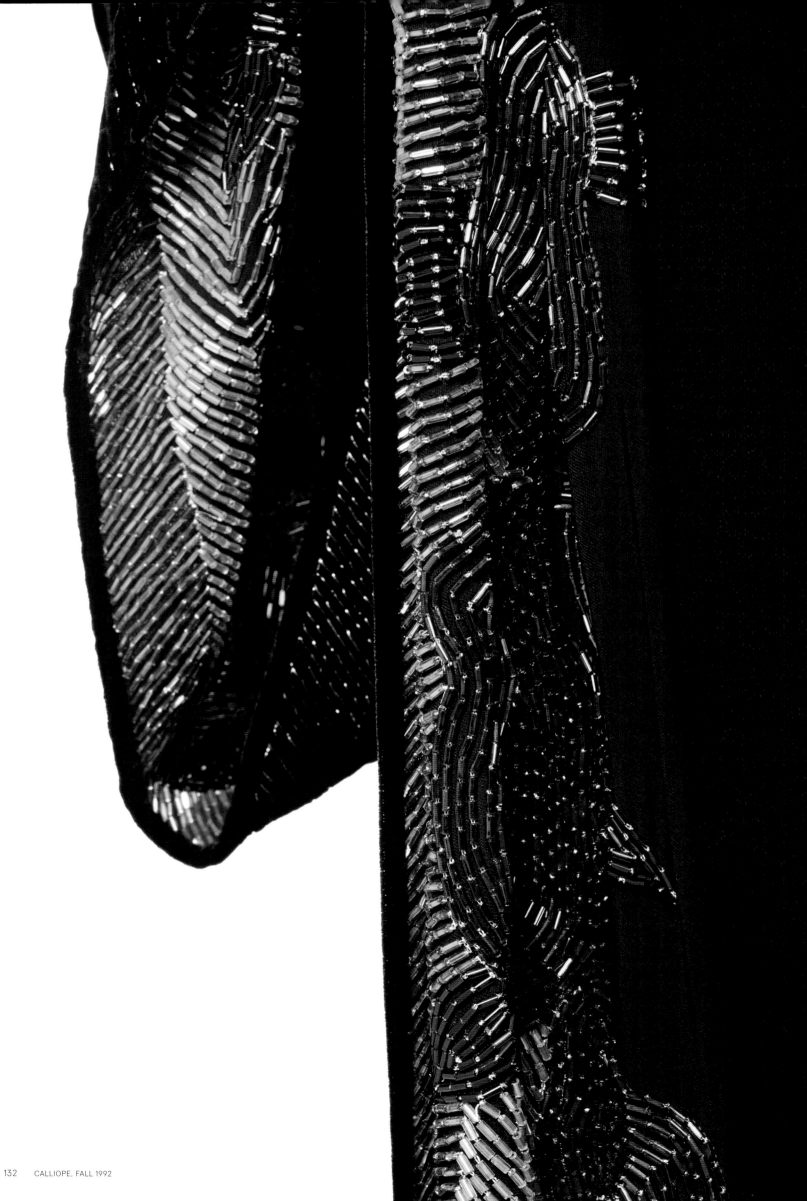

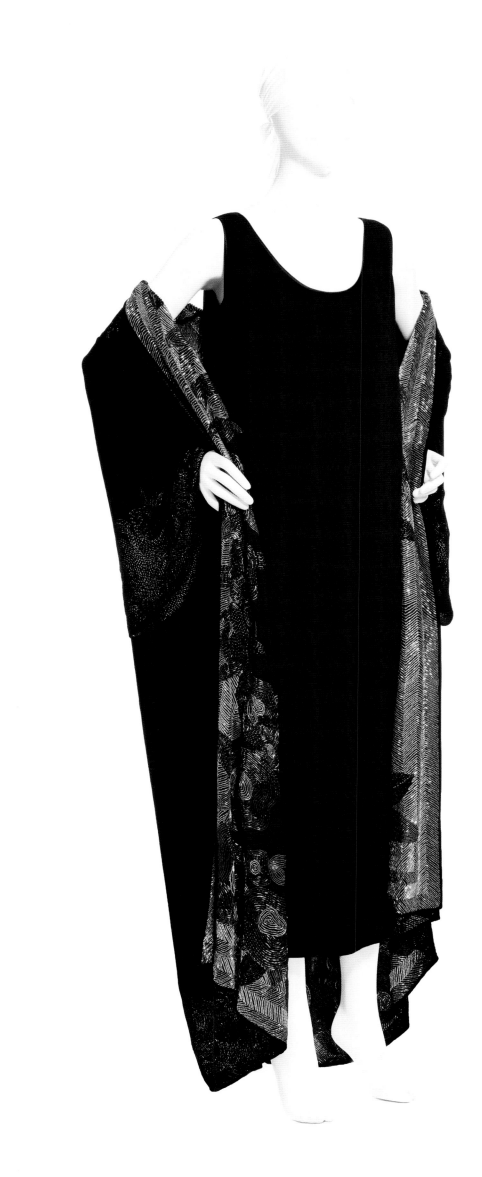

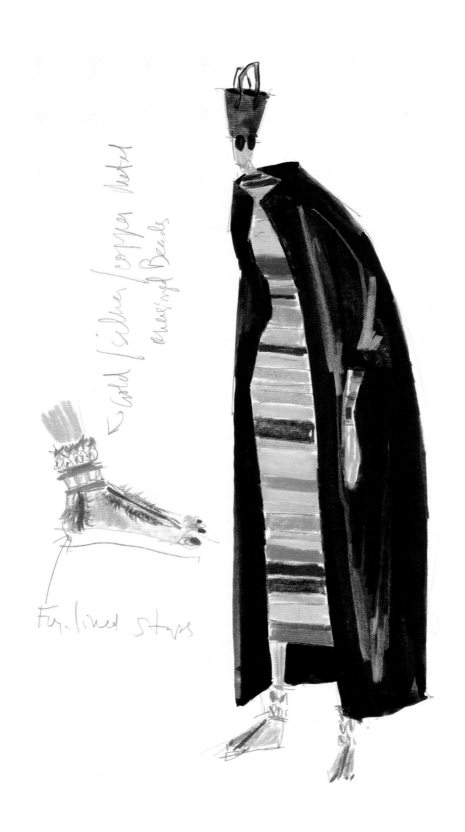

Gold/silver/copper Metal

measured Beads

Fur-lined straps

Brown
Toe-nail
polish

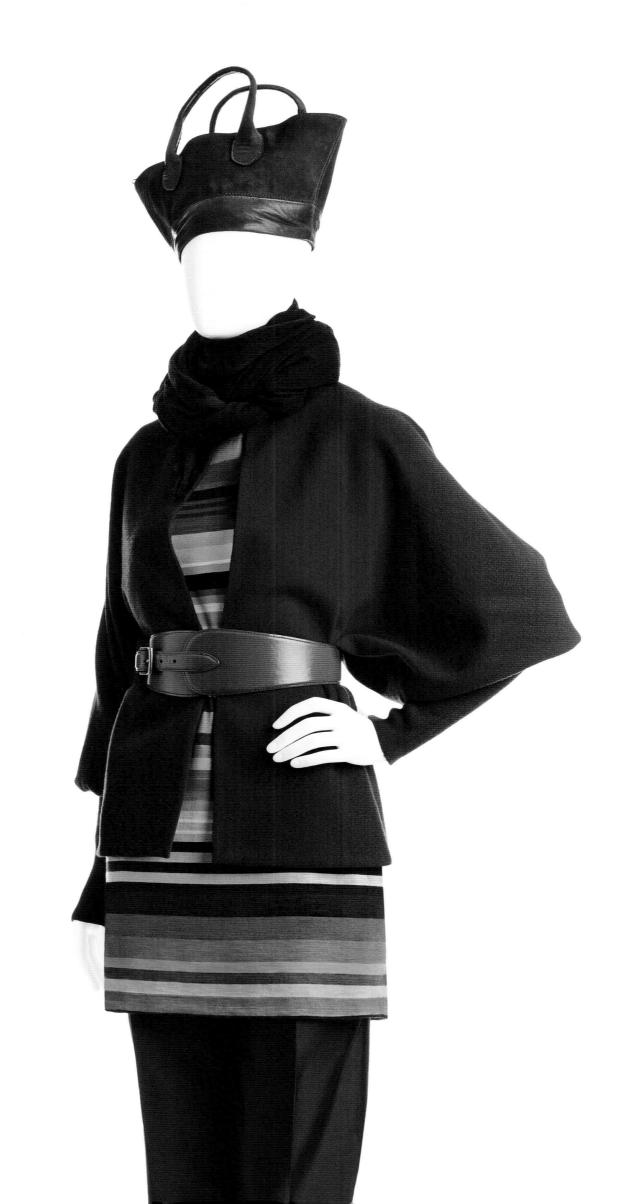

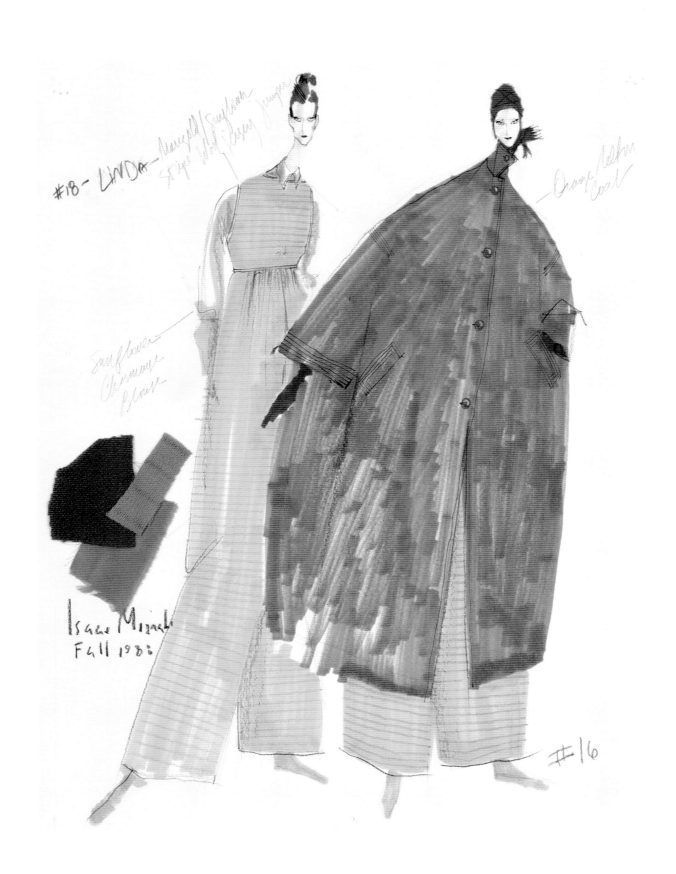

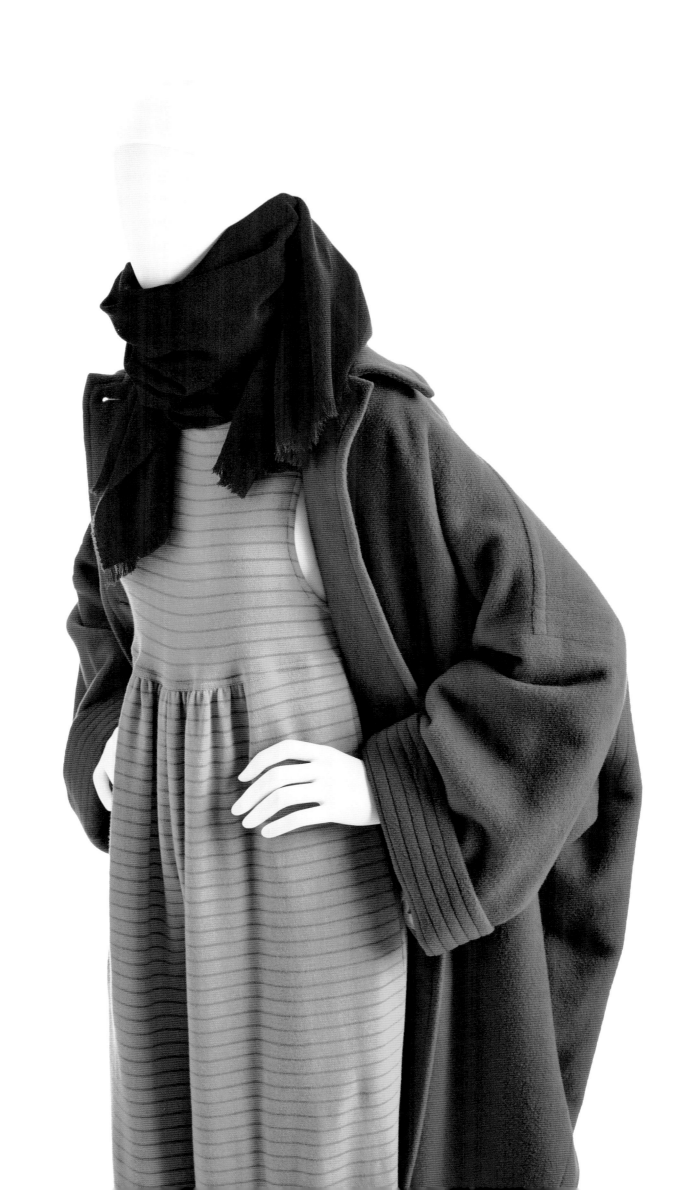

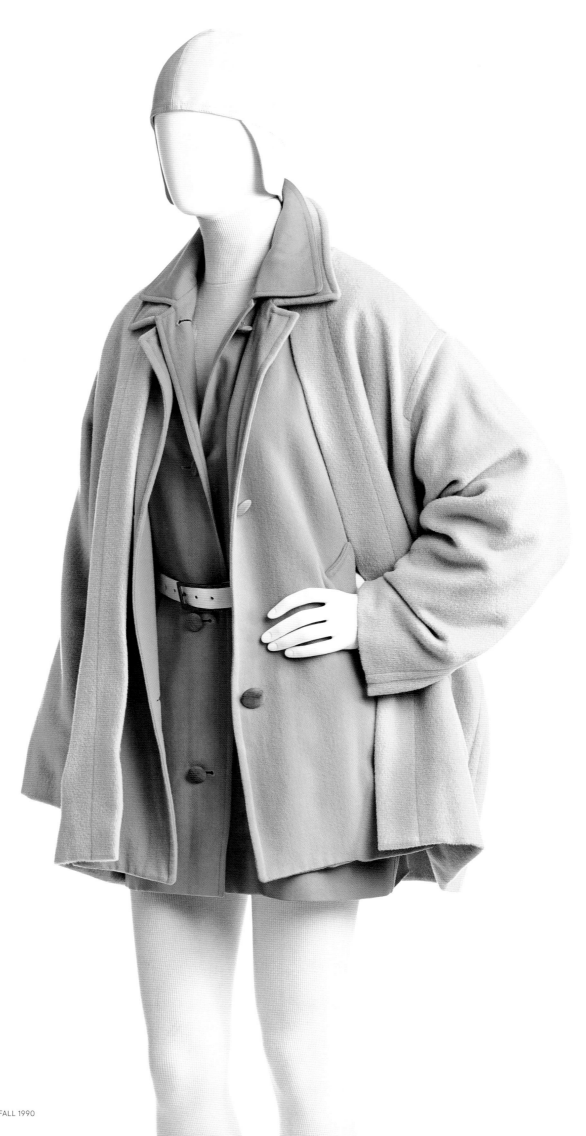

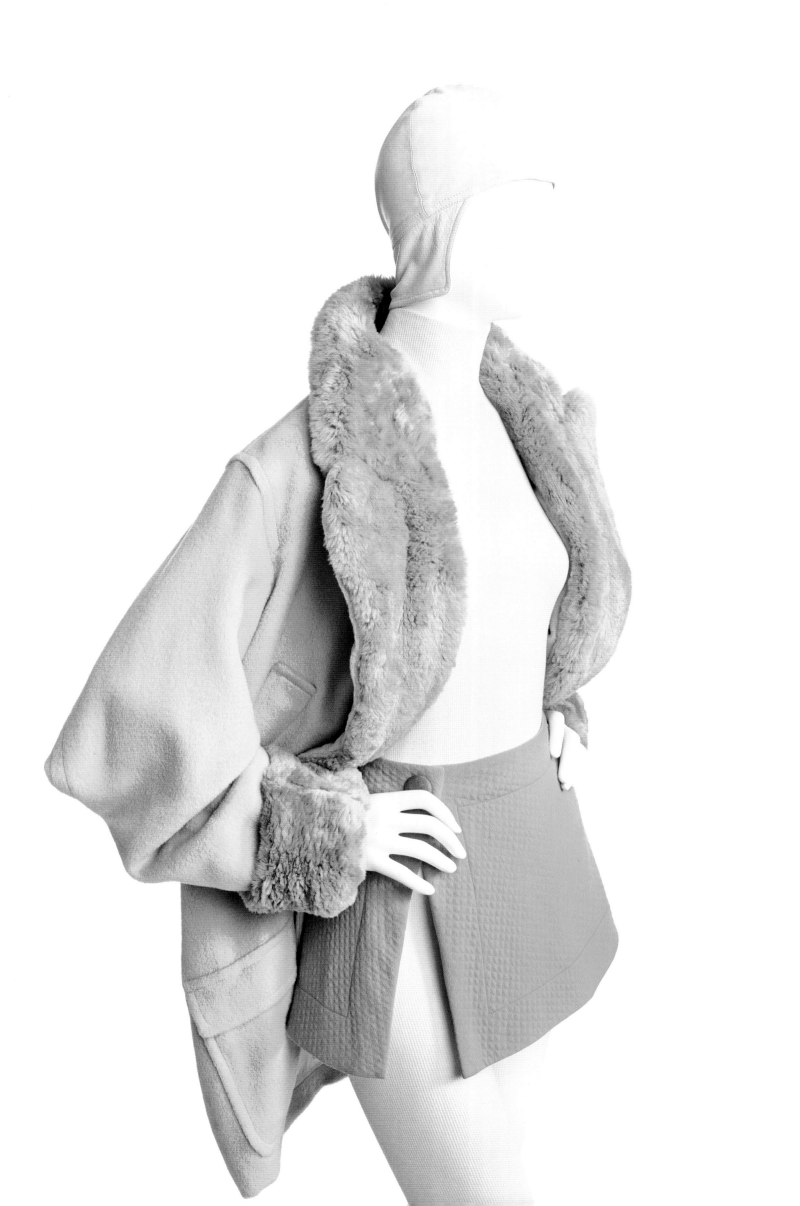

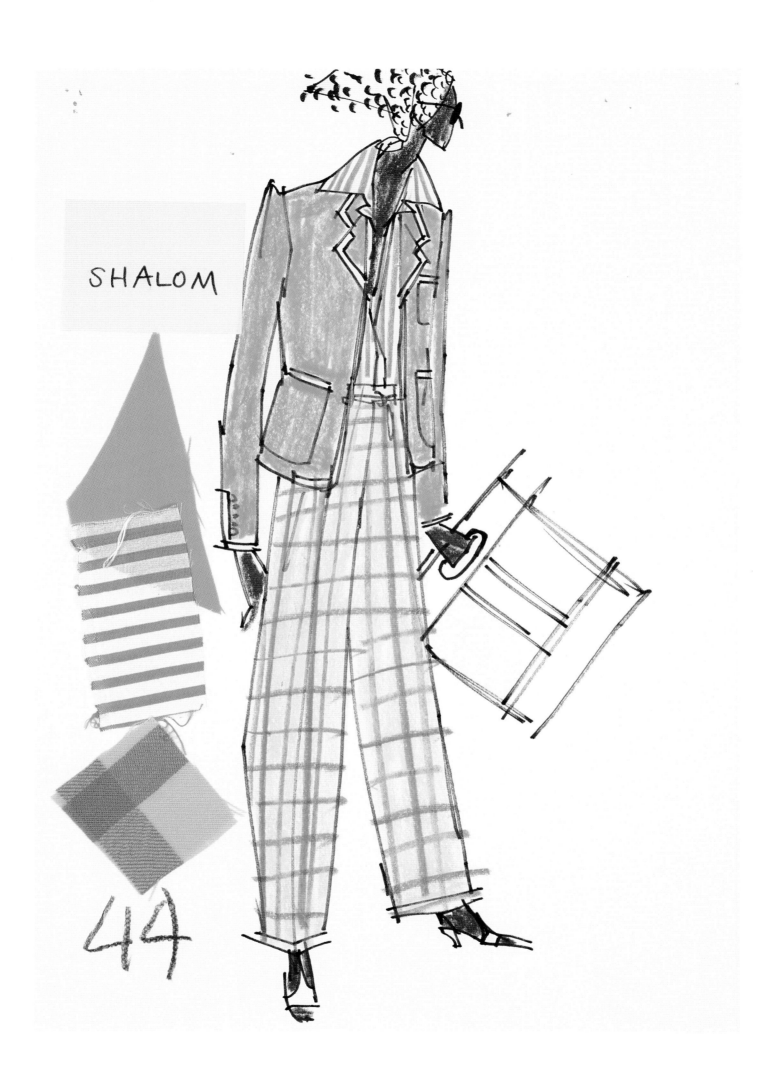

SHALOM

44

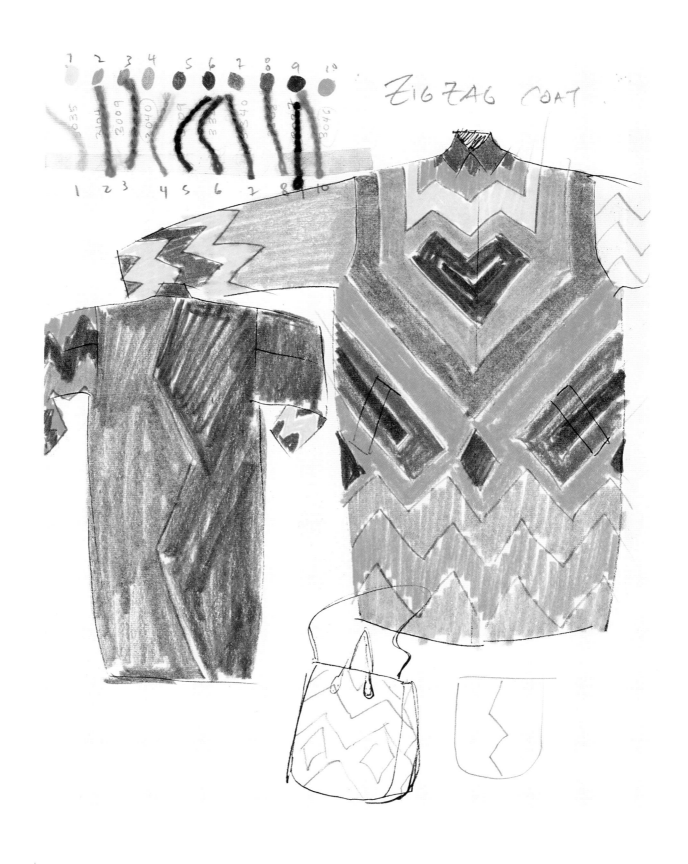

ZIG ZAG COAT

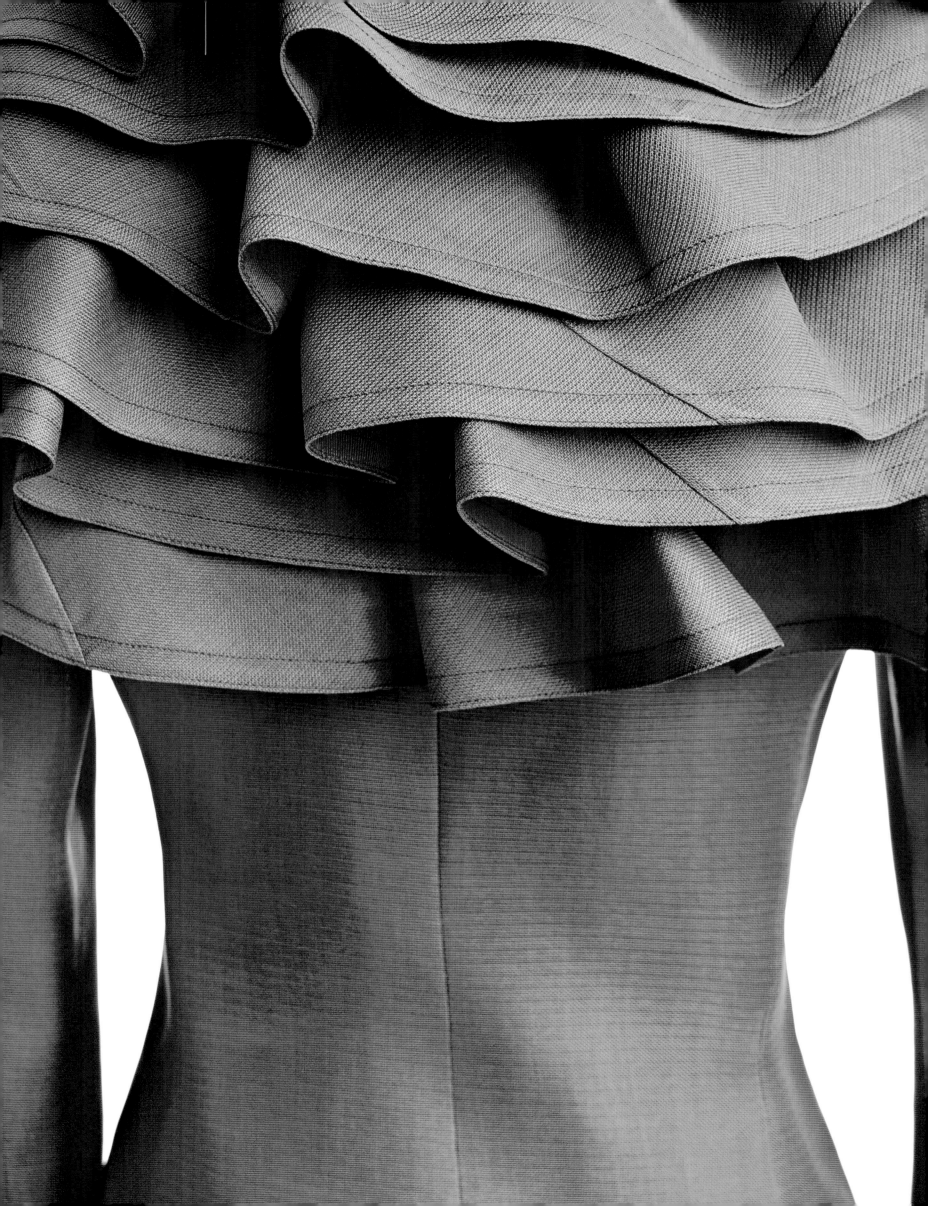

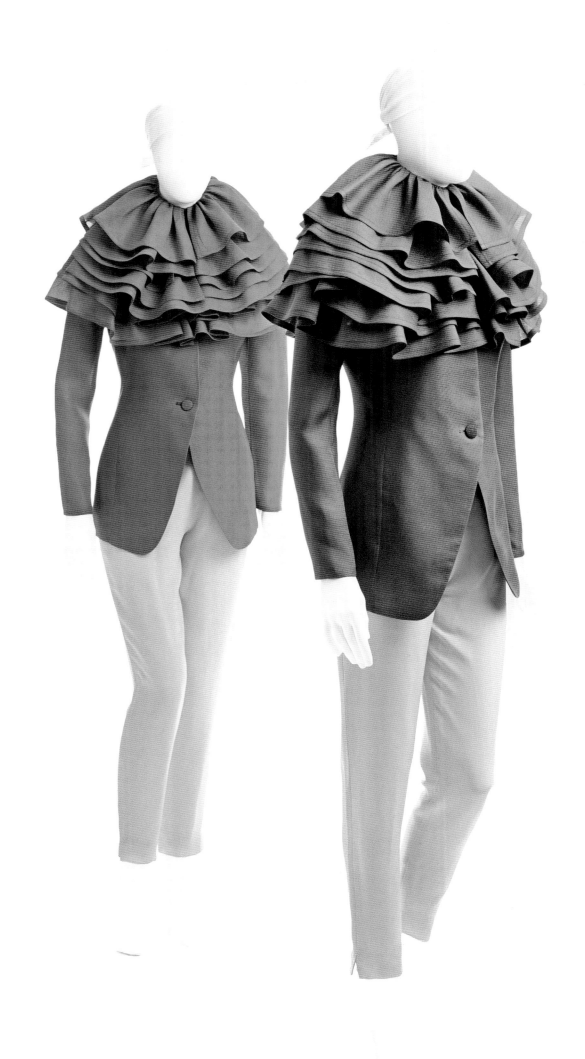

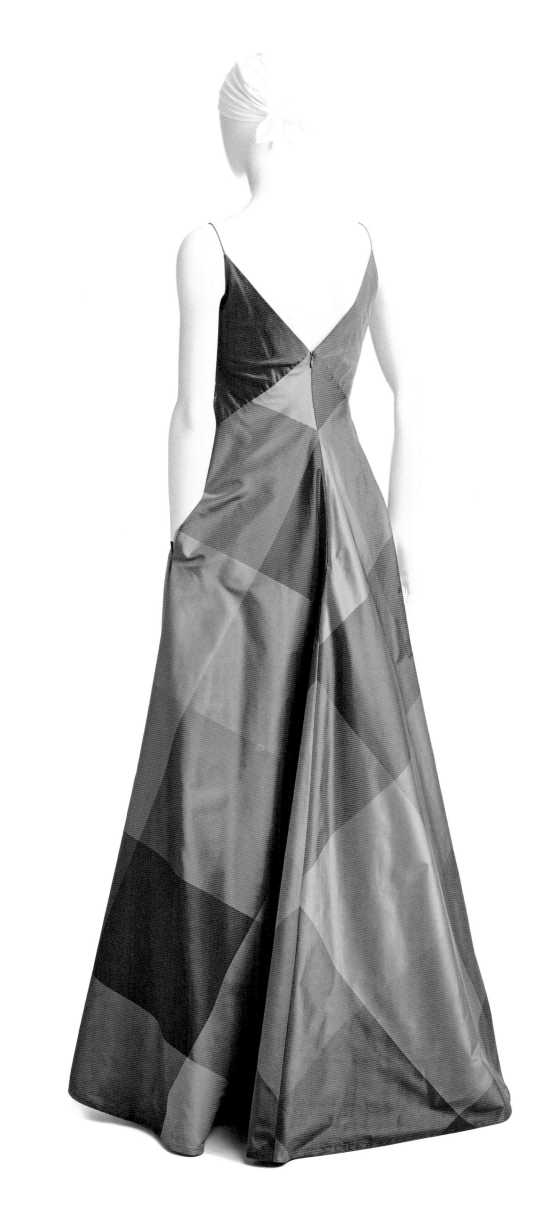

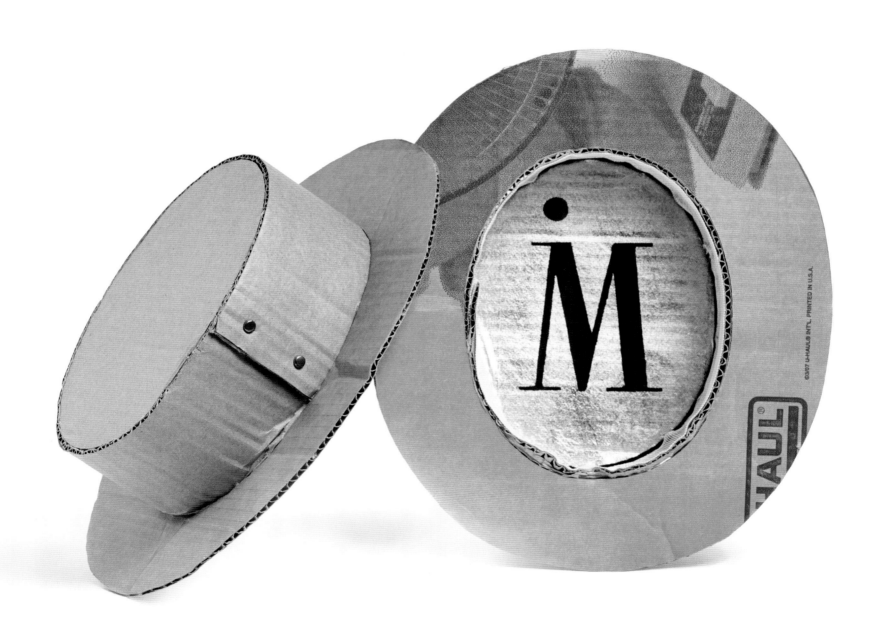

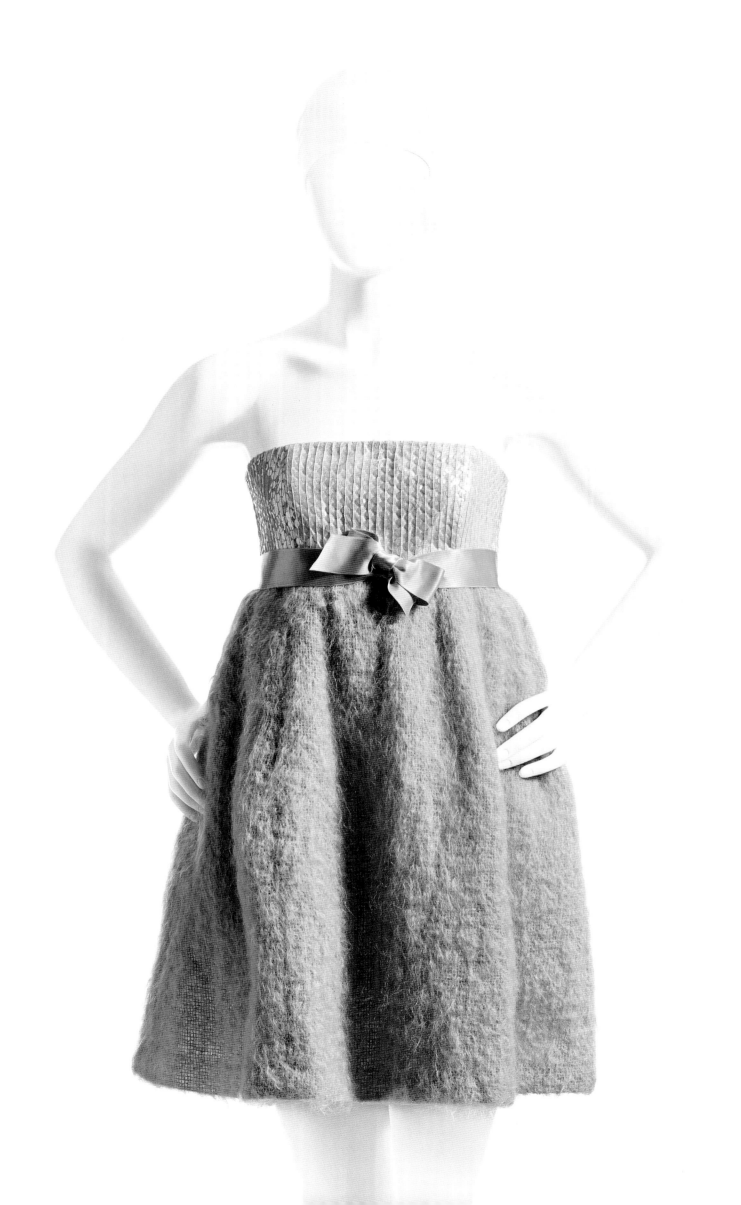

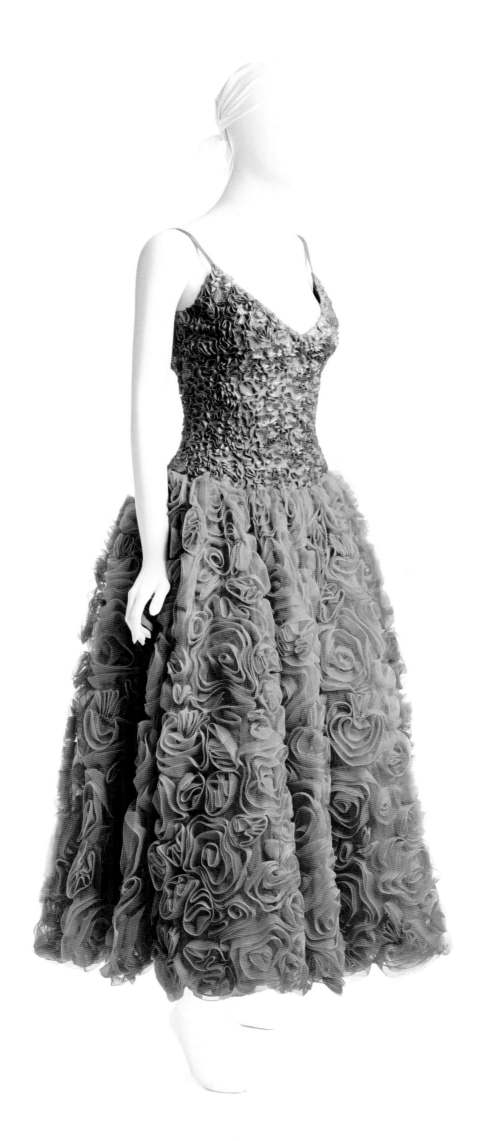

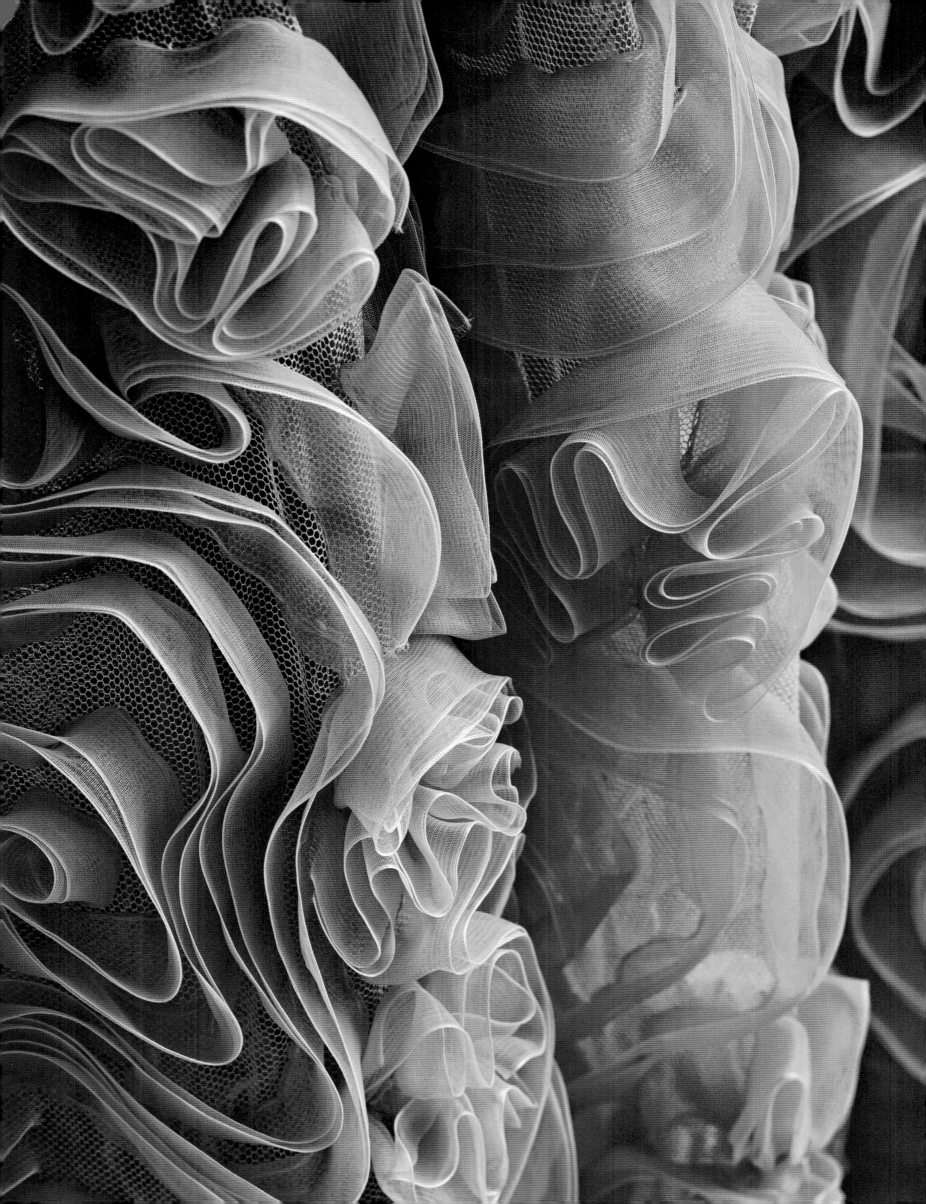

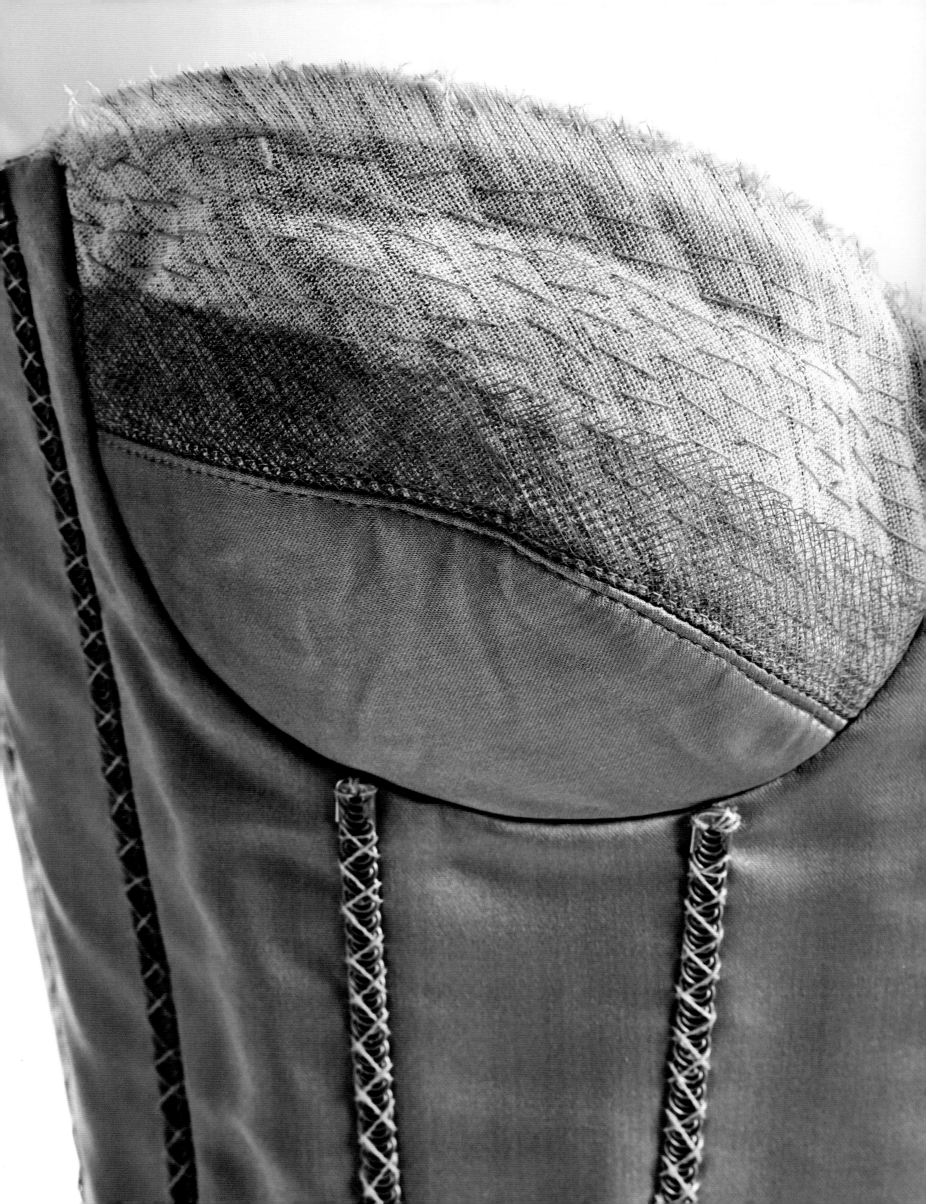

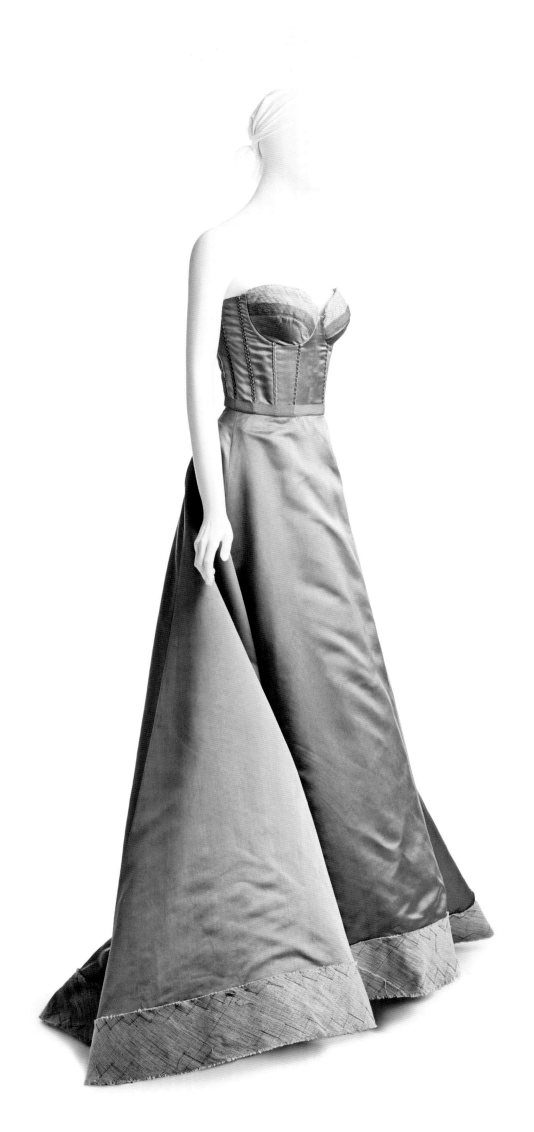

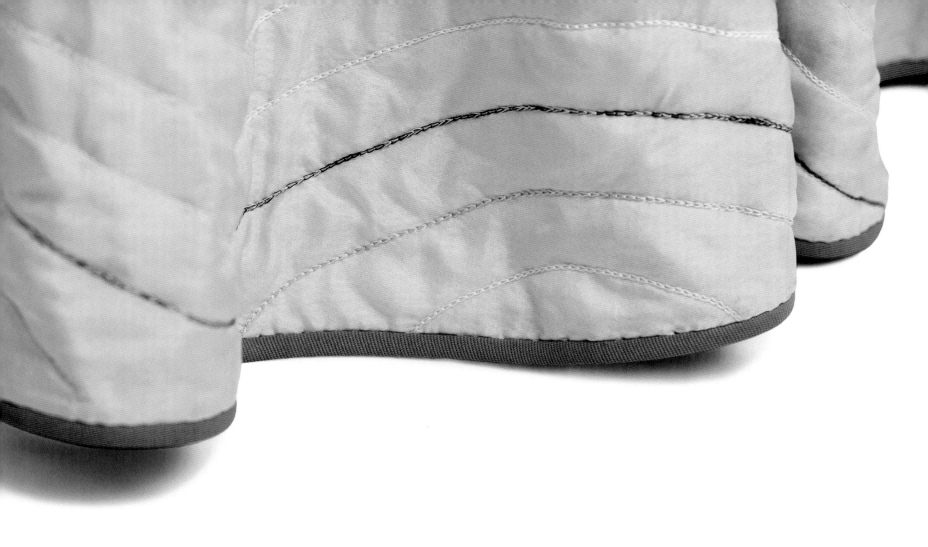

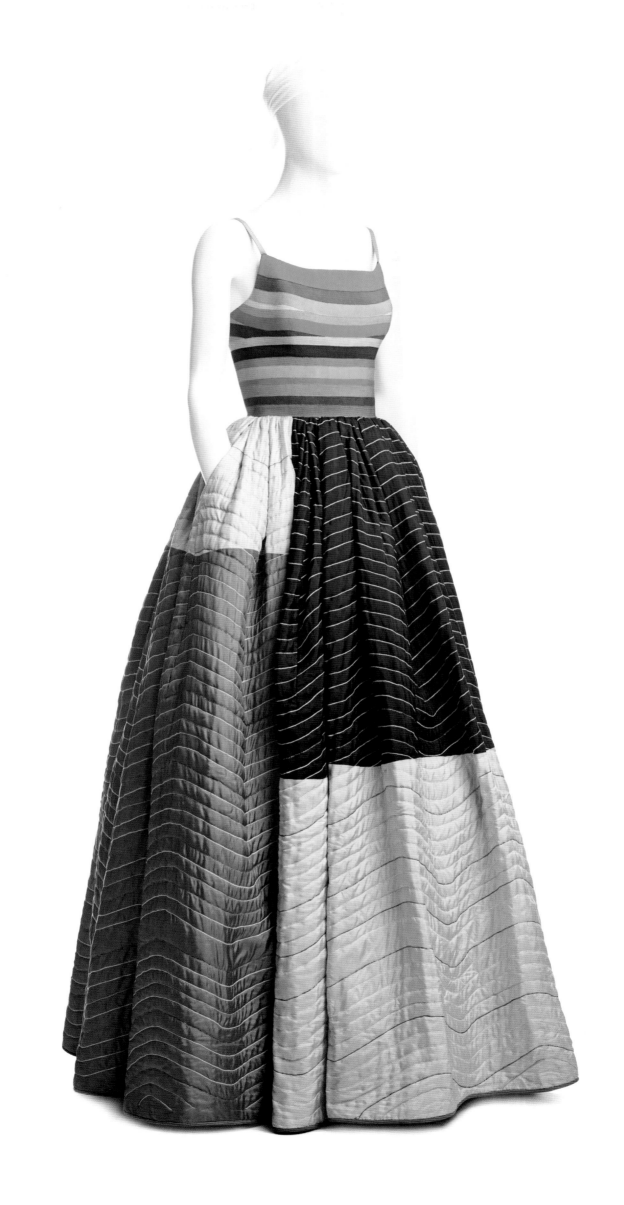

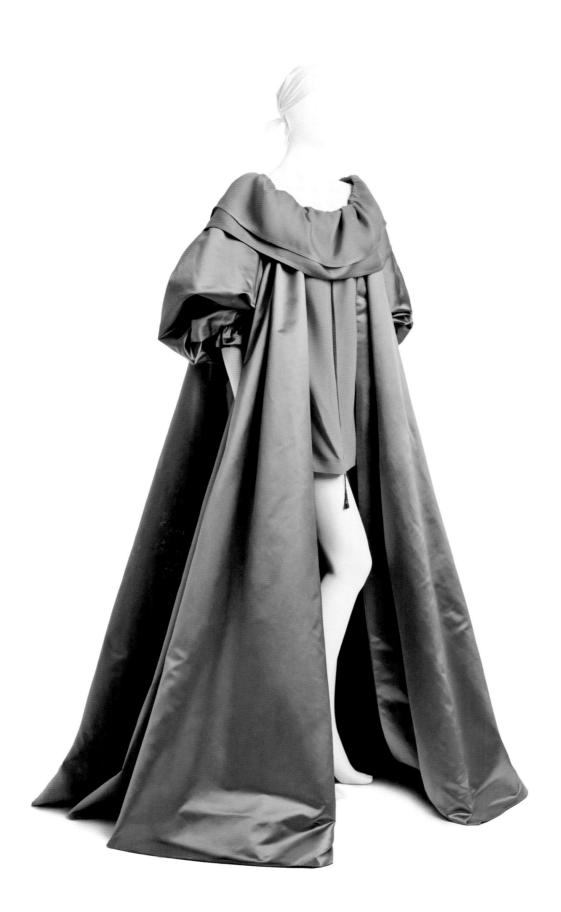

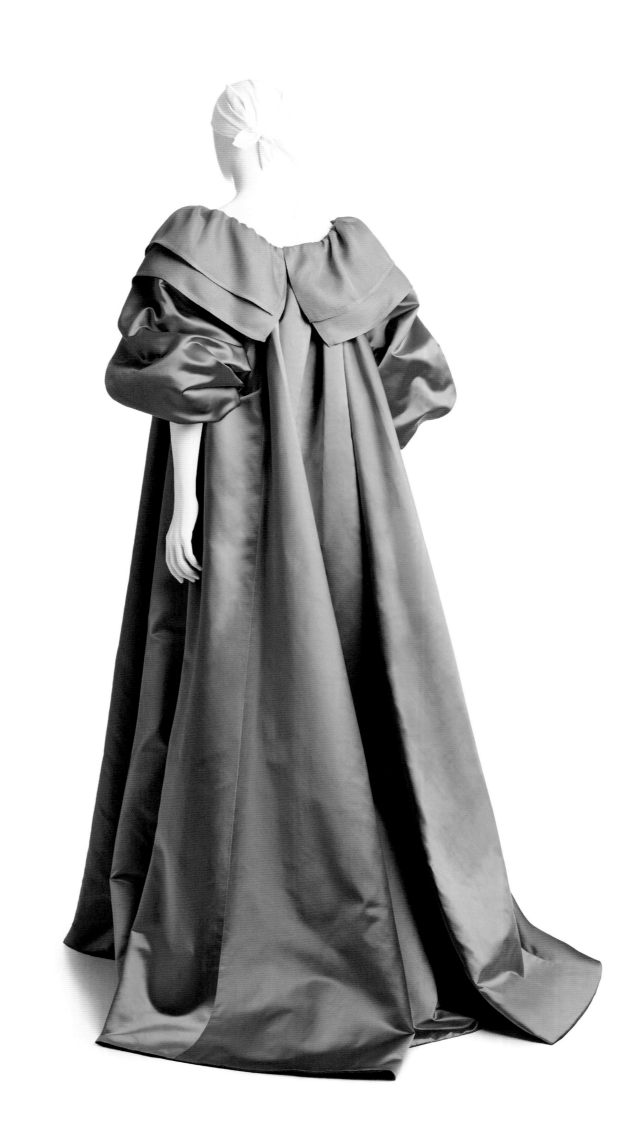

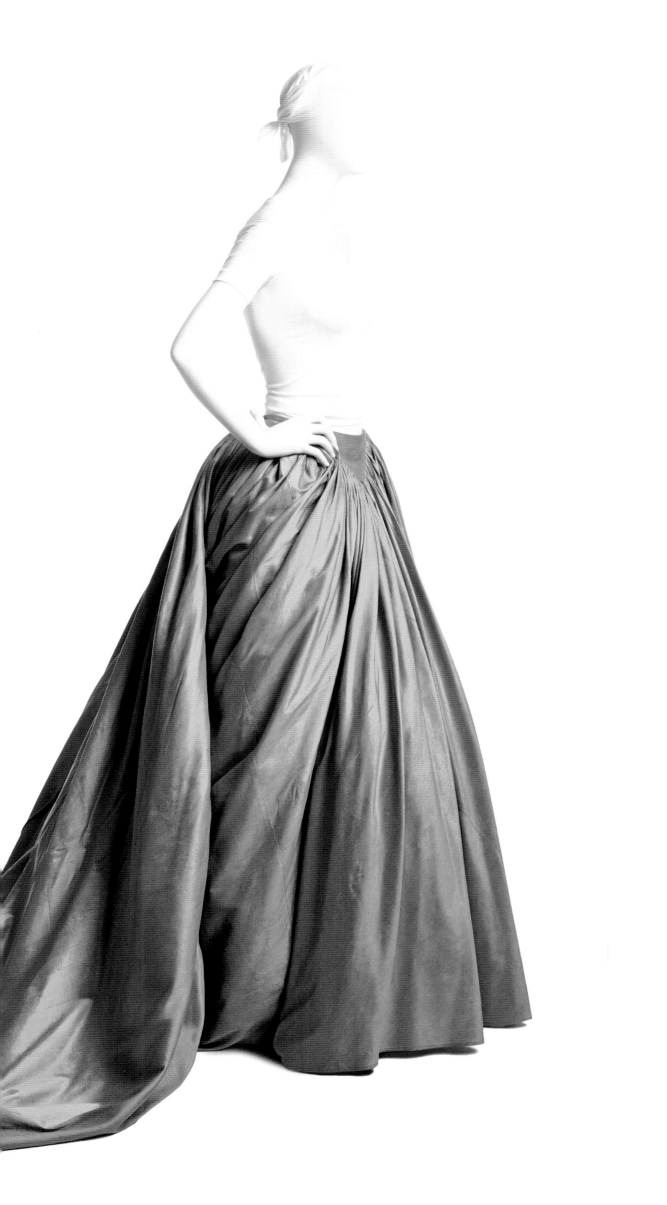

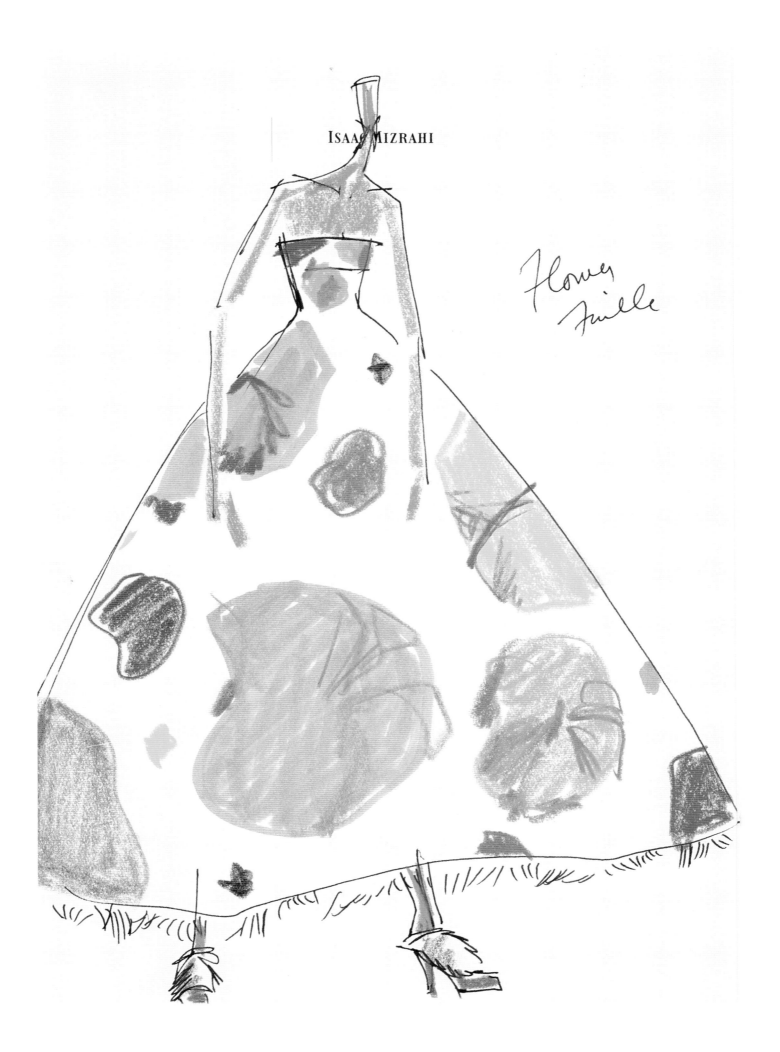

ISAAC MIZRAHI

Flowey
Finlle

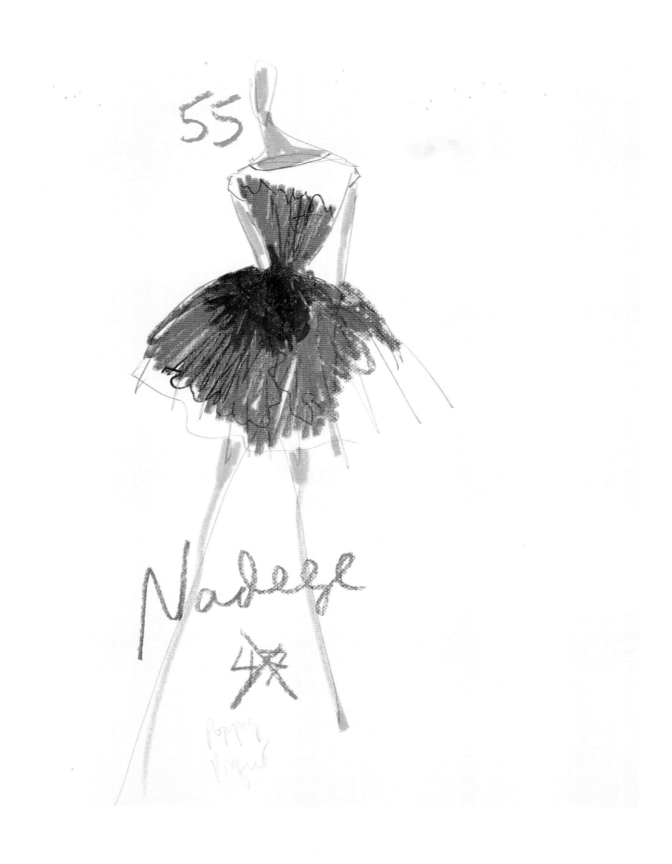

55

Nadege

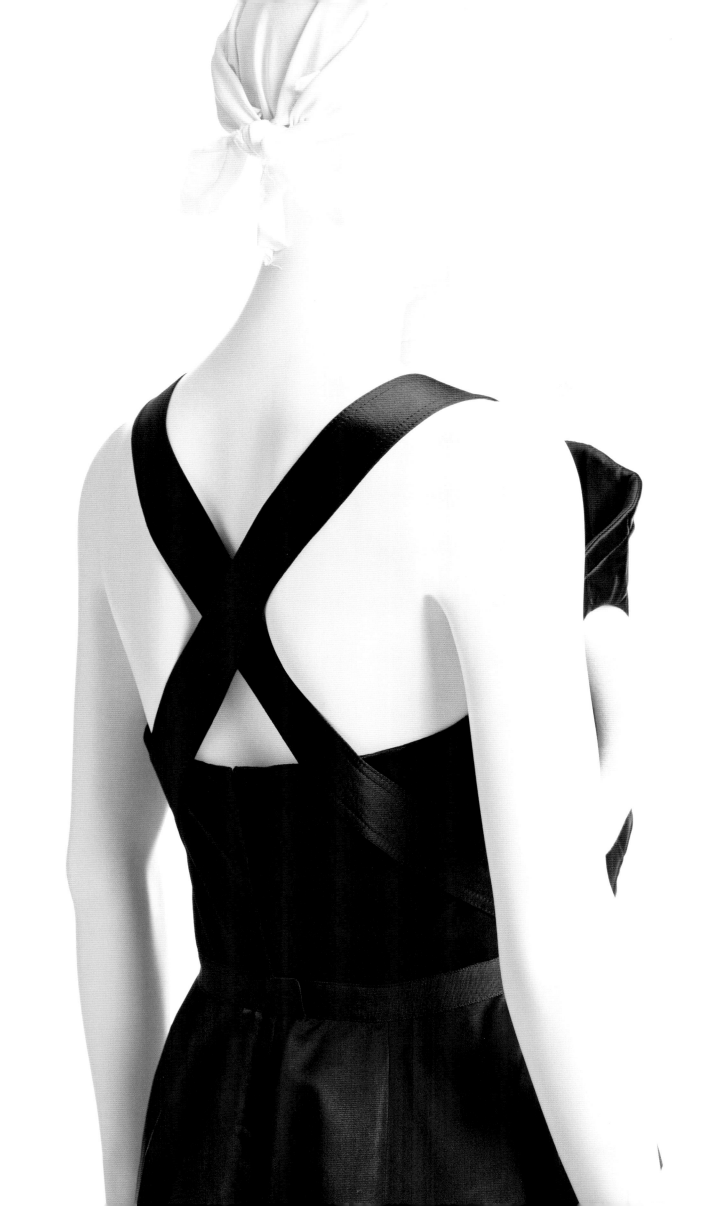

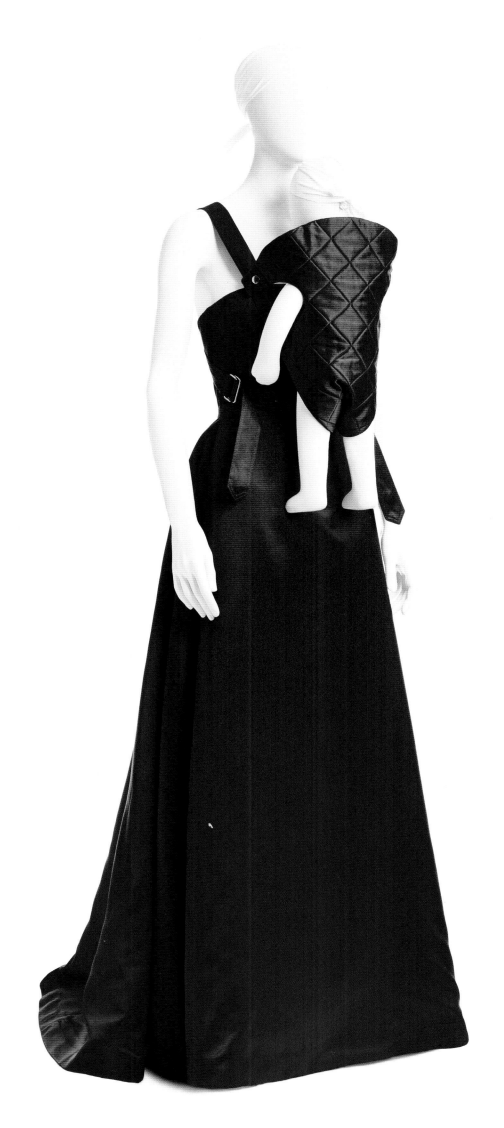

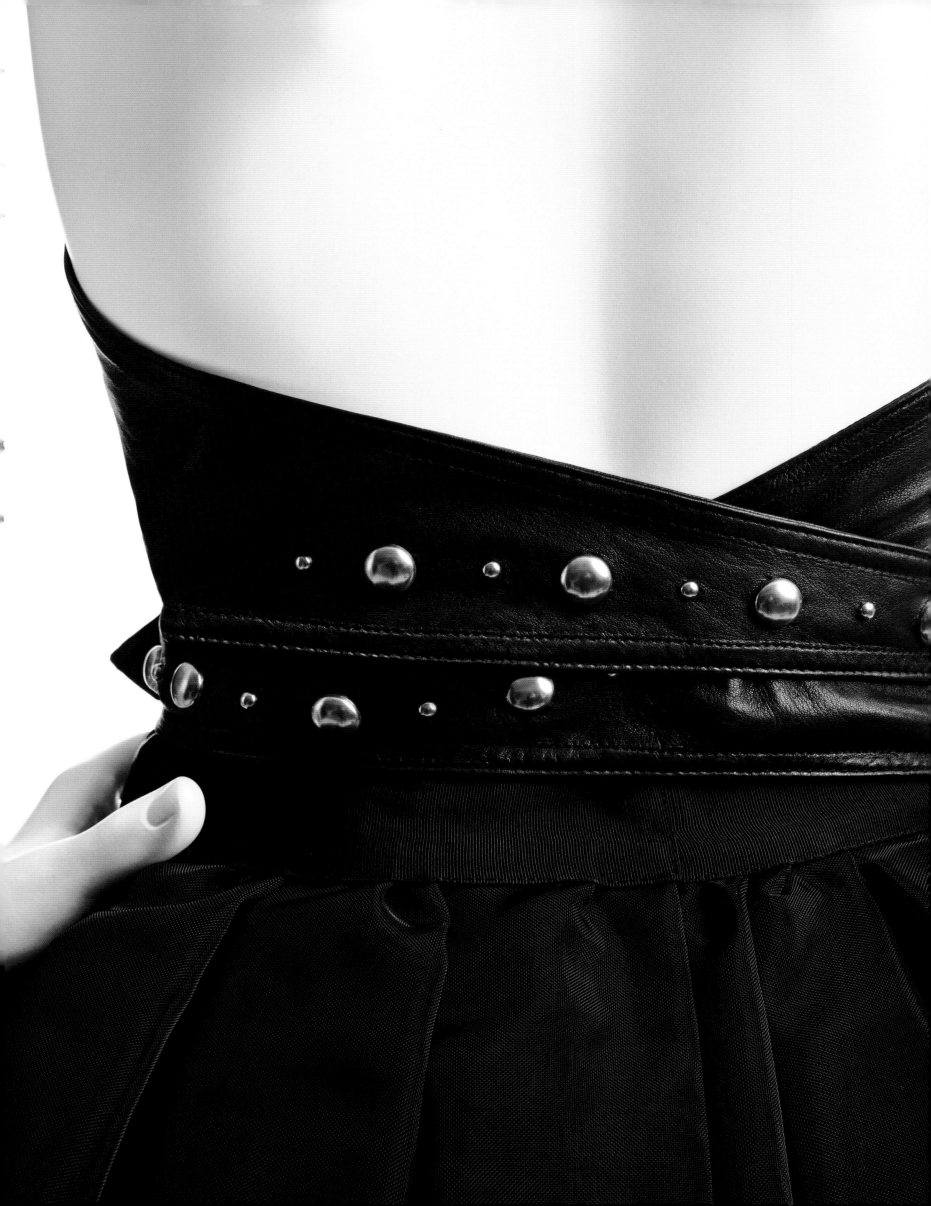

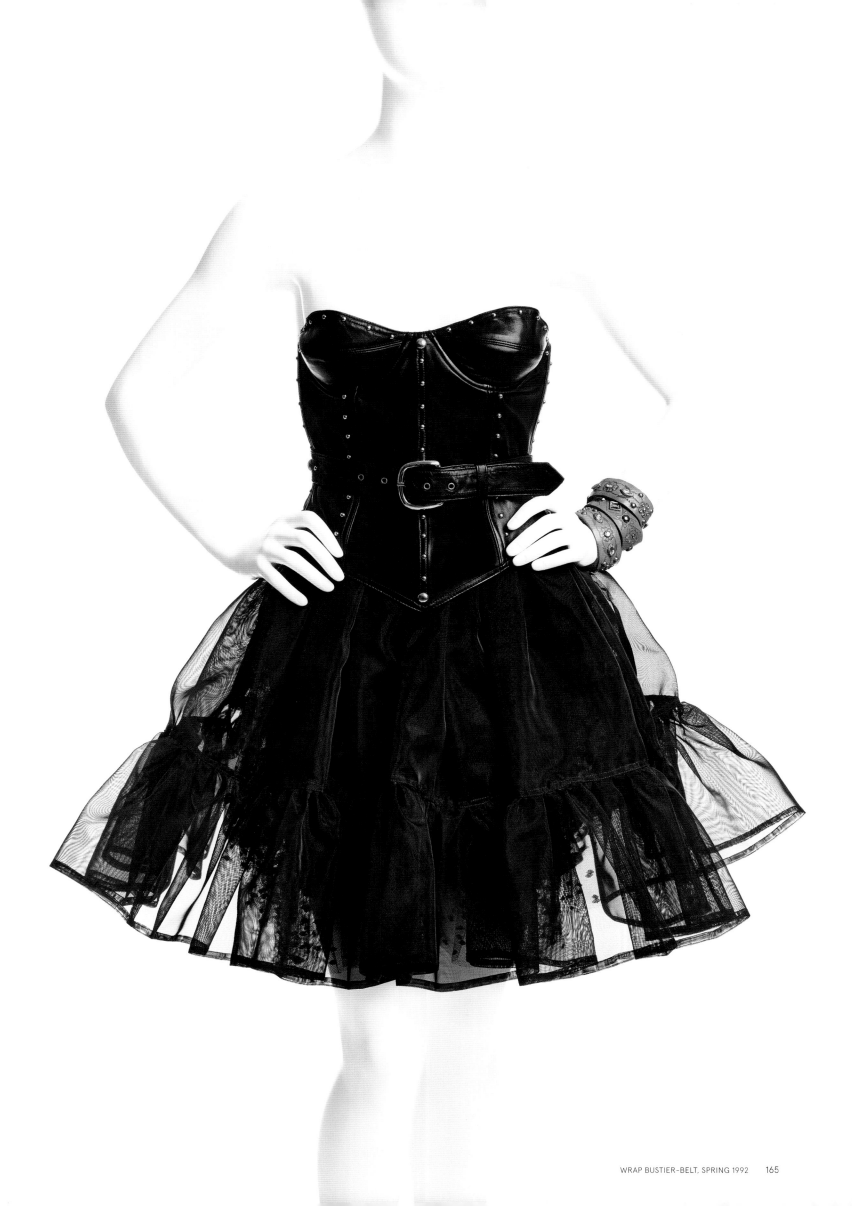

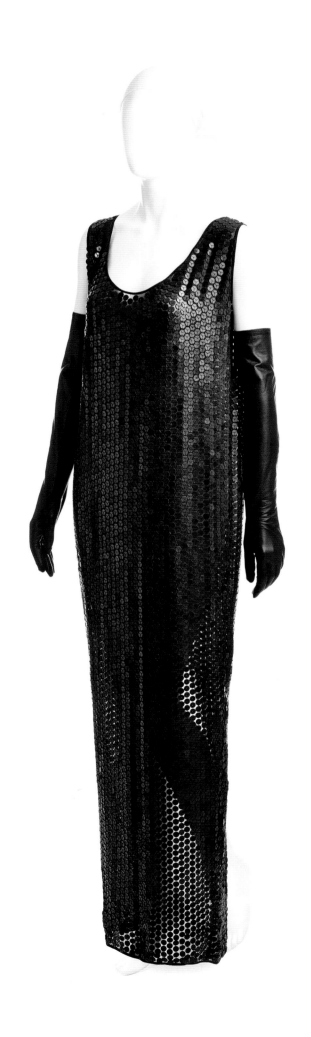

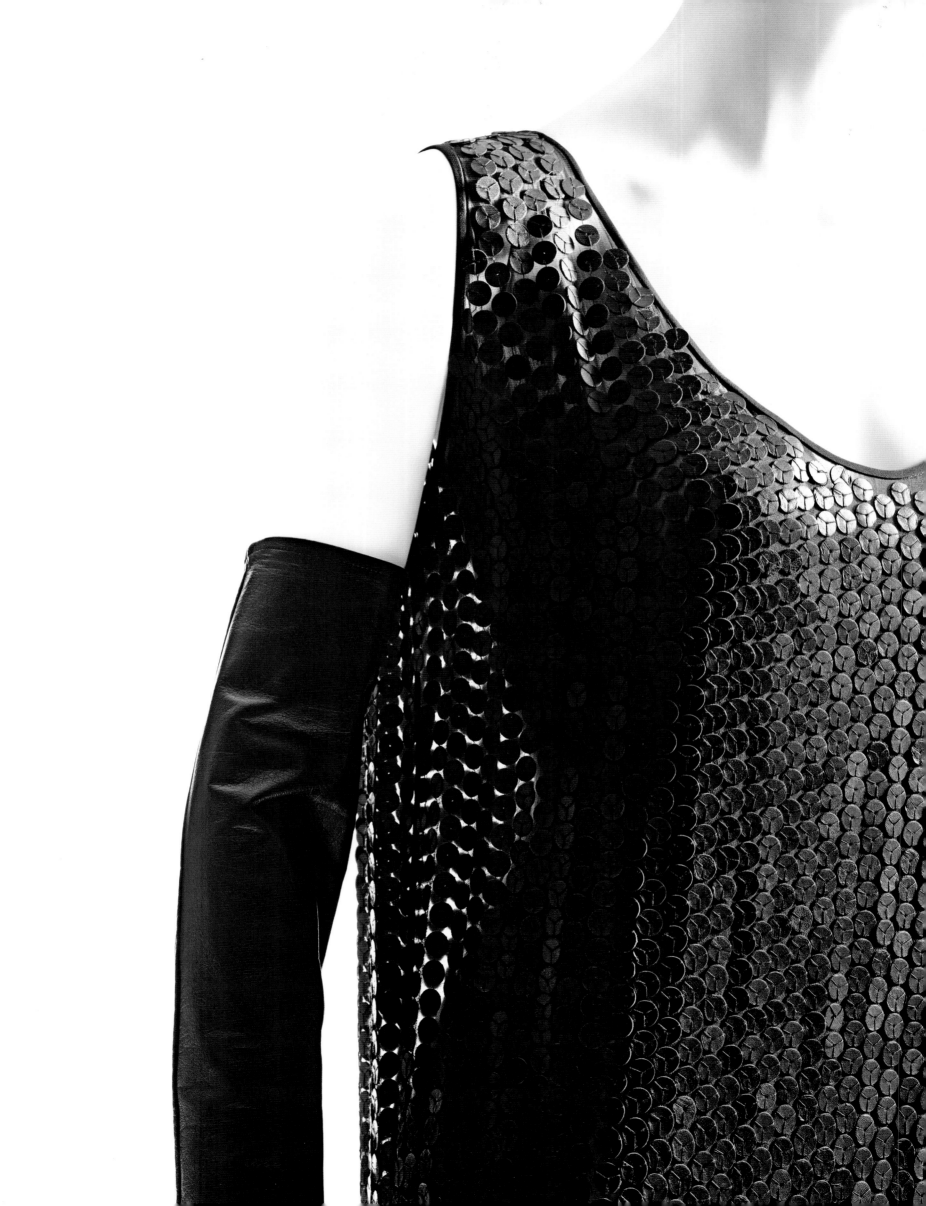

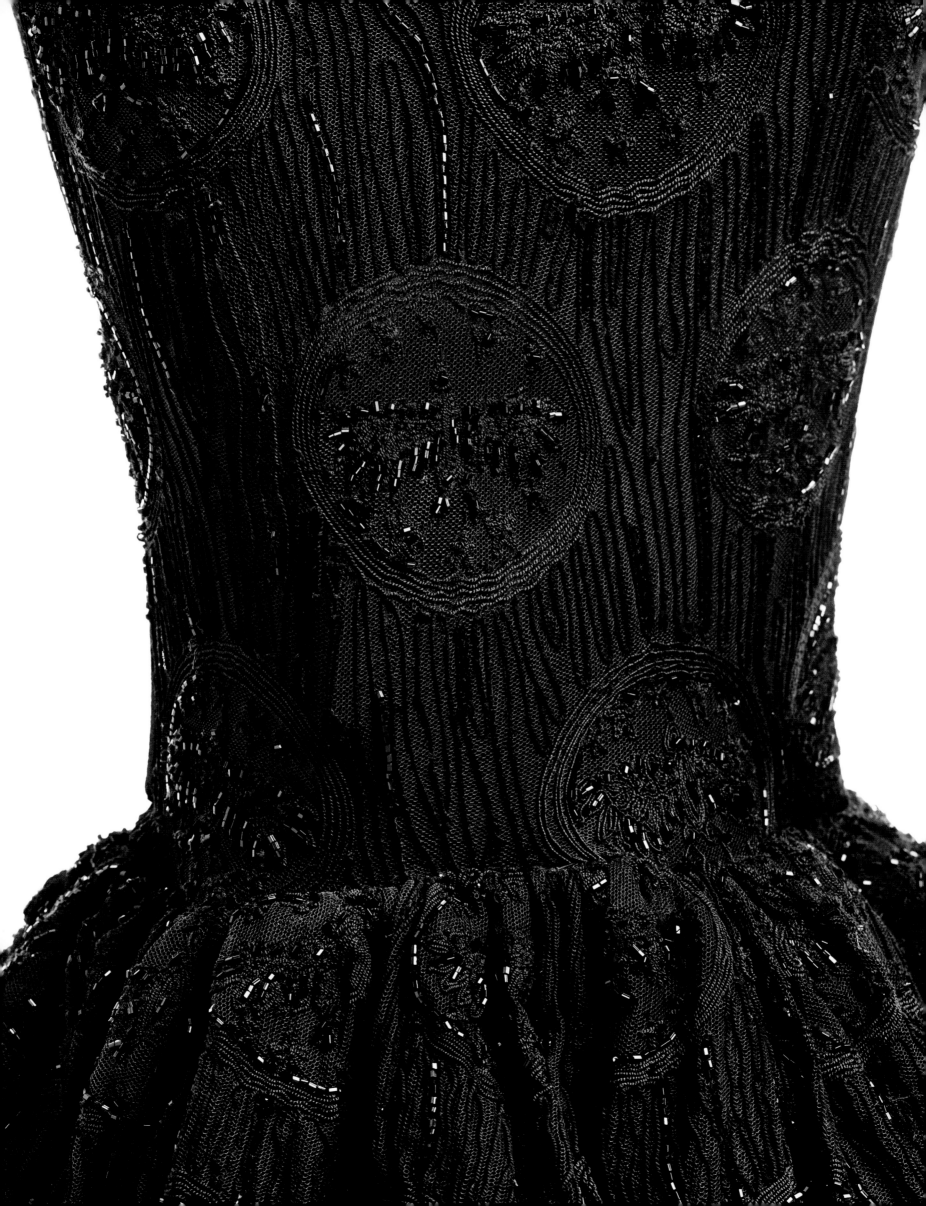

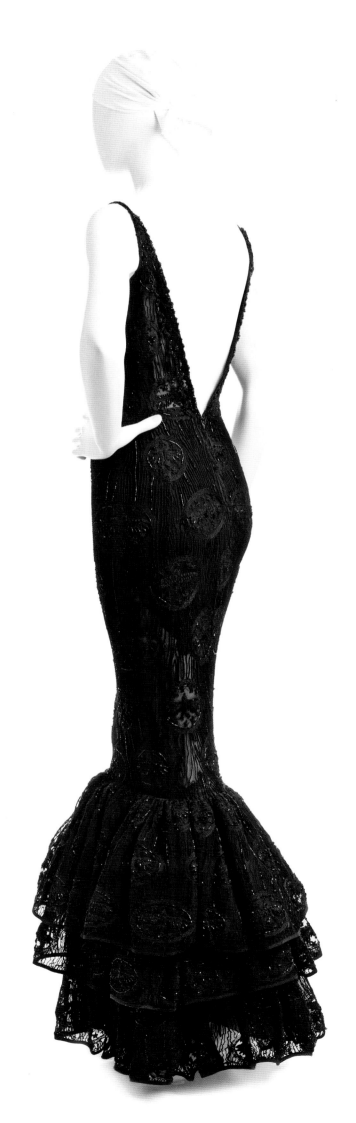

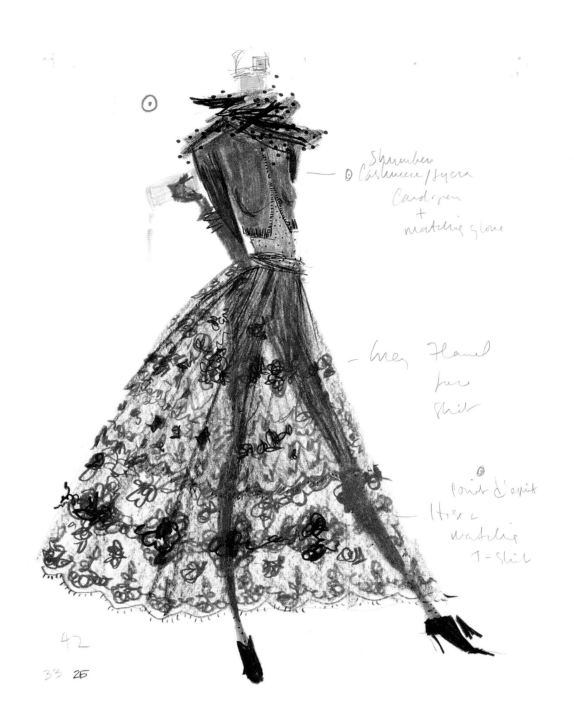

*Shrunken*
ⓞ *Cashmere/Lycra*
*Cardigan*
+
*matching glove*

— *Grey Flannel*
*Lace*
*Skirt*

ⓞ *Point d'esprit*
*Hose &*
*matching*
*T-Shirt*

42

33 25

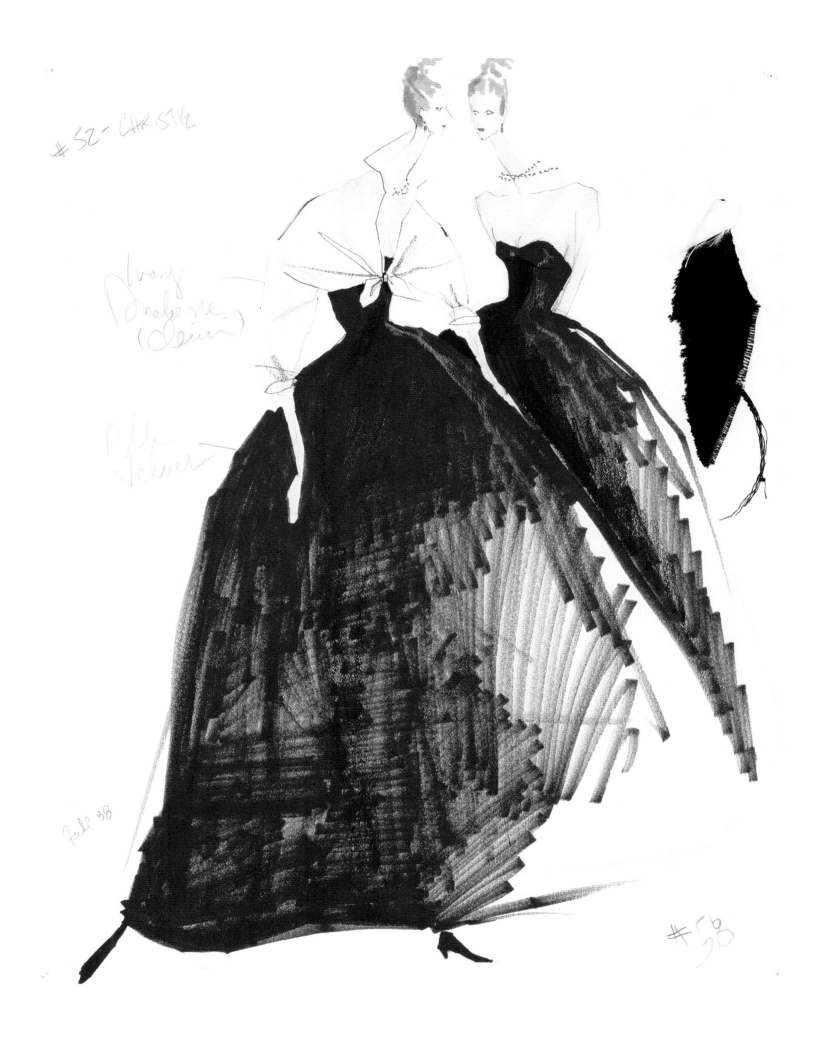

#52 - CHRISTIE

Ivory
Duchesse
(clean)

Ralph
Velvet

Fall 88

#58
98

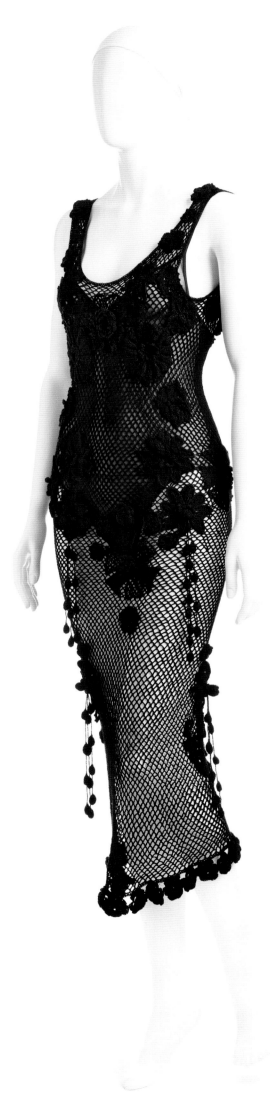

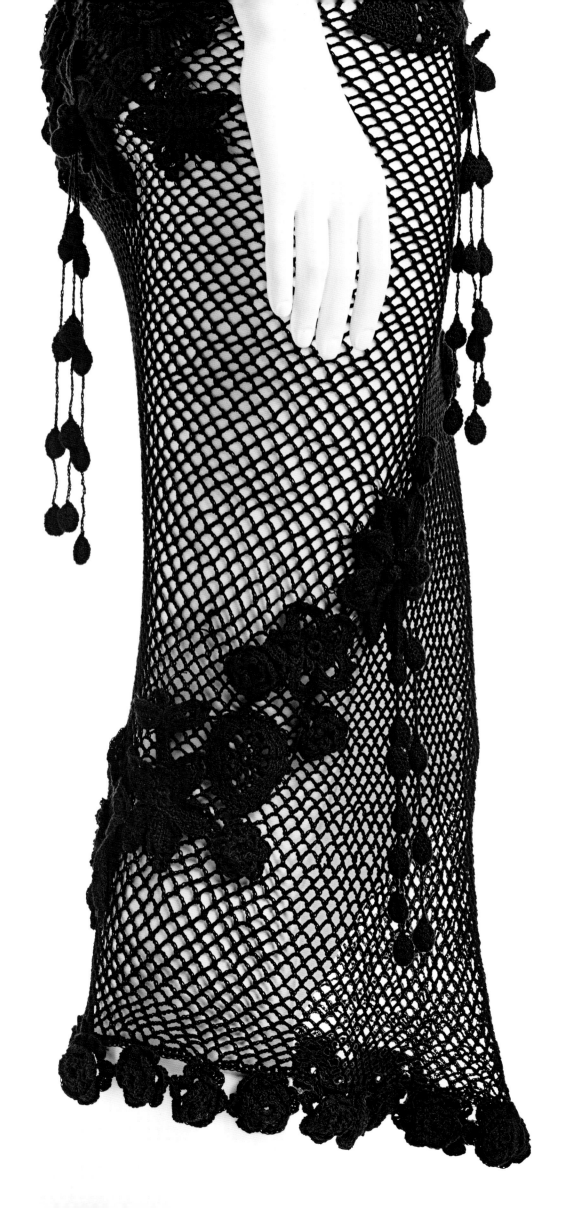

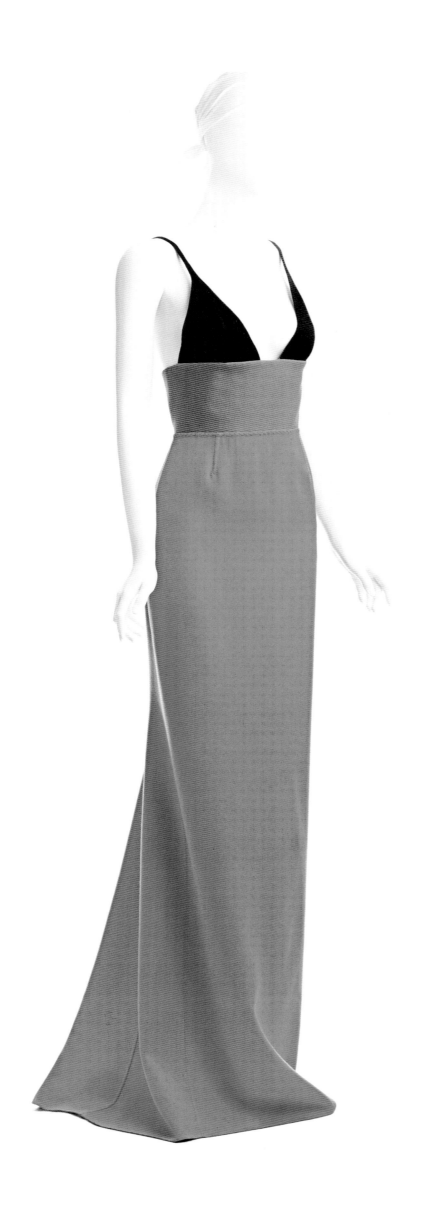

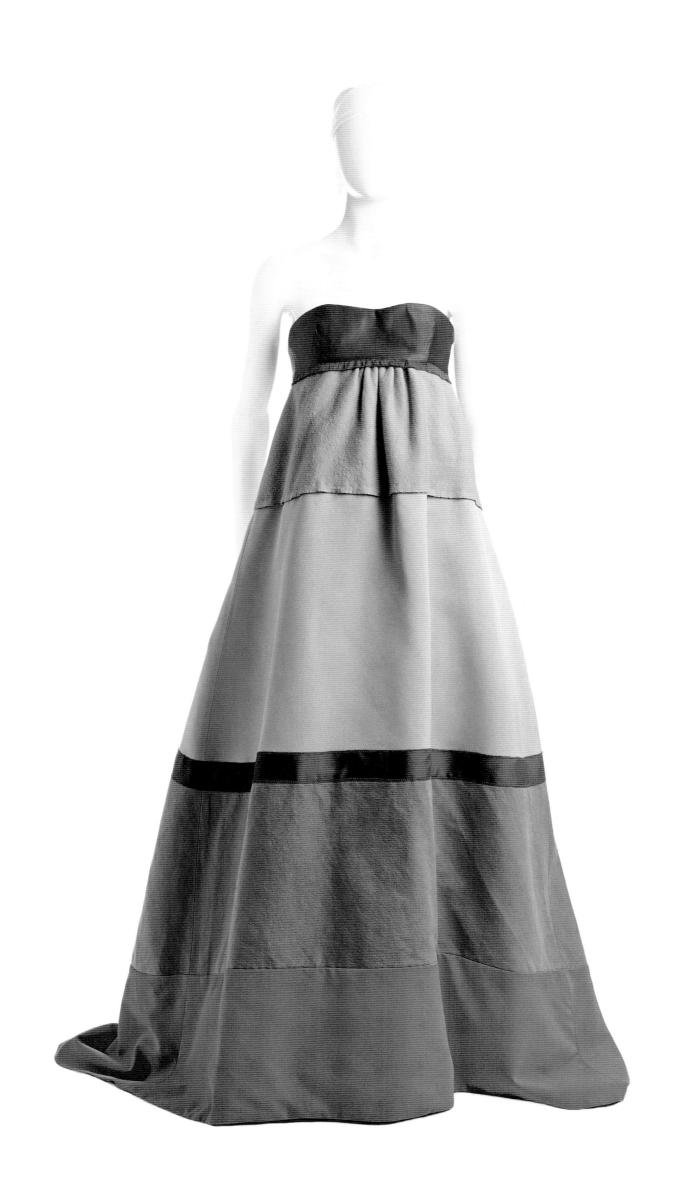

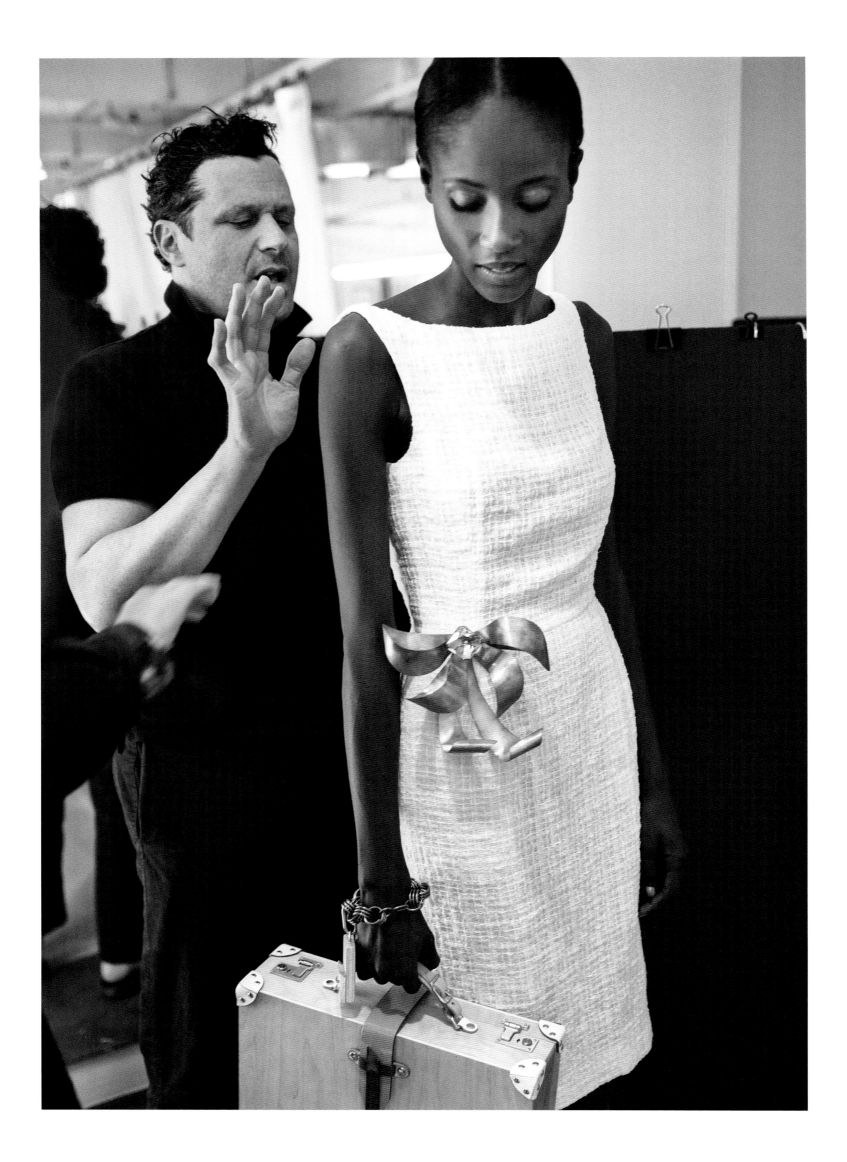

# american
# master

Lynn Yaeger

On an April day in 1988, in a downtown New York loft painted entirely white, Isaac Mizrahi, twenty-six years old, held his first fashion show. There were no mobile phones on which to tweet reviews, no Instagram to share pictures of Mizrahi's alpaca blanket coats, his cropped jackets and wide-legged trousers, his evening shorts, his chiffon jumpsuits. Corporate behemoths with names like Kering and LVMH had yet to begin buying up design houses, lying in wait to devour young designers who exhibited the merest hint of talent. Twenty-eight years ago, a brash young guy with a devoted mom, a radical vision, and a surfeit of confidence could stage an event that would bring the fashion world, stunned and delighted, to its knees.

Mizrahi's show took place in his atelier in SoHo—then still a fascinating mix of artists' studios and small manufacturers. Nearby there were old-world fabric and notions stores; West Broadway was the province of galleries, not chain boutiques; a few restaurants served the local community. The designer's great pal, the model Veronica Webb, walked in that inaugural show. "He had a little room on Greene Street," she recalls. "It was all white: white tables, chairs, and walls, and it was filled with the most amazing colors of fabrics, sketches, and swatches. You could tell right away that something magical was about to happen."

If the event had a seat-of-the-pants quality, a youthful insouciance, the clothing was remarkably assured. By the end of the show, Mizrahi recalled, "everybody was screaming and standing. The music was *happening!* Veronica turned to me and said, 'Honey, you're the king of New York.'"

The future king, whose strong ideas about American fashion and American women propelled him to dazzling heights in the 1990s, was born in Brooklyn in 1961. The son of prosperous Syrian American Jews, Mizrahi was, he claims, the very worst student at his yeshiva, making puppets when he should have been studying Torah. He was chubby; he was sad. He loved shopping with his mother, then as now his warmest supporter. "She took me everywhere, from Saks to Bergdorf Goodman to Loehmann's," Mizrahi told *Women's Wear Daily* in 1988. "Her closet was filled with Norells, Balenciagas, Chanels. I'd go to her fittings with her, when Saks had its custom shop."

Alas, the ability to distinguish a Balenciaga from a Balmain was not cherished by his fellow yeshiva scholars, and Mizrahi prevailed upon his parents to send him to the High School of Performing Arts in Manhattan. "It was dangerous in the seventies—taking the subway from Brooklyn. But it was also fabulous, and it taught me not to be so afraid of things." Like so many misfit children who come to the big city seeking validation and kindred spirits, Mizrahi found a home at his new school. "At Performing Arts, everybody was pregnant or on drugs or discovering whatever their latent sexual tendencies might be," he recalled years later. "There, artists weren't considered odd. It was my first exposure to New York City without my parents—culture shock!"

Manhattan in the 1970s was a percolating blend of the dirty and the thrilling. The subway was graffiti-scarred and decrepit, the crime rate high; but there were plenty of bohemian compensations: you could roam freely after dark in the city that truly never slept; you could shop for cheap wonderful clothes, as Mizrahi did, at Fiorucci, Unique, and Reminiscence; and despite your extreme youth, you might slip into Studio 54 (doormen were far less rigorous about checking IDs back then) and haunt after-hours joints like Escuelita and the Jefferson.

At Fashion Week in New York, readying the fall 2010 collection show.

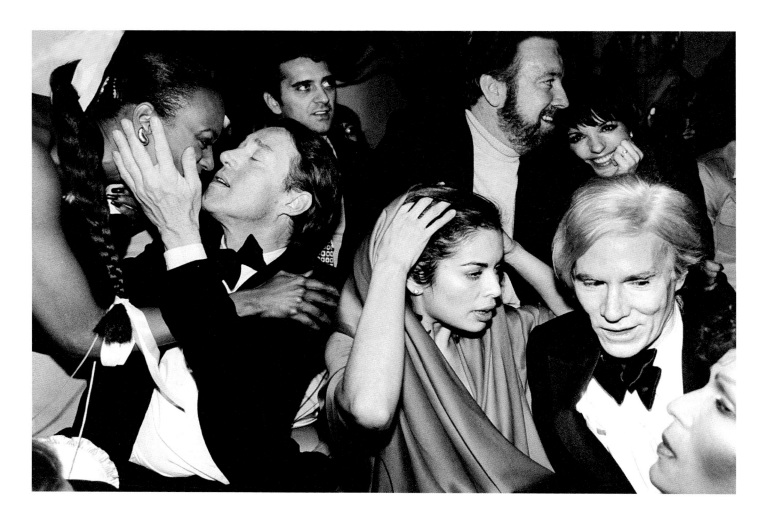

Studio 54 in 1978, left to right: the designer Halston, Bianca Jagger, Andy Warhol, and behind Warhol, Liza Minnelli; in its heyday, the club was a magnet for New York's fashion elite.

Mary Tyler Moore in *The Dick Van Dyke Show*, 1962. Her character, Laura Petrie, was an early sixties style icon.

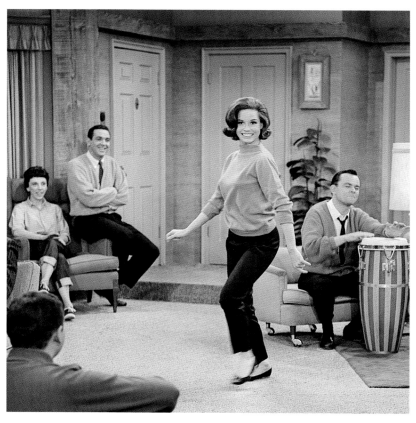

Christy Turlington at a fitting for the fall 1988 collection.

When he wasn't staying out until dawn, Mizrahi was advancing his cinematic education at a host of now-vanished revival movie houses—the Thalia uptown, Theatre 80 St. Mark's in the East Village—where he sat in the dark, continuing a love affair with Hollywood's leading ladies that had begun in his parents' living room. "Watching *Back Street* with Susan Hayward on TV while I was still at yeshiva was the moment I decided to become a fashion designer," he confides. And he wasn't only worshipping at the altar of Greta Garbo and Lauren Bacall. "Between them, Mary Tyler Moore and Jackie Kennedy shaped American style," he once declared with the fierce certainty, the emphatic quirkiness, that makes interviewing him such fun and so illuminating. In 1994 he told *Vogue* that Moore, who played Laura Petrie on *The Dick Van Dyke Show* from 1961 to 1966, "defined the recent heyday of America . . . it's the amazing memory of America's youth. I mean, look at Laura Petrie, the chicest, most fabulous, most adorable button of a girl. Right?"

André Leon Talley, an editor at *Vogue* when Mizrahi first arrived on the fashion scene and one of his earliest supporters, thinks this starstruck quality is central to the designer's aesthetic. He describes Mizrahi's work as "*I Love Lucy* going into high Grace Kelly. Right out of Adrian: big white dinner skirts with black sweaters, and those early Manolo Blahnik signature mules, with the low Louis heel, with a steel buckle. It became a signature look—for the whole show the girls wore those shoes. If Ethel were alive," he adds, "she would be Isaac's best friend!" Does Talley mean Ethel Merman or Mertz? Either, both! "Or maybe Elaine Stritch! Isaac was like a young Bill Blass—he'd run down the runway. I never saw him down or doubtful. He speaks that New York language, he can tell you all about Bankhead, Hellman, Capote!"

Mizrahi perfected his New York language at Parsons School of Design, happily ensconced among other driven, youthful eccentrics. When he graduated he was torn between two jobs—one in the costume department of the Public Theater's Shakespeare in the Park, the other at Perry Ellis, a designer who championed an American aesthetic, Ivy-influenced but never stuffy. Mizrahi chose Ellis. This was followed by a stint at Calvin Klein, another quintessentially American designer. Both employers, like Mizrahi himself, embraced a fashion sensibility that was miles—literally and figuratively—away from the couture traditions of Europe.

Indeed, Mizrahi has described his ideal customer as "an American who believes in American design, not someone who loves European clothes. You see a European woman in a restaurant and she's so done up, in a tailored jacket with lots of jewelry and her hair just so. An American woman in crocodile flats and a tweed skirt looks so much better to me." Valerie Steele, the director and chief curator of the Museum at the Fashion Institute of Technology, believes that this vision contributed to Mizrahi's rapid rise: "In Europe, they fetishize the old names, but in America we want the next new thing."

The next new thing, in Mizrahi's case, included an April 1991 show that *Women's Wear Daily* described as "awash with Indians, cowboys, immigrant Jews, WASPS, homeboys and Hollywood starlets." The designer "nonchalantly blended Guardian Angel trenches with Daniel Boone fringe, Sitting Bull beads with Stormin' Norman camouflage, Stars of David with totem poles, rap knuckles with banker stripes" (pages 50, 90, 123, 129). The references suggest just how topical and

of-the-moment Mizrahi's ideas were, drawing on dozens of unexpected sources, from the look of New York's quasi-vigilante volunteer crime patrols to the fashion stylings of the US armed forces, led by Norman Schwarzkopf, commander in chief in the Persian Gulf War, which was then just ending.

Given the exquisite craftsmanship that underlay this wild eclecticism, it is surprising that Mizrahi has declared, "I don't like construction that much. I like flesh! I have a physical aversion to construction." Veronica Webb begs to differ. A model, a confidante, and a sounding board in those early years, she was also an enthusiastic wearer of Mizrahi's clothes. "Inside and out they are impeccable—beautifully constructed, built to last, the highest level of technique, but at the same time very playful, very original." Mizrahi often named his dresses, and Webb has vivid memories of her favorites: the rainbow sweaterdress that she donated to the Museum at the Fashion Institute of Technology, but that "still lives with me in my dreams"; the black-and-white frock that was a collaboration between Mizrahi and the artist Maira Kalman; the orange wrap coat with the orange fur collar. "I had a Black Watch plaid silk taffeta parka, and I had the kilt dress," Webb recalls (page 79). "Emotionally, you understand who he is through his clothes—open and curious."

This openness and curiosity were introduced to the broader public through the groundbreaking 1995 documentary *Unzipped*, which follows Mizrahi through the making of his fall 1994 collection and was directed by his boyfriend at the time, Douglas Keeve. The film deals with its subject matter with a delightful mix of rigor and humor, and is, in Steele's opinion, perhaps the greatest fashion movie ever made. It's commonplace today to fall in love with a designer not just because of the work but because of his or her winning persona, but as Steele points out, this blending of creator and work was probably seen for the first time in *Unzipped*. "You can't separate Mizrahi's clothes from his personality," she says. "Editors fell in love with the person as well as the clothes—the charm and the humor."

The film chronicles the making of a collection that Mizrahi described as "Fifties cheesecake meets Eskimo." As if this weren't enough, Mizrahi introduced a conceit that quickly became legendary: instead of having a traditional backstage, the models changed their ensembles behind a transparent scrim, in full view of the vast audience of buyers and journalists, celebrities and drag queens crowding the Manhattan Center. And all was recorded for the documentary.

In a way, the notion of transparency can be read as a metaphor for Mizrahi's career in fashion. What he cares about is the idea of seeing, in the best American sense, what you're getting—no tricks, no sleight of hand. "Being a Jew, I think it's about integrity, but maybe with an undeliberate, almost mistaken quality," Mizrahi says, looking back on those early years. "I do want to think that my clothes have been innovative and inventive in the way I think they should be." He has never lost the deeply authentic, homegrown feminism that underlies so much of his work. In 1992 he told the *New York Times*, "It's sexist to think that a woman should have a harder time getting dressed than a man. Tarzan had the right idea with a one-shoulder garment and no underwear. What is modern is to make clothes that are very simple for women."

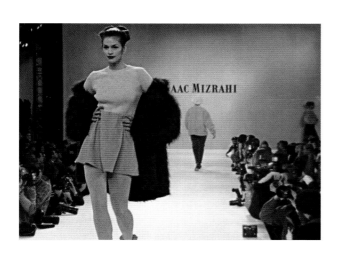

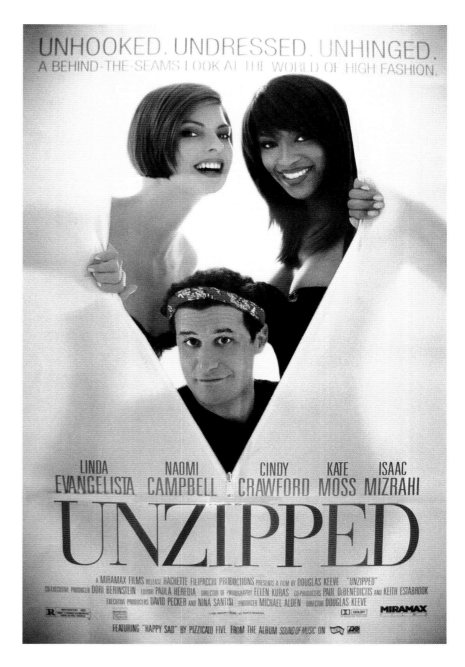

The runway from Mizrahi's fall 1994 show, as seen in *Unzipped*: the scrim backdrop appears opaque when lit from the front; when lit from behind, the models' changing area is visible. The exposure of the undressed models caused a stir at the time.

The poster for *Unzipped*, released in 1995.

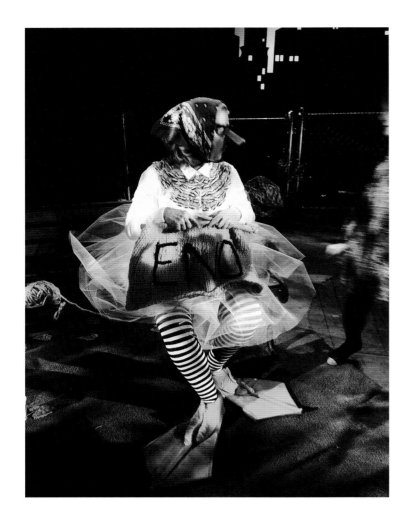

Below: *People* scarf with imagery by the artist Maira Kalman, spa 1990. Left: Kalman as the Duck in Sergei Prokofiev's *Peter and the Wolf,* performed at the Solomon R. Guggenheim Museum, New York, December 2013. Bottom: Daniel Pettrow as the Wolf. Costumes, narration, and direction were by Mizrahi.

But making smart, distinctive clothes hasn't proved quite enough to satisfy Mizrahi's prodigious talents. In the decades since his rise, the designer has proved F. Scott Fitzgerald wrong: there can be plenty of second, third, and fourth acts in American lives. These include a 2002 venture with Target, one of the first of the high/low collaborations between A-list designers and mass-market retailers that are now commonplace, and the 2010 launch of his television program *Isaac Mizrahi Live!* on the QVC television network.

The designer loves to be in front of the camera and is a familiar presence as host and commentator on fashion television. Behind the scenes, he has directed and narrated a production of *Peter and the Wolf* at the Guggenheim Museum, and created costumes for Broadway revivals, operas, and numerous ballet projects with his close friend, the choreographer Mark Morris. And through his Isaac Mizrahi Live! brand his exuberant palette can be seen today enhancing everything from phone cases to Band-Aids to pillows to Kleenex boxes.

In his acclaimed one-man cabaret act, *Les MIZrahi*, the designer appears onstage with a sewing machine and sings "Baubles, Bangles, and Beads," from the 1953 musical *Kismet*. At one point he emerges in white tie and tails, dapper as Fred Astaire, suave as Cary Grant, witty as Noël Coward—a figure out of a 1930s cinematic fantasy, a million miles from Brooklyn . . . but then again, maybe not (pages 21, 217). "Costume is everything," he announces. He isn't only talking about clothing, but about the way in which Americans like him can dress up in whatever suits their aspirations, accoutre themselves in a dream, and then make it real.

# MOSCOW: Can the Center Hold?

# TIME

INTER

# Super models

### Beauty and the Bucks

# isaac mizrahi
# an unruly history

Kelly Taxter

Naomi Campbell was the first black model to appear on the cover of *Time* magazine. She did so on September 16, 1991, and she was wearing Isaac Mizrahi. The young woman is set against stark white, which emphasizes her dark skin and elaborately patterned strapless sheath. Mizrahi's *Totem Pole* gown was inspired by the iconography of the native peoples of the Pacific Northwest, and came down the runway with his fall 1991 collection. The design is simple: a heart-shaped bodice and straight-cut skirt. Mouths and eyes are expertly embroidered top to bottom on gold flannel, strategically overlaid on the body so that the wearer herself becomes totemic. The dress highlights Mizrahi's postmodern mixing—of hues, ethnicities, references, even religions. He ransacks his vast store of knowledge about art, music, theater, dance, what's in the news, and what's underground to infuse fashion with ideas about appropriation, identity politics, and globalization. From his Isaac Mizrahi New York line (1987–98) to his current *Isaac Mizrahi Live!* for the QVC network, the designer has always been in step with the capricious movements of high fashion. And he has an innate understanding of the global shifts that, at the close of the twentieth century, exchanged exclusivity for mass appeal.

Mizrahi's early collections potently commingle innovative design with a mode of appropriation that borrows equally from art and culture. The clothing and runway shows of the late eighties and early nineties offer glimpses of his burgeoning design aesthetic as well as the ferment that was bubbling in New York's artistic communities, where debates about authorship, identity, and power dynamics reached a fever pitch by 1993. In that year's politics-heavy Whitney Biennial exhibition, artworks by Nan Goldin, Andrea Fraser, Daniel J. Martinez, and others addressed the urgent topics of the day: sexuality, race, AIDS, class, and the hidden machinations of the art market (page 188). Those issues reflected global struggles to redefine nations and cultures after major political upheavals: the fall of the Berlin Wall and the Tiananmen Square uprising in Beijing in 1989; the Gulf War in 1990; the end of the Soviet Union in 1991; the Los Angeles riots sparked by the assault on an African American man, Rodney King, in 1992; and the mass connectivity made possible by the Internet, just emerging in 1993. Mizrahi's collections reveal a designer embedded in the cultural landscape of New York City and at large, able to playfully weave art history and politics into a rather lighthearted industry—one often accused of superficiality.

Mizrahi's pedigree is impeccable. He studied at Parsons School of Design and apprenticed with Perry Ellis. Before launching his own line he worked at Jeffrey Banks and Calvin Klein. Mizrahi's first collection already reveals his through lines: a reductive approach to construction contrasting with a maximalist approach to color and surface, and a sharp attention to movement. For example, the *Wings* blouse (spa 1989, page 33) is a long, simple peau de soie tube that stretches across the chest. The *Rabbit Ears* dress (fall 1990, page 111) is a crystal-beaded minidress lightly held to the body by slinglike shoulder straps, staying in place only when the wearer's shoulders are held up and back. The *Bustier-Belt*, which appeared in spring 1992 (page 165), is a belt with a bodice attached to the front, so that the act of wrapping the belt around the waist fits the bustier around the body. To wear these pieces requires a physical gesture, a moment of drama on the part of the individual who puts them on. This movement-oriented approach

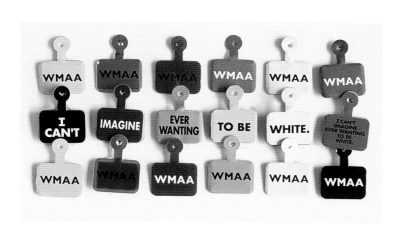

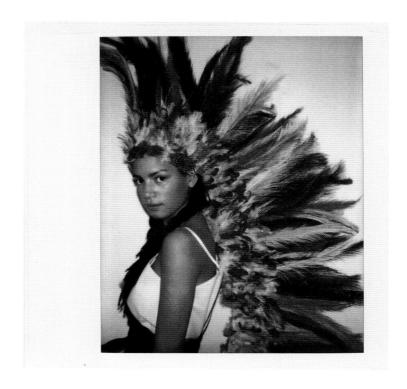

Daniel J. Martinez, *Museum Tags: Second Movement (overture)*, or *Overture con claque— Overture with Hired Audience Members*, 1993, metal and enamel on paint, 12 × 15 in. (30.5 × 38.1 cm), collection of Michael Brenson.

Mizrahi caught Veronica Webb in his studio, playing around with a Native American headdress of unknown origin.

LL Cool J's music video for "Around the Way Girl" (1990) is a virtual manual of the early nineties street style appropriated by Mizrahi: it features neighborhood homegirls hanging out on the sidewalk, decked out in gold bamboo earrings and chains, denim and leather, hair pulled back into tight ponytails or let loose in long extensions.

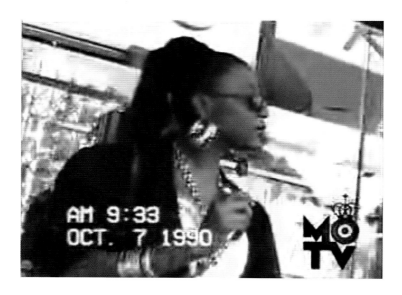

RuPaul wears Mizrahi's *Leather Sequin* dress in her music video for "Supermodel (You Better Work)," 1993.

to dress exemplifies how the young designer applied the exacting tailoring he had learned at Calvin Klein to his own tastes, deeply informed by dance and theater.

A booklet that functioned much like a *Playbill*, which credits a play's cast and provides an act-by-act synopsis, accompanied Mizrahi's shows, listing his cleverly titled looks and passages. Fall 1991 opened with La Casa de Mizrahi and Manhattan Is Burning, references to New York's underground drag balls and voguing competitions of the time. These events, whose participants were primarily gay and transgender African Americans and Latinos, were documented in Jennie Livingston's landmark film *Paris Is Burning*, released that August. Drag aspirationally and satirically appropriates the signifiers of high fashion, and voguing is a performance style inspired by the posing and posturing of supermodels. The competitors were broken up into "families," groups who often named themselves after couture houses, such as the House of Chanel, House of Saint Laurent, and even House of Mizrahi. The designer responded to his subcultural counterpart in kind, fostering a fluid exchange of information, slang, and garments, which in turn created community. The drag superstar RuPaul wore Mizrahi's fresh-off-the-runway *Leather Sequin* gown in the video for the 1993 song "Supermodel (You Better Work)," a campy fantasy in which she channels Naomi Campbell, Linda Evangelista, and Cindy Crawford, three star supermodels of the time. Twenty years later that fanciful thinking has become reality, with transgender models such as Lea T and Andreja Pejic starring in campaigns for Redken, Barneys New York, and Jean Paul Gaultier.

If the first half of the fall 1991 show elevated the underground, the second half, titled Pow Wow Dressing, brought the elite to the street. This passage comprises looks the designer refers to as Tee Pee Town. The name evokes an imagined, or reinvented, roadside tourist shop of the sort popular in mid-twentieth-century America, where kitschy souvenirs such as Davy Crockett coonskin caps and Native American beaded moccasins and headdresses could be purchased. Mizrahi subtly links this fictionalization of American history to the equally dehistoricized WASP lifestyle marketed by Ralph Lauren. That company's hyper-Anglo image masks the fact that Jewish designers and garmentos (of whom Lauren, born Lifshitz, is one himself) dominate the business of high fashion—and have a long history in the garment industry. Mizrahi took Lauren's very serious Navajo-patterned jackets, quilted skirts, and ruffled lace and gave us a witty tweed suit with tasseled leather trim, worn with a tooled leather belt closed by a big brass *Star of David* buckle. Jewish and Native American symbols were elaborately beaded onto suede shearlings and cocktail dresses, fusing the American West with the American Immigrant. Mizrahi accessorized with bamboo earrings and layers of gold chains weighed down with *Star of David Medallions*, an ironic take on New York's hip-hop–inflected street style (pages 90, 126, 195).

In the middle of all the leather, beads, and bling came *Desert Storm*, a diaphanous, silk georgette halter dress in a tan and green camouflage print. A direct reference to the combat phase of the 1990 Persian Gulf War, it also calls to mind Andy Warhol's *Camouflage* paintings of the late 1980s, the artist's

Andy Warhol, *Camouflage*, 1986,
screenprint, 38 × 38 in. (96.5 × 96.5 cm)
The Museum of Modern Art, New York.

take on abstraction. True to form, Warhol had not rendered original, gestural reimaginings of existing material, but turned to readymade "landscapes," pre-distilled into paint-by-numbers patterns. Mizrahi employed a similar appropriative gesture—one with a charged subtext. Inserting a loaded image, borrowed from an unpopular war, into the superficial context of fashion was a deliberately provocative move. The woman who wears the semisheer, skin-baring dress would never blend in, but quite stunningly stand out from the crowd.

In a more direct yet still oblique art-historical reference, Mizrahi transposed Irving Penn's photographs of flowers onto dresses and suits for his spring 1992 collection. *Exploded Tulip* dress is an ankle-length, short-sleeved shift with a huge pink tulip printed from neck to hem on its front. As in *Totem Pole* gown, the bud, leaves, and stem are placed to mirror and fuse with the woman's body. Mizrahi created his own photographs in the style of Penn's, the better to manage scale and print quality, so that the dress is not just a vehicle for an image, but also a kind of photograph itself. This approach to print and pattern parallels the reframing and recycling in the work of artists working in New York in these years: notably Richard Prince, Sherrie Levine, and Robert Longo, who were playing with the ways photography repositions images that are already circulating, rather than generating new material. For example, Prince's *Cowboys* series comprised blown-up, grainy photographs the artist made by cropping and enlarging sections of Marlboro cigarette ads. Prince peeled apart the commercial and artistic content of the image, allowing a third meaning to emerge, dictated by the artist's compositional choices.

*The Real Thing* (spring 1994) is another simple shift dress with an elaborate flourish, made from both figurative and literal recycling (page 109). Mizrahi worked with the New York charity We Can, which employed ex-convicts and the homeless to gather and flatten empty *Coca-Cola* cans. These were then shipped to the luxury sequin-maker Langlois-Martin in Paris, who cut the aluminum into quarter-size paillettes. These were then sent to India, where they were hand-embroidered onto silk. The finished garment returned to Mizrahi's New York showroom. Coke is an icon of American capitalism, and has been the subject of many artworks, such as Warhol's *Coca-Cola (3)*. Painted starkly in black and white at life size, Warhol's glass Coke bottle occupies the left-hand side of the canvas, its curves reminiscent of a female form. His interest in Coca-Cola, like his fascination with Campbell's soup, was in its ability to cut across class lines—a democratized idea of luxury that Mizrahi was also exploring. For only a few cents a very rich and a very poor person could enjoy the same, perfectly executed product.

As the Coca-Cola brand grew global, its image and name acquired further layers of meaning. The Chinese artist Ai Weiwei's *Han Dynasty Urn with Coca-Cola Logo*, made thirty years after *Coca-Cola (3)*, and at the same time as Mizrahi's dress, is a Han dynasty vessel with a Coca-Cola logo painted across its surface. This piece speaks to a rising tension in China in the 1990s between the desire to retain tradition and the call to modernize, as well as to Western capitalism's infiltration of the communist East, where borders both economic and cultural had been closed for centuries. Han dynasty (206 BCE–220 CE) ceramics were a very early example of Chinese industry, with vessels produced from molds in large

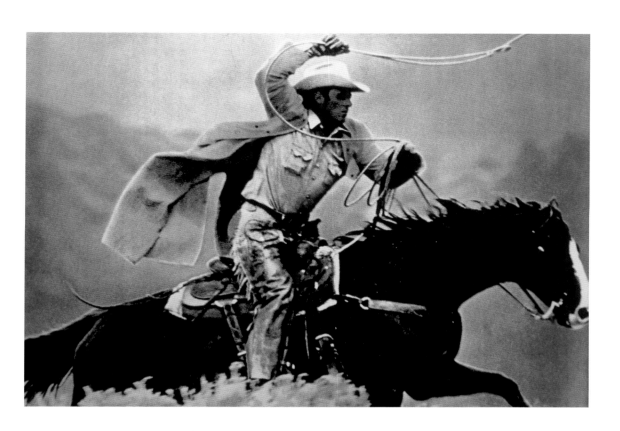

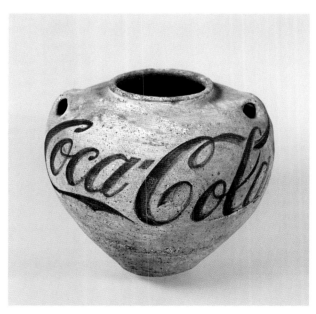

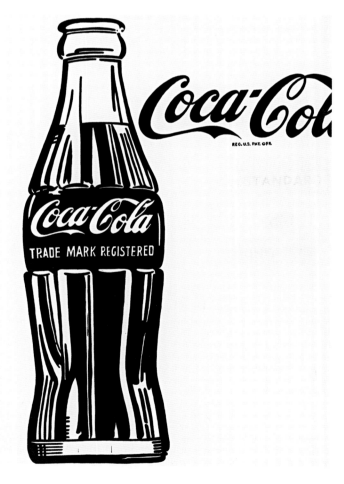

Richard Prince, Untitled (*Cowboy*), 1991–92, chromogenic print, 49 1/4 × 70 5/8 in. (125.1 × 179.4 cm), San Francisco Museum of Modern Art.

Ai Weiwei, *Han Dynasty Urn with Coca-Cola Logo*, 1994, Han dynasty vessel with paint, 10 × 11 × 11 in. (25.5 × 28 × 28 cm), Mary Boone Gallery, New York.

Andy Warhol, *Coca-Cola* (3), 1962, casein on cotton, 69 3/8 × 54 in. (176.2 × 137.2 cm), private collection.

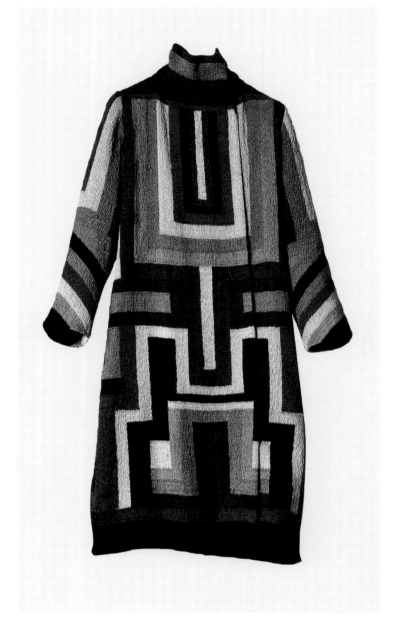

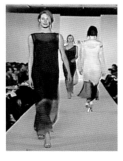 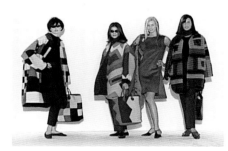

Top: Mark Rothko, Untitled, 1960–61, private collection.

Above left: Mizrahi's printed silk dress, influenced by the paintings of Rothko, spring 1997.

Above right: Mizrahi's fall 1995 *Zig Zag Green* and *Maze Red* rug coats, inspired by Sonia Terk Delaunay.

Right: Sonia Terk Delaunay, coat made for Gloria Swanson, 1923–24, private collection.

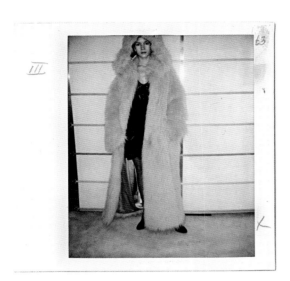

Patricia Velasquez in Mizrahi's design studio, wearing one of his iconic *Beast Coats* during a pre-runway fitting, fall 1994.

batches and stamped with their place of manufacture. Mizrahi titled his spring 1994 presentation Over Here, and the manufacturing path of *The Real Thing*, from New York to Paris to India to New York, was a precursor of the global outsourcing so common today. Like Ai, who merged a native Chinese object with a Western export, Mizrahi mixed high and low—skilled and unskilled workers, high-end fashion manufacturers and craftspeople—an approach that signaled an oncoming sea change within the luxury-goods market.

The play between high and low was grandly stated in the fall 1994 collection. Political correctness was in the air; responding to the Zeitgeist, Mizrahi produced hyperglam, cartoonishly hued fake furs called *Beast Coats*, in place of luxurious real fur. He threw these over itsy-bitsy, candy-colored sequined minidresses. But his most iconic look that year was a cotton T-shirt paired with a floor-length silk taffeta ball skirt, complete with crinoline and delicately tied bunting at the back. Mizrahi's take on formal wear harkened back to Warhol's love of Coca-Cola: if a $10 cotton T-shirt was just as glamorous as a $1,000 silk skirt, then anyone could experience luxury.

Mizrahi continued to push the boundaries between high and low season after season. Key to that project was his constant interweaving of underground culture and Park Avenue, his ease at merging high art with a Pop sensibility. For example, the boldly graphic, riotously colored textiles and paintings of the French abstract artist Sonia Delaunay inspired an oversized rug coat, and Mark Rothko's quietly composed, elegantly hued Color Field paintings served as impetus for a series of breezy silk slip dresses.

Despite critical and commercial success, Isaac Mizrahi New York closed in 1998, and the designer turned his attention to performance. In rapid succession he debuted his one-man cabaret, *Les MIZrahi*, appeared on the television series *Sex and the City*, and became a talk-show host with the premiere of *The Isaac Mizrahi Show* on Oprah Winfrey's Oxygen network (page 195). Just when the fashion world might have considered Isaac Mizrahi passé, he was becoming a household name. By 2002 he had quietly returned to fashion, designing small collections he dubbed "semi-couture," a nod to the fact that the term *haute couture* applies only to houses deemed eligible by the Chambre de Commerce et d'Industrie in Paris. These comprised made-to-measure garments in ultra-luxurious materials with expertly handcrafted finishes.

While in the midst of this refined activity, he struck a deal to design a line of clothing for the big-box retailer Target, launching that same year. Mizrahi's name brought symbolic value to IM for Target, which featured affordably made and inexpensively priced items. Alexander McQueen, Proenza Schouler, and Rodarte were subsequent collaborators, and the practice of working with top-of-the-line designers was adopted by other fast-fashion companies—H&M, for example, brought in Stella McCartney, Rei Kawakubo, and Alber Elbaz, among others. Mizrahi understood that the knowing chic signaled by affordability was just as appealing to his semi-couture clients as it was to Target shoppers, and in an intrepid move he styled his fall 2004 collection together with the IM for Target line. A well-designed $25 wool sweater came down the runway with hand-beaded and cashmere-embroidered lace pants, worn with inexpensive pointy-toe penny loafers (page 60). A high-collared, sleeveless black cotton Target dress was

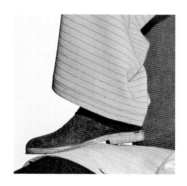

Linda Evangelista on the runway for Mizrahi, fall 1988.

Manolo Blahnik's 1988 hush puppies for Isaac Mizrahi came in many colors.

accessorized with dramatic white opera gloves, looking every stitch high end. Throughout the show untucked, slouchy cotton T-shirts and tanks were worn with one-of-a-kind ensembles. With this collection Mizrahi branded and stamped high/low fashion with his name. Master as he is of that concept, far more radical is his willful clashing together of worlds that are not supposed to blend.

Mizrahi has never fully accepted the rules of the fashion game. As this essay's title suggests, with uncompromising talent comes an unruly spirit. His process is closer to that of the artists who inspire him than it is to a typical designer's; design answers questions, but art asks them. Throughout his thirty-year career Mizrahi has challenged definitions of beauty and industry dogma. As economies and culture were becoming global and interconnected, black, Latino, and Asian models populated his runways; markers of many cultures appeared on the surfaces of his clothing; and he broke away from the largely inaccessible high-end luxury market, into the wildly accessible mass market. His current collection, Isaac Mizrahi Live!, is sold twice weekly on the QVC television network, by none other than Isaac Mizrahi himself. In addition to those appearances, he is a regular judge on Lifetime TV's *Project Runway All Stars*. Bringing his own history full circle, he has served as a guest judge on *RuPaul's Drag Race*, a competition that gives ballroom its own show on Logo TV—a network whose programming is aimed primarily at the LGBTQ community. Mizrahi has always understood that the underground, the marginalized, and even the inexpensive would eventually become iconic.

Once a fledgling downtown designer known mainly to New York's fashion insiders, and now a media mogul who appears in living rooms across the county, Mizrahi connects with people who may not have much interest in high fashion or high culture. In so doing he crosses a border closely policed by designers with similarly stellar credentials. Mizrahi has taken Andy Warhol's idea of Pop to its final conclusion. From the House of Mizrahi to La Casa de Mizrahi, from Irving Penn the fashion photographer to Penn the subject of fashion, Mizrahi opens up the potential for radical change—in micro and macro power structures, in the world of fashion and the world at large. Back in the fall of 1988, Mizrahi expertly choreographed his highly anticipated first runway show to hinge on one very simple event that effectively launched his career. He sent down look after look in acceptable shades of black, gray, and brown. At about the halfway mark Linda Evangelista, then unknown, walked out in a giant, hot-orange overcoat and bright-yellow wide-leg jumpsuit; a lipstick-red scarf was wrapped around her neck, and purple Manolo Blahnik desert boots were on her feet. As the *New York Times* noted, this was the moment when the applause started. The antithesis of a body-conscious ensemble on a beautiful girl, in crazily clashing color, was the most outrageous thing the crowd had ever seen.

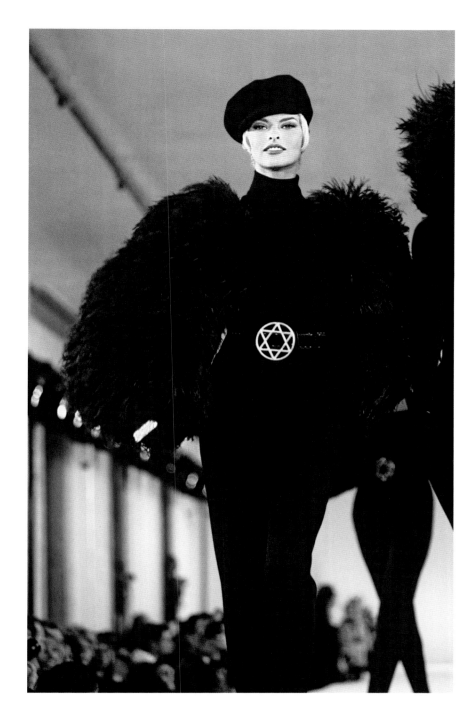

Linda Evangelista in feathered sleeves, stretch wool jersey pants, and the *Star of David* belt, fall 1991.

*Sex and the City*, 2002: Sarah Jessica Parker, above right, wears a Mizrahi *C* sweater; Isaac Mizrahi, right, plays himself.

# performance
# in three parts

Ulrich Lehmann

## Prelude

The potential for movement animates the work of the fashion designer. When cloth and cut envelop the wearer's form or create space around her, it is her moving body that renders particular the design. Raised arms extend the silhouette, steps expand the clothed space below the waist, a shimmy of the hips flares up soft fabrics, while hunched shoulders and the thrust of hands into pockets create large folds and creases. But movement is also a daily ritual: the hurried walk to the subway, running up or down steps, operating machinery (in the factory, office, studio), or stepping out after work—all are built into the outfits a wearer selects, constricting or liberating her posture and gestures. Movement transforms clothing from passive, designed object, imbued with the designer's or manufacturer's ideal, to a particular, subjective animation by the wearer, filling textile volumes with life.

If such action occurs in the public arena (or sometimes just before a mirror), movement becomes performance. The clothes accompany the playing of a conscious or unconscious role; they are meant to match the intention of the everyday performer. Here performance is not only a physical act but an anthropological fact: however transitory, the performance of class, gender, sexuality, or age is as much a momentous game of concealment and revelation as it is a mimesis of behavior observed in others. The performer of everyday rituals *is* not one thing or another but *becomes* it for a moment, before she changes into something else. She can act out almost simultaneously the roles of worker, interlocutor, friend, or aggressor, and the material that clothes her in such social performances adapts subtly to her intentions in the eyes of her beholders— willfully contradicting the impression she intends to convey or, conversely, as the saying goes, fitting her like a glove, creating a perfect synergy between organic subject and material object.

Performance is an essential aspect of human communication that combines with language and sign systems to form and maintain codes of expressive behavior. Because of their proximity to the body and their ability to illustrate and support role-play, clothes are a key element in the rituals of cultural performance. Through fabrics and fastenings, a liminal space is created around the wearer, which permits her a brief, specific awareness of the self as projection and reflection of the people and commodities surrounding her. The performance is composed of gestures and rituals that are often barely recognized. But the fact that the process is not entirely conscious only strengthens the claim that our acts and actions are self-determined.

Three interrelated meanings of performance within fashion uniquely come together in the work of the New York designer Isaac Mizrahi: first, the everyday performance of wearing particular clothes; second, the material designing of (dramatic) performance as connected to narratives and characterization; and third, the relationship between the public role assumed by the designer and the meaning of his design.

*Gong,* choreographed by Mark Morris, American Ballet Theatre, 2001, with Mizrahi costumes.

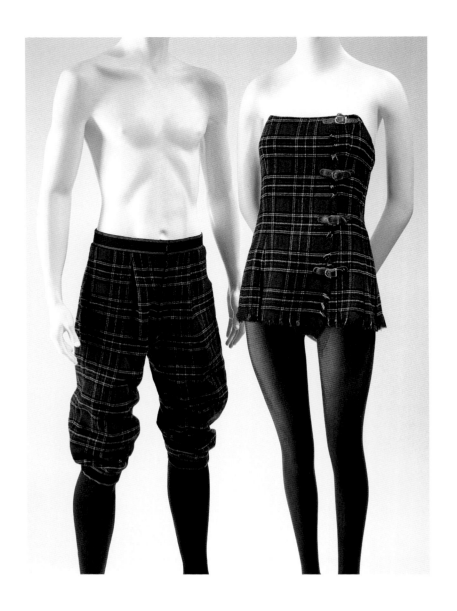

Hand-painted linen canvas *Colorfield* coat, lined in double-face alpaca bouclé with Baccarat crystal buttons (pages 92, 93), paired with Target handbag and capri jeans, fall 2004.

Costumes and sketch for Twyla Tharp's *Brief Fling*, American Ballet Theatre, 1990: Mizrahi repurposes tartan in the context of contemporary ballet.

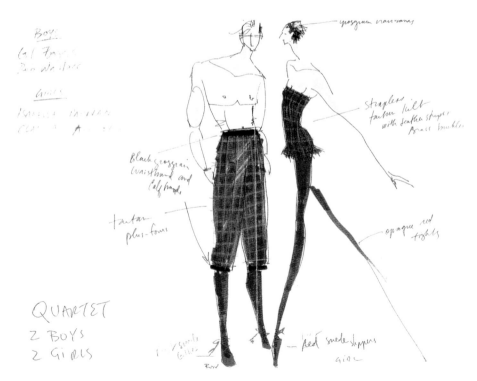

## 1: Woman in Movement

Mizrahi describes himself as "belonging to the school of people who cut things to move."[1] Though this statement might appear applicable to the work of most fashion designers, a reflexive relationship between wearer and clothing as part of the design process is far from self-evident. Obviously, a body has to be able to move within an outfit—and clothes may have to permit particular, dramatic types of movement as part of their characterization. But an in-built reflection on movement as determining the formal realization of an outfit for the wearer is comparatively rare. Partly this is due to the (mass) production methods used for most clothes, where flat-pattern cutting—now increasingly using lasers—and universal silhouettes and sizing are generalizing design, including the extent and type of movement accommodated. Casual wear and sportswear are cut from fabrics and in patterns that allow the widest possible range of contemporary, everyday movement, yet without making such movement expressive. In contrast, couture and custom-tailored garments have emphasized movements that appear exclusive to certain social rituals and environments (a "cocktail" dress or "ball" gown); in this way they claim subjective movement as part of the expressive quality of the design.

In keeping with his distinctive strategy of mixing custom with mass-produced garments, Mizrahi in 2004 sent skinny jeans down the runway together with a hand-painted *Colorfield* coat. The jeans were manufactured in stretch denim by the discount retailer Target—with whom Mizrahi had a contract—while the coat was tailored from stiff canvas with expressive painterly effects along the seam lines and custom-made Baccarat crystal buttons. The pliable cotton twill of the jeans clung to the wearer's lower body and emphasized selective movements, while the squared-off shape of the heavy coat rendered each gesture deliberate, even dramatic, through its weight, articulated surface, and sound. Casual movement and subjective expression—the incidental drama of the everyday—are directed by Mizrahi to heighten awareness of contrasting performances: the casually neglected symbolism of the jeans versus the deliberate look of a couture study in toilelike canvas.

Something similar occurred in 1994, when Mizrahi combined a gray sweatshirt with a Loden jacket and an elaborate silk taffeta skirt (page 69). Here the customary shapes of the upper garments contrasted with the exclusivity of their fabrics: the Loden jacket as a working staple of Alpine peasants was tailored from the finest wool felt, while the fleece of the sweatshirt came not in brushed cotton but in two-ply merino wool. For the skirt the principle was reversed, so that the expensive and expansive flowing silk was patterned in a plain cheesecloth-check and slubbed to give the textile surface a purposeful appearance of imperfection. The deliberate mix of what is perceived as "casual" and what is "elegant" encapsulates a playful up-and-down movement between hierarchies of dress. This strategy is famously employed in Mizrahi's use of tartan, taking the general pattern and cut of the wrap-around kilt and channeling them through sophisticated tailoring into, for instance, a fitted strapless dress made from cashmere flannel (page 79).

When the articulating of movement for and in clothes presents not merely a stylistic trope but a *leitmotif* for the designer, the gestures and posture of the

body within clothes become generalized. They turn from individual, subjective moves into components of social and cultural movements, in which the personal narrative of the wearer can become a paradigm for principles of behavior or perception. The meaning of subjective sartorial expression for general social movement is determined as much by the language of its design as by the language chosen for its communication. This becomes significant for the way in which the three types of performance relate to each other within Mizrahi's work.

In his fashion designs Mizrahi uses performance as a bridge between mass-produced fashion and personal articulation. He shares with some other designers the belief that a highly individualized style or an esoteric dress is not fashion; fashion emerges from social communication within a group—the interplay through which new fashions are accepted and past ones rejected. Significantly, for Mizrahi this personalization of performance becomes a narrative: the story of how something produced in a garment factory and sold in a shop becomes momentarily part of the wearer. Mizrahi respects not the codified personalization within high fashion but the act of personalizing through narrative action: the capacity of a particular dress, coat, or bag to tell of a remarkable moment during a daily routine or convey the dramatic snippet in an otherwise ordinary life story. Such a narrative becomes absorbed into the characterization of the wearer, so that a tale can be seen as emblematic for her personal and social relationships.

In staged performances, narrative and characterization are combined demonstratively through costumes. Emotions, status, rank, or pathologies are communicated through fabrics, colors, shapes, and insignia, and these assist the beholder to recognize key points in the story and dramatic relations between people. For designers the shift from narratives in mass-produced fashion to costumes for a staged performance often involves an exaggeration, a heightening of details so that individual characters or stories take on extreme, easily recognizable visual form. In 1997 Mizrahi designed the costumes for Mark Morris's production of Jean-Philippe Rameau's 1745 opera *Platée*, one of the rare comic operas of the French Baroque. Morris toyed with the established formal unity and compositional patterns: historical research on the use of ballet in the operas of the early eighteenth century led him to expose the performative aspect of *Platée*'s narrative—from the prologue announcing a play within a play to the deceptive roles taken up by gods and muses to the convention of casting a male high tenor in travesty as the female title character.

Morris rendered the chorus as a corps de ballet, placing the ensemble singers in the orchestra pit while the dancers onstage evoked the lyrics through movement. Here, the language of the work (as narrative in the libretto as well as in Rameau's musical notation) was visualized directly as design through choreographic patterns and costumes. These simultaneously illustrated the opera's action and undermined it by revealing the plot as an elaborate exercise in disguise. Rameau himself was conscious of this game, deliberately positioning the opera as "comic," and asking the librettist to write the character of a fool as spokesperson for the composer himself.

Mizrahi's designs for *Platée* used the focus on playful disguise to visualize the idea of "performance" on multiple levels. He dressed the nymph Plataea as an alien frog with matching feet and horns, swathed in padded and printed

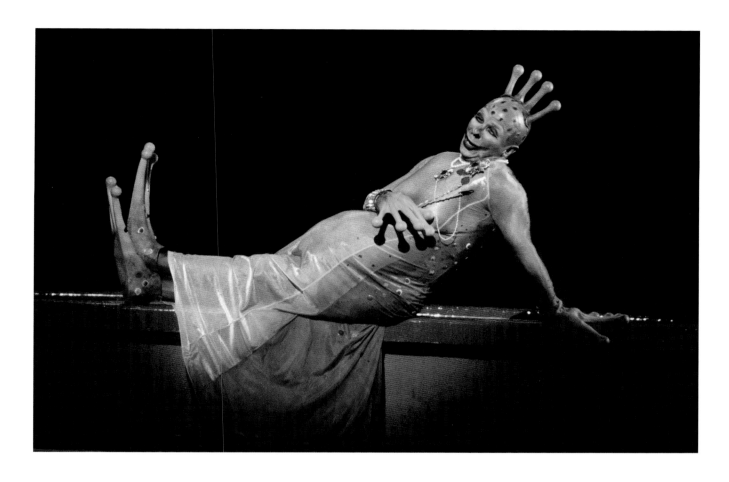

Mark Morris's production of Rameau's *Platée*, Royal Opera, 1997: Mizrahi notes of the title character, above: "I've dressed her like a dowager, with big freshwater pearls and a handbag. I have this fantasy that she's really Margaret Dumont with webbed feet."

Right: an ensemble scene.

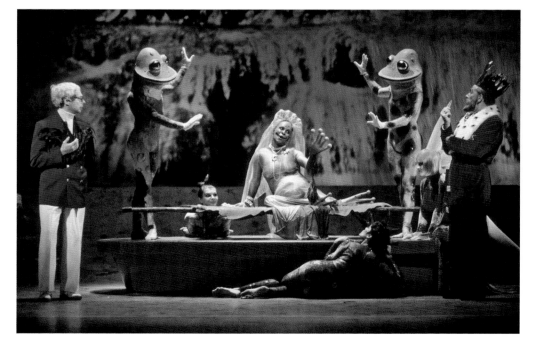

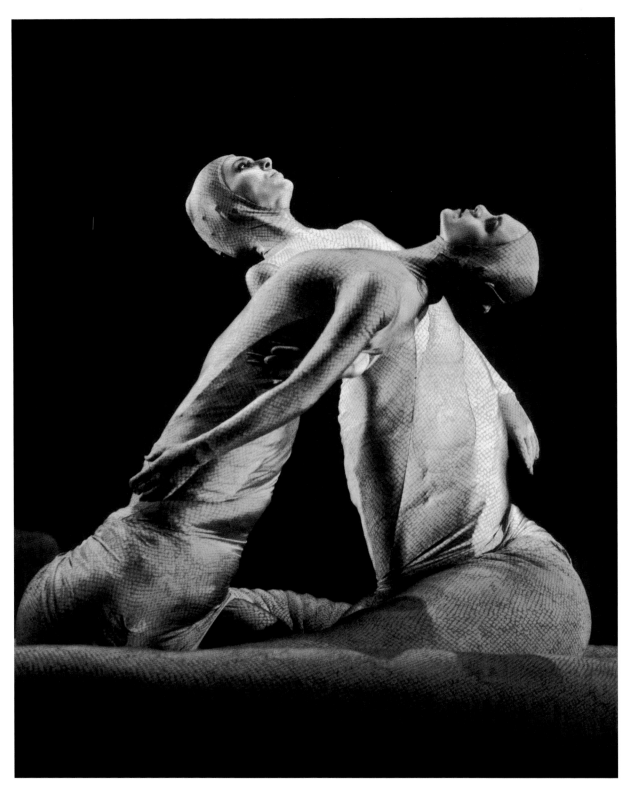

Above: snakes from *Platée*; right: sketch for the frog attendants.

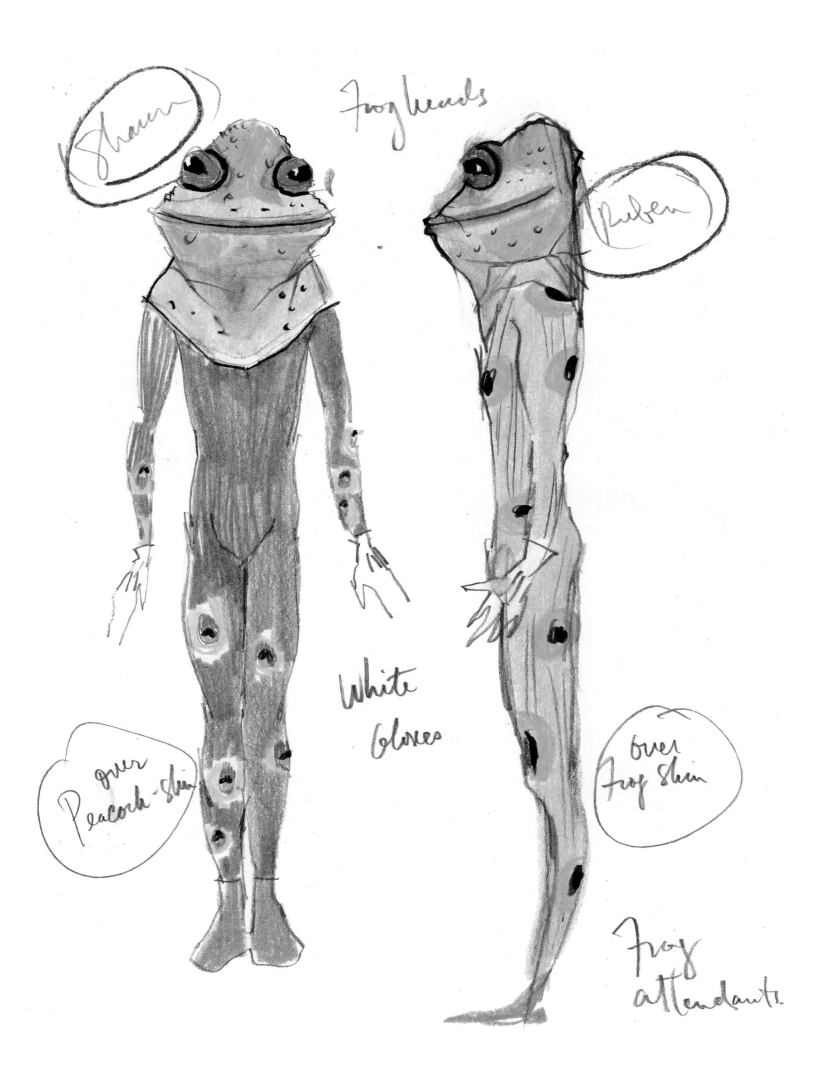

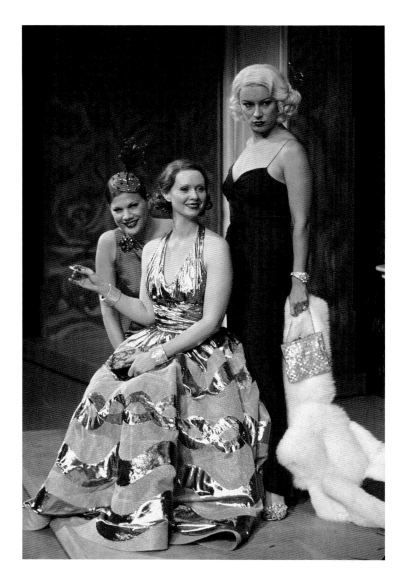

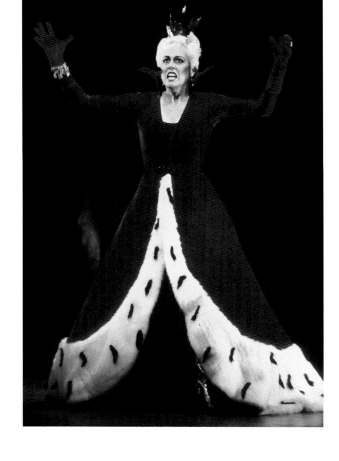

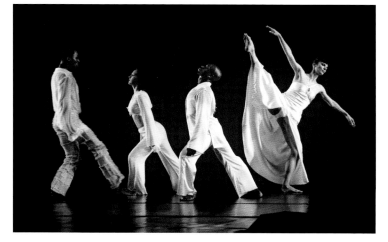

Clockwise from above:

A Mizrahi dress for Clare Boothe Luce's *The Women*, revived at the Roundabout Theatre, New York, 2001.

Juno, from *Platée*, 1997.

*I Don't Want to Love,* Mark Morris Dance Group, 1996, with costumes by Mizrahi.

nylon. The costume simultaneously restricted and liberated the physicality of the singer: on the one hand, it was cumbersome and awkward; on the other, he could use his voluptuous breasts and behind as props for exaggerated postures and could crouch and hop across the stage in a way quite unlike the stately manner of classical operatic performance. Other jarring juxtapositions abounded: the sequined and patterned jumpsuits of the dancers contrasted with the costumes of the choral singers, who appeared in the prologue as clichéd characters in a New York bar, while Jupiter and Juno were dressed up as king and queen in mock velvet and ermine dressing gowns. Here, the performance deliberately used familiar visual tropes to counteract the abstracted movements of the ballet dancers on the same stage. The final effect of these self-conscious strategies is to make the spectator aware of his or her own participation in the performance: the viewer assumes a role to enact the necessary social rituals required by the work of art. The opera's narrative concludes with the cruel exposure of the nymph, revealed as having been made the butt of an elaborate joke by the gods; her humiliation is designed to evoke moral reflection amidst the laughter.

In 2010 Mizrahi presented his fall/winter collection under the title Central Park Story Book. Once again narrative as performance became an expressive theme; models walked down a runway built to look like a cement sidewalk, in outfits with names that hovered between designed object and site of performance: *Parka Avenue, Vagrant Fairies* (page 206). Although these witticisms reflect Mizrahi's sense of humor and verbal gamesmanship, they are also crucial to the fusion of a language of design with a language of communication. The combination of fitted evening dress with large, fur-lined hood is a stylistic fusion; at the same time, it constructs a fictional narrative of its own—say, the story of an affluent Park Avenue resident who fortifies herself against urban angst through sportswear, or an imaginary creature (a New York fairy, a Baroque nymph) who sleeps rough on a park bench and wraps herself in a dress tailored from quilted performance fabrics. As the title Central Park Story Book suggests, for Mizrahi such narratives are a kind of fable. They are not embedded in any concrete reality, but inhabit an egalitarian social and artistic space in which styles mingle and social strata mix—the populist and the exclusive. He calls this imagined place "Central Park, the heart of New York City."[2] Mizrahi's typical emphasis on a particular gesture or social occasion is here heightened from the momentary drama of a runway show to a floating, freestanding fictional tale. The 2010 collection, and its presentation, are theatrical and dramatic expressions of the kind the designer cherishes.

The transitory passage among different social and geographic settings is a hallmark of Mizrahi's design. In fashion, that liminal space must be transferred from the design concept to the real practice of wearing. A person moving around Central Park at different times of day and in different weather flits across the confines of class and space. She is, thus, the embodiment of the possibility of disrupting such barriers. Dressed in Mizrahi, she conforms to—or rather, stays just ahead of—the style preferences of sets of people from these various spheres.[3] Performance, as in *Platée*, is here defined as the conscious enjoyment of the pretense that results from the act of dressing up or down.

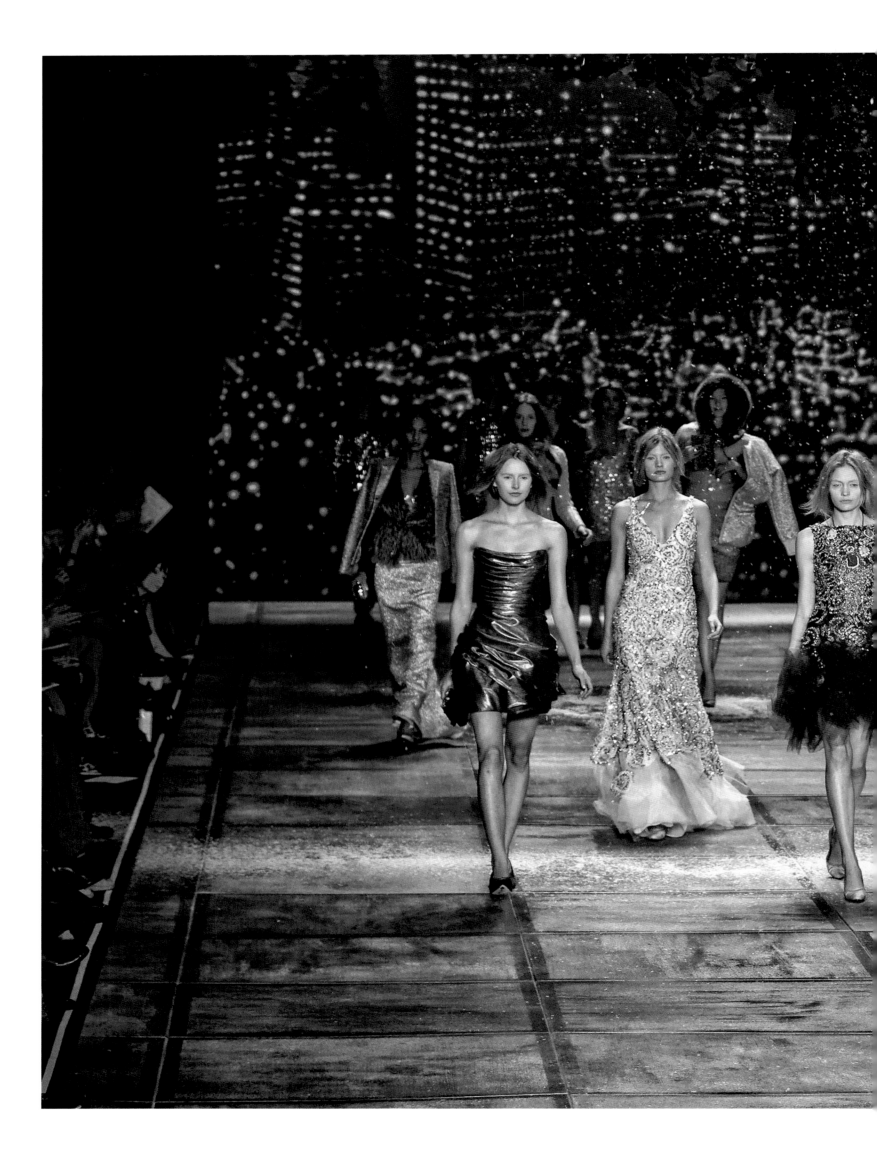

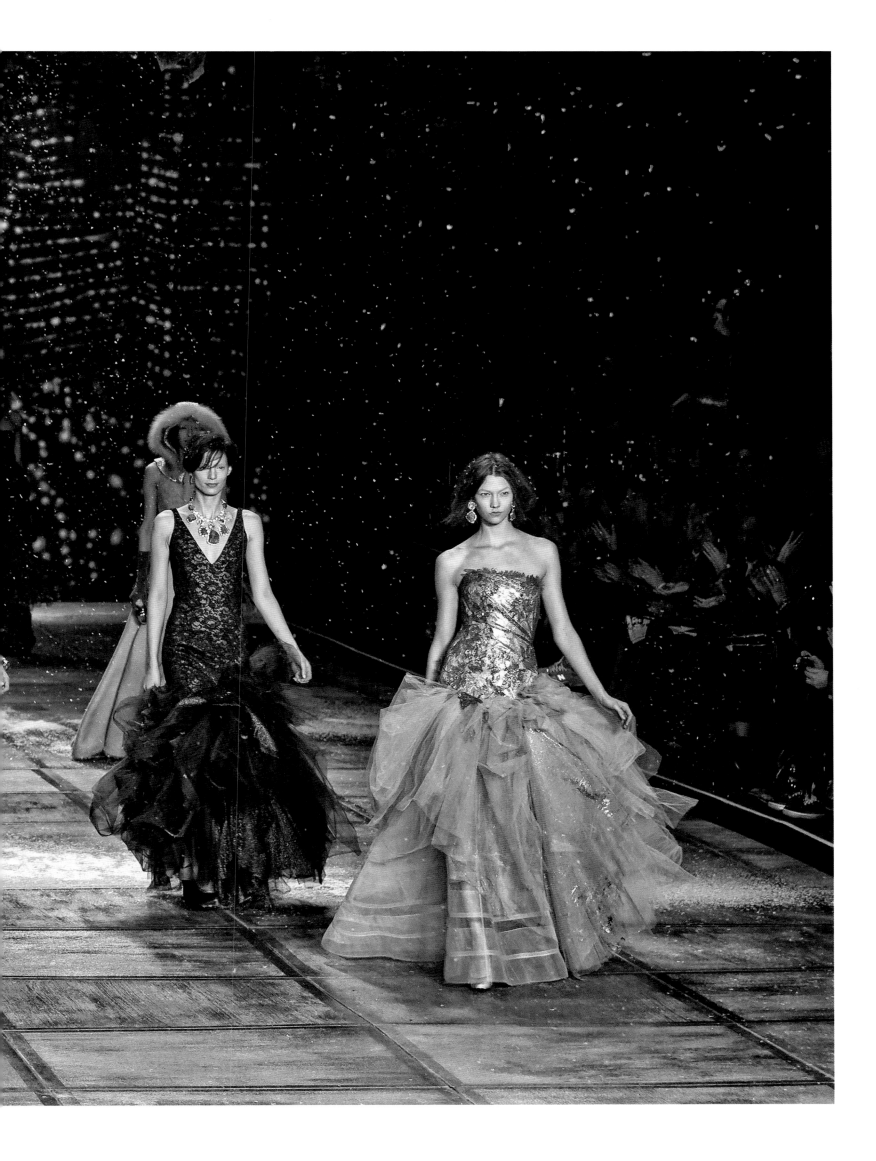

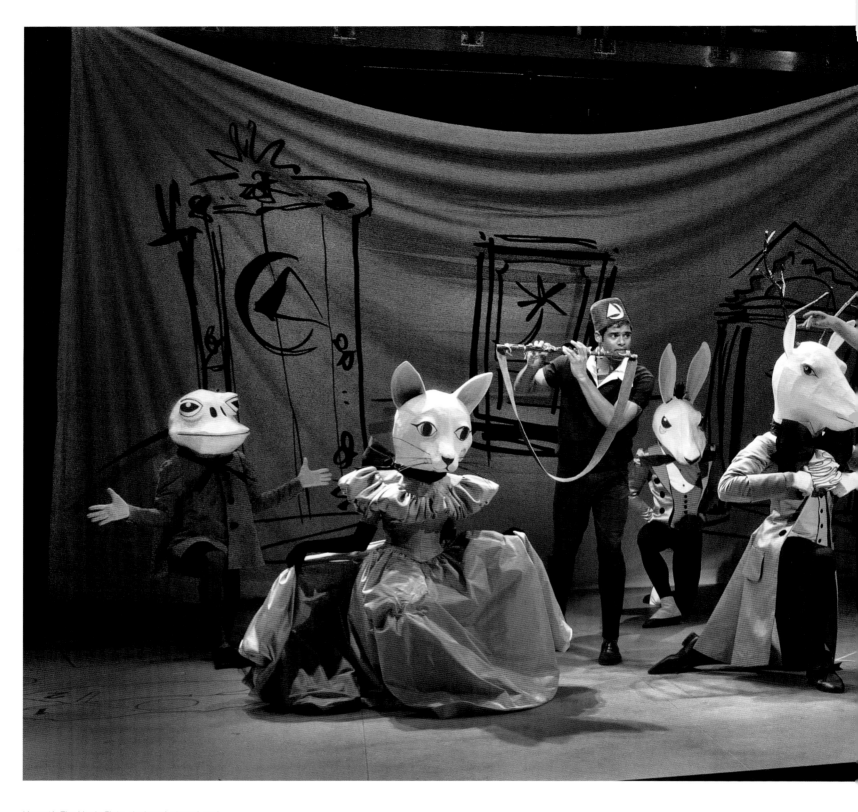

Mozart's *The Magic Flute*, designed, staged, and directed by Mizrahi, Opera Theatre of Saint Louis, 2014.

Previous page: Central Park Story Book, fall 2010 runway show, New York.

## 2: Staged Performances

Mark Morris maintains that Mizrahi's designs for his productions fall into two categories: in his operas they are a means of characterization and illustration of the narrative; in his ballets they are congenially abstract embodiments of musical and physical movement.[4] Morris excels in an artful blending of opera and ballet in ways that are both historically reflexive and aesthetically poignant. In his productions, the performance of song and the performance of dance are employed as structural, visual, and dramatic contrasts. So his description of his collaborator's work is perhaps a touch too formalistic, separating the designs too neatly into discrete categories. The costume does not exist in the abstract—it exists as part of the performance. Mizrahi's work does not need to be understood in either/or terms—narrative or antinarrative, illustrative or abstract. His distinctive talent, like Morris's, resides in the act of translation, the conversion of one idea or medium into another. They both revel in creating narratives from musical abstraction, representing notes as movement—whether danced or dramatized—and telling a tale through expressively animated clothes. The collaboration of Morris and Mizrahi differs qualitatively from other celebrated pairings of choreographer and designer—Rei Kawakubo with Merce Cunningham, for example, or Issey Miyake with William Forsythe. There, the spectator finds a fused formal abstraction, in which clothing patterns and choreographic patterns combine in deconstructing and reconstructing bodies in space. Instead, for Mizrahi and Morris the representational element is key. This commitment to story, or narrative, shows in their shared enthusiasm for Mozart's music, which has shaped their collaborations and has led Mizrahi to stage his own holistic production of *The Magic Flute*.

Mozart's melodies and perceptive musical structures conceal tonal complexities as well as psychological depth. As such, he stands as a reference point: representation does not imply simple narrative realism or mere illustration; it opens up a creative space in which performance directs a reading proper of design. A representational performance in clothing is tricky, as it suggests that form should follow function for the wearer. Yet clothes abstract the body and thereby harmonize it with social and aesthetic ideals. So when costumes represent performance they continue to represent the body of the wearer as much as the way in which the choreographer wants a body to perform in a given scene. A harmony needs to be found between the performance that is permitted by the clothing and the performance designed for the dancer or singer.

In Mizrahi's production of *The Magic Flute* for the Opera Theatre of Saint Louis, performance is articulated in two ways. First, the narrative created by Mozart with his librettist, Emanuel Schikaneder, is set on a Hollywood soundstage of the 1950s, signaling the double face of performance as joyful immersion and knowing conceit. As the Queen of Night introduces herself by walking across the stage and up the stairs to a crossover gallery, the train of her dress extends to cover the entire path of her stately progress—the material expression of the long reach of absolutism (page 213). Sartorial splendor is turned beautifully into a sinister reminder of power; at the same time, the limit of power is alluded to in the queen's makeup, which turns her into Greta Garbo or Gloria Swanson in her final years.

Sketch for *The Magic Flute*, Opera Theatre of
Saint Louis, 2014.

PUSSY CAT

BUNNY

Second, performance reflects back onto itself. The *singspiel*'s arias and dialogues are mirrored by dance solos, creating parallels between the sung and spoken word and physical movement. In the same way, the costume designs establish a direct, immediate correspondence between the emotional expression of the performers and their bodies' visual and gestural expressions.

The Masonic principles that serve as underlying tenets of *The Magic Flute* are depicted ironically, as if the performance of historic ideals could now result only in pathos or parody. Mizrahi dresses the Masons of the Enlightenment—the torchbearers of freedom of expression—as modern-day Shriners; in this ironic mode, freedom means license to run around bedecked in red sport coats and fezzes. Even so, the Shriners still formally constitute the opera's choir, accompanying and commenting on the action; they are the conservative social bedrock of postwar North America that provides a normative context against which the expressive performance of the two main characters can rally.

The working relationship of Mizrahi and Morris strikes a balance between the designer's autonomy to create patterns and silhouettes and the director and choreographer's mandate to determine and interpret the content and form of the overall production. Their working method is illustrative: an initial idea for a piece is formed and both men engage in independent research and develop prototype designs, which they then review in a communicative and mutual editing process. The openness of the process is effective because the two share certain principles: spectators must be able to discern and follow a narrative (which does not need to be linear); measure, balance, and symmetry are key compositional tools; a smart, self-reflexive sense of humor must animate the work; and functionality, the ability of the body to move constructively with and in the designs—costume and set—has to be maintained.

Two ballets that frame their collaboration across a dozen years reveal how these principles are applied: *Gong* and *Beaux*. *Gong*, with fifteen male and female dancers, uses the presence and absence of music and light as a conceptual device across which stretch movement and costumes. Orchestrated sections with Colin McPhee's gamelan-inspired music and brilliant illumination are set in counterpoint to sparsely lit duets, danced in silence. Mizrahi produced a kaleidoscopic selection of outfits whose primary hues are animated by the shifts in light levels (page 196). The women wear simplified, flat tutus with petticoated and pleated construction; they extend stiffly, seemingly inanimate, like ironic signifiers of "ballet." Their rigid shape requires the men to circumnavigate the women in a calculated ratio of physical proximity. Together, the dancers form a palette in which each body is coded as a tonal value within a composition that dissolves and coalesces according to the choreographer's painterly gestures. At the same time, each body, dressed up in a single color tone, is displayed as an independent element of a composition in which each sound and movement has equal value. The work takes on a serial, conceptual character that is usually underplayed in Morris's and Mizrahi's work.

*Beaux* has an all-male cast of nine dancers, performing to Neoclassical scores by Bohuslav Martinů. Mizrahi's color coding here comprises a camouflage pattern in brilliant hues (pink, yellow, orange), so that performance is visually transposed from military maneuver to balletic movement. The camouflage pattern extends

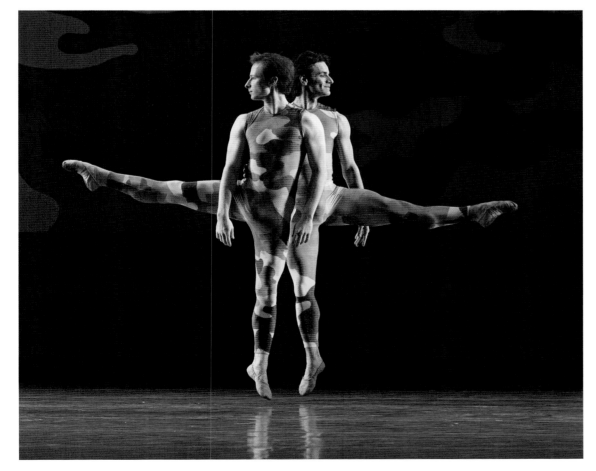

The Queen of Night in Mizrahi's staging of *The Magic Flute*, with her stage-filling train, Opera Theatre of Saint Louis, 2014.

*Beaux*, choreographed by Mark Morris, San Francisco Ballet, 2012.

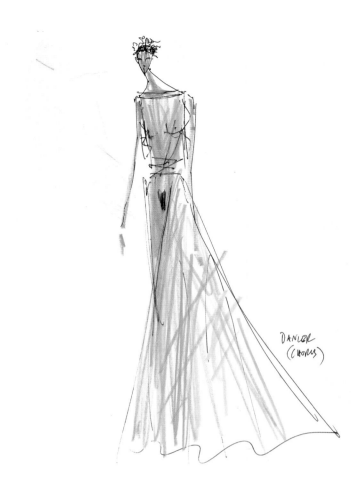

Costumes and sketch for George Frideric
Handel's *Acis and Galatea*, Mark Morris Dance
Group, 2014.

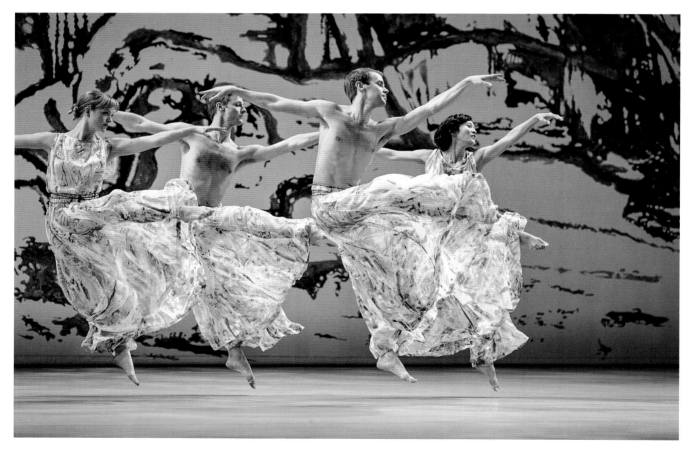

to the large panel that serves as backdrop. Similar to the costumes for *Gong*, the unitards in *Beaux* tightly envelop every moving limb and leaping body. By effacing the space between skin and nylon surface and rendering the physical surface a colored abstraction, the body is defined *as performing*, in constant movement, so that character and psychology are expressed through physicality only. In dance, communication is first and foremost physical, and in *Beaux* it is conceived as a set of witty conversations among men. But these are not quite as unconcerned, goofy, and loose-limbed as their staging suggests. A keen sense of role-play screens an underlying struggle to stay together as an ensemble, to demonstrate patterns of belonging—both in formal, physical movement and in the effort to express intimacy. So the candy-colored costumes both camouflage and define the actual body they encase, dampening gaiety by emphasizing physical effort, which in turn has to be performed as confidently and relaxedly as possible.

Mizrahi has cited Fred Astaire and George Balanchine as exemplars of how effortless performance results from the meticulous study and practice of technique—and this extends, by implication, from choreography to clothing design.[5] But the masking of effort is of course self-reflexive in that it consciously permits the struggle to be legible beneath the surface and to hint at not merely technical but emotional challenges.

When Morris polemically states, "If you can't dance in them, they're not costumes," he echoes Mizrahi's credo about creating clothes for the woman in motion.[6] Obviously, different types of wearers can animate all kinds of clothing through a wide range of movements, and the material potential of fabrics and cuts for performance (or even comfort) is very relative—even in dance. But the notion that clothes need to accommodate even a very artificial, choreographed sequence of steps and gestures is analogous to Mizrahi's notion that fashion designs accommodate social movement. His clothes suggest carefully choreographed transgression, where irony holds social challenge in check. In his fashions such irony is demonstrated through odd pairings of stylistic elements or fabrics and textures to provide unaccustomed effects, which exaggerate dramatic contrasts. The clothes seem to say, "If you can't wear us, we're not fashion," but substitute "wear" with "perform" and you may get closer to the truth.

## 3: The Designer as Performer

At the start of Mizrahi's biographical film *Unzipped*, the designer describes his working process: "I get inspired, somehow, somewhere; from the ballet, from dance, from a movie, from something. I get this gesture in my head. . . . And from there I just do all these millions of sketches about that one gesture."[7] The centrality of performance—a mobile gesture, not a static silhouette, shape, or posture—is indicative of Mizrahi's understanding of fashion. The basis of design is the representation of the movement of a hand or a walk, and that representation is tested out repeatedly on models sashaying through the studio—ideal preludes to the later use of the clothes in everyday contexts.

Mizrahi is unique as a fashion designer-*cum*-trained performer. He is an alumnus of the High School of Performing Arts; early on he appeared in *Fame*, the movie about the school; he is the protagonist of the multilayered *Unzipped*, in which the cliché of the fashion designer is exposed as a self-conscious, ironic

At nineteen, soon after graduating from New York City's High School of Performing Arts, Mizrahi had a bit part in the 1980 movie *Fame*, a fictionalized account of life at the school. In a brief scene, he auditions for the part of Touchstone, the Shakespearean clown, wearing a clown hat and carrying a clown puppet, both of which he made.

performance; and he has starred in his own solo cabaret, *Les MIZrahi*, in which he visualizes social anecdotes through rapidly sketched dress designs, accompanied by satirical banter. Any intelligent artist will incorporate self-reflection into his work, but to demonstrate awareness of the self through public performance generates a different type of reception. The wearer of Mizrahi's designs, whether customer or dancer, is primed to see the performative quality of designs as reflected in the elaborate performances of their creator—the narrative of having to enact the clothes is more or less woven into their very fabric.

The designer as a designed character has a long tradition in fashion. A direct historical lineage can be traced from the pioneering couturier Charles Frederick Worth, who played the tormented artist to excess, to Hubert de Givenchy, who cultivated the character of a white-coated craftsman, and Coco Chanel, who assumed the role of reclusive oracle of fashion, to the outré personage of John Galliano, who transgressively embodied the theme of each runway show, including seasonal hairstyle and makeup, and Mizrahi, who simultaneously laid bare and mythologized the fashion designer's working process in *Unzipped*. ("All I wanna do is fur pants; but I know, like, if I do them I get stoned off of Seventh Avenue. . . . It's about women not wanting to look like cows, I guess. . . . And in fact, there is something charming about cows.") Mizrahi repeatedly mixes the fictional, the satirical, and the self-reflexive—in the film; in his appearances on the TV series *Sex and the City*, *Project Runway*, and *Ugly Betty*; and in his work on the program *Isaac Mizrahi Live!* for QVC. He is *homo performans*. In the true spirit of late modernism, he is exceedingly aware of how to play the player, how to reveal that he knows he is performing while at the same time using the performance to expose proclivities and anxieties beneath the work—even when these, in turn, appear to be private, intimate, confessional moments. For example, the filmed dialogues with his mother in *Unzipped*, or the chat-show–style questions to Madonna, can be understood thus: they enact disclosure.

Like the narrative in *Platée*, these performances are comical as well as searching. Mizrahi's fashion plays are also morality plays. Errors are what animate the wearer as performer; she or he struggles against them and thereby makes them all the more obvious. Likewise, Mizrahi prizes subtle faults in his work as revealing necessary fault lines. Apparent mistakes in performing become creative choices. He once observed a dancer who leaned forward and let her shoulders droop too much during a fitting, so that her dress fell off. He used this posture as the starting point for the design of a backless sling-back dress (page 111), whose straps loop around the shoulders so that it looks as if it has fallen out of shape and is about to slide off the wearer. Held to the body only by the straps behind the arm, the design achieves formal distinction while the back gains an unexpected degree of freedom to move, and exposure. The habitual relation between body and clothes is changed to heighten an awareness of movement as the basis for a new aesthetic idea.

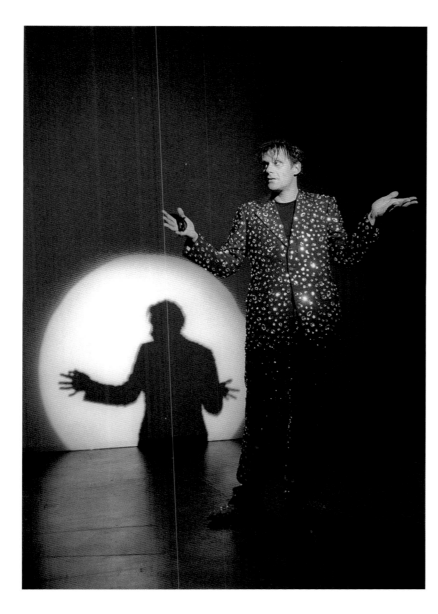

Mizrahi in *Les MIZrahi*, 2000.

Mizrahi on *Project Runway All Stars* with his fellow judge Georgina Chapman, 2015.

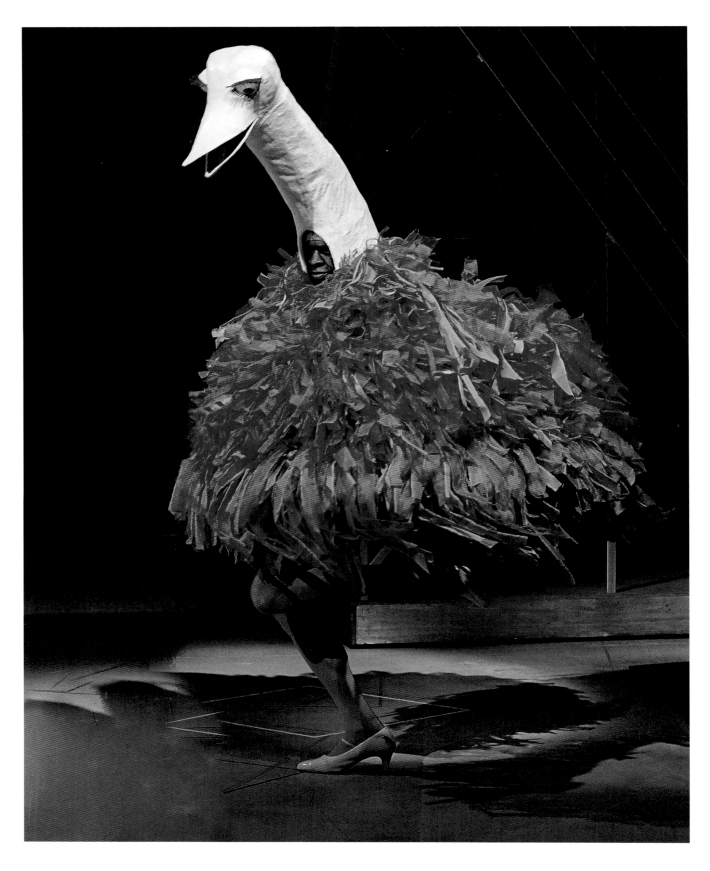

The ostrich costume from *The Magic Flute*,
worn by a male dancer in pumps, deliberately
constricts movement.

## Coda

The relationship between performance and fashion in Isaac Mizrahi's work is revealed in myriad details. It remains to ask more generally what the ontological function of performance is for a person. What does it mean for the consciousness of *being*? What happens when the wearer understands that she *is* not, but is always *becoming*—perhaps in both senses of the word? It is a revelation to discover that in clothing one's body, one turns momentarily into something or somebody, rather than existing with a single identity all the time. The wearer performs her or his gender, class, age, and ethnicity, and the choice of performance at any given point alters one's perception of oneself. Surely this leads not to more comprehension or self-awareness but to irritation and neurosis. Mustn't one—wearer, dancer, fashion victim—be very self-aware and grounded to carry off the wearing of clothes? Here, it is important to understand fashion not as a costume or disguise. Neither the everyday, routine performance nor the appearance onstage is a masquerade. Performing in and through fashion implies drama and narrative to communicate a tale that the wearer would like to tell about herself. Mizrahi, the designer and the consummate performer, provides breezy but considered directions for such tales, and he fits the wearer with the necessary clothes and accessories, so that she can engage fully with her intended roles.

In 1992 Mizrahi's friend, the comedian Sandra Bernhard, was presenter at a men's fashion award show. Mizrahi had designed a flamenco dress for her to aid a dramatic entrance onto the stage, marking her as a fully paid-up performer in the fashion play. But the dress-as-costume was so tight that she was hardly able to descend and ascend the steps to the podium. So she publicly commandeered a troupe of men to carry her on and offstage each time. The fault line in the design raised its value as dramatic piece; an errant performance revealed a secondary one; and Mizrahi's not-so-subtle "mistake" made the work. The dress was ostensibly not "cut to move" but to perform a narrative in keeping with the character of its wearer. Enactment finds the function of both fashion design and its communication, so that a message about clothes and our perception of them—aptly transitory—can be transmitted best in and through performance.

### NOTES

1. Unless otherwise noted, all quotations by Isaac Mizrahi are from an interview with the author in New York, September 25, 2014.

2. Mizrahi described the collection in February 2010: "The fable begins with a kind of Cinderella tale of girls trying on glass slippers, glass coats, glass skirts, and it ends with evening clothes that might be confused with camping gear"; quoted by Samantha Critchell for Associated Press, February 18, 2010.

3. Mizrahi let fake snow fall during the runway show in February 2010 to point to the functionality of his fabrics and design details.

4. Mark Morris's statements are from an interview with the author, October 9, 2014.

5. Conversation with the author, September 25, 2014.

6. Conversation with the author, October 9, 2014.

7. Douglas Keeve (director), Isaac Mizrahi, *Unzipped*, 1995.

# collection checklist

**[33] WINGS**
Silk peau de soie, spa 1989

"This shouldn't work. But I was myopic about figuring out the technology to do it." Mizrahi's meditation on the female form is engineered, with just the right amount of elastic, to stay on the body, albeit somewhat precariously. This risqué offering was produced for his first spa collection—Mizrahi's name for his resort collections.

**[34, 35] TIE-UP V-NECK**
Triple-silk crepe gown, spring 1998

"Invention is coming up with something that is so elemental it's as if it's always been there." Mizrahi took inspiration from classical Greek statuary, wrapping a slender, deeply plunging V-necked tunic with silk cords that wind and tie to create a sheath. "This is the simplest dress in the world."

**[36, 37] SEA ISLAND**
Sea Island cotton apron-shirtwaist, spring 1990

"I was inspired by aprons, the idea of tying around the waist." The body is the defining point for a flat pattern that when wrapped and tied becomes a dress, executed in shrimp pink. "It's about a positive shape that creates a negative shape with what's left."

**[38] SEA ISLAND**
Sea Island cotton apron-shirtwaist, spring 1990

**[39] SKETCH FOR GRAND PUPA**
spring 2009

**[40, 41] GRAND PUPA**
Butterfly-printed silk gazar pocket-gown, spring 2009

For spring 2009, Mizrahi riffed on the theme of insects in a runway show that was choreographed to a symphony of insect sounds commissioned from Nico Muhly. The hand-painted *Grand Pupa* dress has a loose cocoon shape, affirming Mizrahi's conviction that clothes don't have to be corseted and uncomfortable to be elegant.

**[42, 43] GAZAR DUFFLE**
Double-face silk gazar coat with leather and horn fasteners, spring 1989

The classic duffle coat is made from coarse, heavy wool; its chunky toggle fasteners are designed to be easily buttoned while wearing gloves. Mizrahi insouciantly upends the formula in a variant in diaphanous gazar that can be worn as an elegant evening coat.

**[45] EXPLODED TULIP**
Printed silk crepe dress, spring 1992

**[46, 47] EXPLODED ROSE**
Printed wool trousers and jacket, spring 1992

Mizrahi pays homage to the fashion photographer Irving Penn, one of his heroes, with the Tulip and Rose series. He commissioned photographs in the style of Penn's celebrated images of flowers and printed them in large scale. On simply tailored dresses and suits, the flowers were decidedly "not sexualized like the giant flowers of O'Keeffe or Mapplethorpe" and the designs "did not get in the way of the print."

**[48] SKETCH FOR CATERPILLAR SWEATSHIRT**
spring 1989

**[49] SKETCH FOR DRIP-DRY COCKTAIL**
spring 1991

**[50, 51] DESERT STORM**
Silk georgette camouflage-printed halter dress, fall 1991

As Desert Storm, the 1990–91 US war in the Persian Gulf, was drawing to a conclusion, Mizrahi created the *Desert Storm* dress. It was not meant as overt commentary, but a transgression of both the politics of the moment and the politics of textile design. "I was enthralled that a new camo had to be created for the desert and thought it was ironically beautiful."

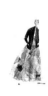

**[52] SKETCH FOR HOLOGRAM LEAVES**
fall 2008

**[53] HOLOGRAM LEAVES**
Leaf-print embroidered tulle, plaid silk taffeta, and re-embroidered lace dress, fall 2008

A gold-and-orange plaid taffeta petticoat is the backdrop for a layer of diaphanous tulle appliquéd with apples, pears, roses, and leaves, each printed from a photograph and individually attached. "It's a joke about autumn, like a sophisticated version of a terrible fall-themed hand towel you might find at a resort in New Jersey." The raised Empire waist is a nod to Neoclassicism, the "Jane Austen-esque dandy period—my favorite in fashion."

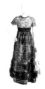

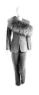

## [54] HOLOGRAM LEAVES
Leaf-print embroidered tulle, plaid silk taffeta, and re-embroidered lace dress, fall 2008

## [56, 57] MOTH SUIT
Handwoven ombré cashmere suit with coyote stole, fall 1990

Mizrahi went to Agnona, an Italian fabricator, to have this ombré cashmere custom woven. This suit intentionally includes the widest possible range of colors of natural wool. "At the factory, I practically picked out the sheep!" The separate fur trim, a versatile piece on its own, is a precursor to the fur donut Mizrahi introduced a few years later.

## [58, 59] CAMEL-HAIR JUMP-COAT
Camel hair and coyote, fall 1989

## [60, 61] HIGH AND LOW
Wool IM for Target sweater, lace pants embroidered with cashmere and rhinestones, trapper hat, fall 2004

"The right sweater, one that fits and serves you well, is as much a luxury as anything couture. Luxury should be integrated. Even the fanciest people want things that are easy."

## [62] WRAP COATDRESS
Stretch wool sharkskin coatdress, spring 1998

## [63] SACK PANTS
Canvas, spring 1989

*Sack Pants* are a big rectangular sack with legs. The waist is created only when they are belted, so that they fit any body type and the human figure gives structure to the design—a recurring theme in the Mizrahi repertoire. Mizrahi originally created this design for himself and for a time wore these trousers, in blue canvas, as his daily uniform.

## [64, 65] X-RAY
Cashmere and acetate coat, fall 2010

This inside-out cashmere coat reveals its infrastructure as if it were a work of experimental architecture—perhaps the Centre Pompidou in Paris, whose mechanical systems are on the exterior. Stitching and hymo canvas—used to give structure to a garment—are on the outside. Mizrahi protects the exposed workings with a vinyl shell, as if the coat were preserved under glass. "Sometimes the most beautiful thing is the raw construction."

## [66] LOUIS VUITTON CENTENARY CELEBRATION TOTE BAG
Acetate trimmed with saddle leather, 1996

## [67] DRESS-UP RAIN BOOTIES
Tulle, acetate, plastic, fall 2010

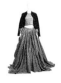

## [68, 69] DISTRICT-CHECK BALL GOWN
Loden-cloth Tyrolean jacket, merino fleece sweatshirt, district-check slubbed-silk taffeta skirt, fall 1994

A precursor to the High/Low collection of 2004, this ensemble cross-pollinates genres. The classic Loden jacket, a staple of Alpine peasants, is tailored from fine wool felt and worn over a sweatshirt of luxurious two-ply merino wool. The elaborate silk taffeta skirt is patterned in a menswear-inspired district check to give the textile an informal appearance.

## [70, 71] STRAPHANGER
Brown Watch plaid raincoat with tortoiseshell sequin button-in lining, tortoiseshell sequin dress, fall 1989

Mizrahi pays homage to the stealth luxury of Norman Norell's late-fifties *Subway* coat and dress, an unassuming coat lined with gold sequins over a sequined dress. Mizrahi substitutes large tortoiseshell disks for Norell's gold sequins.

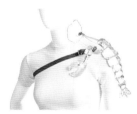

## [72, 73] LOBSTER EPAULET
Lucite with leather strap, spring 2010

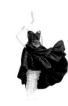

## [74, 75] TOOLED BUSTIER-BELT
Hand-tooled saddle-leather bustier-belt, silk and wool faille matelassé skirt, cotton lawn pantaloons, spring 1992

Mizrahi sought the skills of a saddler in Wyoming to hand-tool this bustier-belt—another riff on the concept seen in his black version (page 165). Here, it is paired with a flounced skirt and white ruffled pantaloons straight out of the 1939 Marlene Dietrich Western *Destry Rides Again*.

**[76] SKETCH FOR LONG TUTU WITH FAKE-FUR JACKET**
Unzipped collection, fall 1994

**[77] TOOLED AND JEWELED HEADBAND**
Leather and rhinestone headband, spring 1992

**[82] SKETCH FOR STRAPLESS KILT DRESS AND GINGHAM TAFFETA PARK-ETTE**
fall 1989

**[83] SKETCH FOR A TARGET SUIT WITH CUSTOM LEATHER GLOVES WITH FOX-FUR CUFFS**
High/Low collection, fall 2004

**[90, 91] BLACKBIRD, STAR OF DAVID BELT**
Ostrich-feather hood, stretch wool jersey bodysuit, stretch wool jersey pants, suede-and-brass belt, fall 1991

Mizrahi irreverently puts symbols to work as part of the religious, political, and cultural mash-up of the fall 1991 collection. "If crosses are everywhere, why not make the Star of David ubiquitous too? Just another thing?"

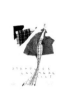

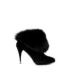
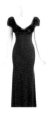

**[78] SKETCH FOR EXTREME KILT**
fall 1989

**[79] EXTREME KILT**
Stewart plaid cashmere flannel gown, fall 1989

"Everyone I admire has done a tartan collection: Perry Ellis, Ralph Lauren, Vivienne Westwood. I tried to do this without taking it too seriously." Mizrahi's visual pun converts the Scottish kilt into a strapless floor-length gown, with buckles repeated up to the bustline. Mizrahi later created a version of the dress as costumes for Twyla Tharp's dance *Brief Fling* (page 198).

**[84] BOOTIE-MULES**
Suede, fox, fall 2007

**[85] MINKY**
Jersey gown with recycled mink top, fall 1997

A clean-lined, unostentatious jersey dress is made glamorous with the addition of a mink bodice. The combination is elegant yet demure, a technique Mizrahi learned from designers like Orry-Kelly, who dressed leading ladies of classic Hollywood movies. The lesson: "Don't make it shiny unless it's for a showgirl! I made this at a moment when fur and fur trim were beginning to look matronly. One way I thought to remedy this was to use old furs. I only used recycled furs that season."

**[92, 93] COLORFIELD**
Hand-painted linen canvas coat lined in double-face alpaca bouclé with custom-made engraved Baccarat crystal buttons, fall 2004

For his landmark High/Low collection of 2004, Mizrahi presented his luxury made-to-order designs with items from his mass-market line IM for Target. The canvas coat is hand-painted in a nighttime forest green with a double-face alpaca bouclé lining and custom crystal buttons engraved with the designer's name (the first time Baccarat had made buttons). On the runway the coat was worn with his Target capri jeans.

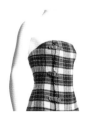

**[80] EXTREME KILT**
Stewart plaid cashmere flannel gown, fall 1989

**[81] TARTAN ON TARTAN**
Gordon plaid rep-silk parka and cashmere scarf skirt, Hunting Stewart plaid chiffon camisole, fall 1989

Mizrahi pursues his exploration of tartan, using it in unexpected ways—in chiffon, fine wool, and a high-quality, ribbed rep silk traditionally used for men's ties. "I love the contrast of something sewn and constructed next to something that's not. This is just a gorgeous piece of plaid cashmere pinned as a skirt." In the silk parka he pokes fun at WASP culture, with its fixation on plaid, but also appropriates that style and makes it his own.

**[86] CENTRAL PARK ROCK NECKLACE**
Molded resin, fall 2010

**[87] STORM COAT**
Impermeable iridescent cotton coat with alpaca button-in lining, wool jersey hat, fall 1989

"This basic piece has become a luxurious item based on a few modifications that are barely noticeable to the naked eye. No pretense. Sensuality and proportion. True ideals of luxury."

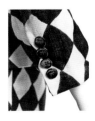

**[94] SKETCH FOR FLOWER SUIT**
spring 1990

**[95] HARLEQUIN SUIT**
Linen suit, print collaboration with Maira Kalman, spring 1990

Inspired by Henri Matisse's costumes for Sergei Diaghilev's Ballets Russes, Mizrahi worked with the artist Maira Kalman to create artwork for this black-and-white series of prints. "I wanted elemental things: stripes, gingham, checks, harlequins, dots of different sizes, swirls. Who else could give brush strokes this kind of intention and weight? Maira can give meaning to a stripe."

**[88, 89] LUMBERJACK BALL GOWN**
Lumberjack plaid impermeable-silk down-filled jacket, silk taffeta skirt, fall 1994

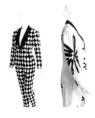

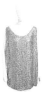

**[96, 97] HARLEQUIN SUIT, FLOWER SUIT**
Linen suits, print collaboration with Maira Kalman, spring 1990

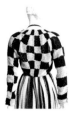

**[98] SKETCH FOR STRIPED DOUBLE-FACE SATIN SMOCK**
fall 1989

**[99] CHECKERBOARD AND STRIPED**
Jacket with wooden beads, print collaboration with Maira Kalman, spring 1990

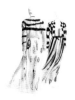

**[100] SWIRL, CHECKERBOARD AND STRIPED**
*Swirl*: jacket with wooden beads, linen and chiffon apron gown; *Checkerboard and Striped*: jacket with wooden beads, chiffon apron gown, print collaboration with Maira Kalman, spring 1990

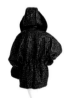

**[102, 103] EXPLODED SEQUIN PARKA**
Wool Melton parka with sequins and fox-fur trim, fall 1989

Giant sequins hand-sewn on a wool Melton drawstring parka are Mizrahi's nod to the late-eighties explosion of bling, and reflect his interest in appropriating street style in high fashion. "Hip-hop culture affected me a great deal. And maybe I affected it as well."

**[105] GARBAGE CAN DRESS**
Exploded aluminum-sequin tank dress, fall 1989

After a trip to London at age seventeen, Mizrahi became obsessed with armor and the "feral past" of the British Empire, "which belies what we consider a highly civilized, genteel society." Here, custom-made, oversize matte sequins make reference to medieval armor; they also came to be known as "garbage can lids."

**[106] RHINESTONE COLLAR**
Rhinestones, melamine placket, spring 2011

**[107] SHIRT CUFFS**
Resin, rhinestones, fall 2011

**[108, 109] THE REAL THING**
Coca-Cola–can paillette dress, spring 1994

The Coke can makes an improbable appearance on the runway: Mizrahi used an elaborate process to create these custom paillettes from real Coca-Cola cans. He worked with the charity We Can, which employed homeless New Yorkers to collect cans to recycle; these were shipped to the sequin-maker Langlois-Martin in Paris, where they were cut into paillettes that were then sent to India to be sewn onto dresses. The result is a high-fashion, nearly weightless modern take on a ubiquitous American icon.

**[110, 111] RABBIT EARS**
Silk georgette sling-back dress, crystal beads, fall 1990

Mizrahi's first costumes for dance were for Twyla Tharp's *Brief Fling* (page 198). At a fitting, a dancer shrugged her shoulders and off came her clothes. The memory led to the *Rabbit Ears* dress. As in the backless *Wings* shirt (page 33), a gesture becomes the starting point of a garment's architecture. The straps and low-slung draped back were a design breakthrough, based on close observation of movement and studious care to avoid complexity in construction.

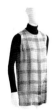

**[112, 113] SEQUIN MATRIX**
Square sequins, silk chiffon, spring 1991

The challenge here was to explore the interplay of the opaque and the transparent. Mizrahi mapped a peekaboo arrangement of square sequins strategically onto diaphanous silk chiffon by first making a grid of their placement on muslin. The effect recalls bitmapped or pixilated patterns—still a new visual motif in 1991.

**[114] GINGHAM BUGLE BEADS**
Bugle-bead dress with cotton turtleneck, spring 2007

**[116] SKETCH FOR THE FALL 2009 COLLECTION**

**[117] SKETCH FOR MAZE RED RUG COAT**
fall 1995

[118] **DUST BAG BAG**
Leather, silk, canvas, fall 2009

[119] **FLIP-FLOPS**
Leather, mink, fall 2009

[120] **MINK BLANKET**
Mink coat, fall 1988

For his first runway show, Mizrahi was already keenly attuned to the notion that beauty was to be found in the most elemental construction. The pattern for this coat is deceptively simple: a straight piece of cloth, with tube sleeves inserted and a seam up the back. The coat was made in a number of fabrics, but mink provided the most striking contrast to the straightforward design.

[122] **SKETCH FOR TEE PEE COCKTAIL**
fall 1991

[123] **TEE PEE COCKTAIL WITH GLOVES**
Suede cocktail dress with glass beads, suede gloves, fall 1991

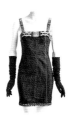

[124, 125] **TEE PEE SHEARLING**
Beaded shearling coat, stretch wool crepe jumpsuit, fall 1991

Cultural references from Mizrahi's youth are liberally mined for the Tee Pee series—he cites "homegirls, JAPs, and American Indians" as source material integrated in a shearling coat richly beaded with Maltese crosses, Jewish stars, and Native American motifs of the sort that might be found in a souvenir shop. "It's sporty, functional, easy to wear, and yet hilarious."

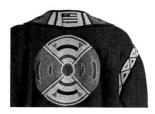

[126, 127] **TEE PEE SHEARLING**
Beaded shearling coat, stretch wool crepe jumpsuit, fall 1991

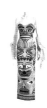

[128] **SKETCH FOR TOTEM POLE GOWN**
fall 1991

[129] **TOTEM POLE GOWN**
Embroidered wool flannel, chamois gloves, fall 1991

The *Totem Pole* gown inadvertently became a Mizrahi icon when donned by Naomi Campbell on the cover of *Time* magazine in 1991 (page 186). Part of the Tee Pee series, the design was his take on indigenous American symbols.

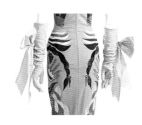

[130, 131] **TOTEM POLE GOWN**
Embroidered wool flannel, chamois gloves, fall 1991

[132, 133] **CALLIOPE**
Velvet kimono with glass bugle-bead interior and metallic silver-thread exterior, wool jersey dress, fall 1992

The interior of this lavish robe is lined with beaded floral patterns reminiscent of Tiffany glass. Yet while the beading inside plays coy, the exterior is equally wrought with metallic silver stitching that counters the weighty black velvet. "It was my intention to innovate this technique of beading so that it's just as beautiful on both sides—to hide the beading inside and create a new surface on the exterior."

[134] **SKETCH FOR UNHAPI COAT**
fall 2009

[135] **TOGETHER BUT SEPARATES**
Wool crepe batwing jacket, striped cashmere jersey tunic, silk and wool trousers, leather tote hat, fall 2009

Mizrahi stayed true to his inventive humor, even as the challenges of the fashion business were growing. For a show called Smile, he borrowed from images of women in Africa carrying large baskets balanced on their heads. The famed Elsa Schiaparelli *Shoe Hat* was also a reference, but "this is less surreal and comes from a source of utility. And it's also hilariously funny."

[136] **SKETCH FOR ORANGE-ORANGE COAT AND JUMPSUIT**
fall 1988

[137] **ORANGE-ORANGE COAT AND JUMPSUIT**
Wool Melton coat with wool jersey striped jumpsuit, wool crepe scarf, fall 1988

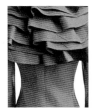

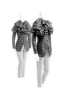

**[138] KIMONO LAYERS**
Alpaca kimono robe, wool Melton coat, wool crepe coatdress, ribbed cotton turtleneck and matching hose, leather belt and cap, fall 1990

Three strata in a bright palette are worn one on top of the other over a base of white tights and turtleneck, together with a matching white cap. This layering was inspired by a Japanese tradition within geisha culture in which kimono, *haori,* and other precise items of clothing are worn in a specific order. Mizrahi mingles this concept with an obsessive mixing of colors. The idea was produced in several different palettes, each in a narrow spectrum of hues—greens, pinks, purples, or yellows. "I would do color stories with swatches. My dream was to make textiles in every color."

**[139] PLACEMAT SKIRT**
Alpaca and sheared beaver peacoat, wool and cotton matelassé skirt, cotton turtleneck, matching hose, fall 1990

In the streamlined *Placemat* skirt, "I was trying to make things simpler, to take everything away; so there are no darts, nothing, just one button." Mizrahi adds "the thickest pair of tights imaginable, with a flat shoe and a cloche hat, to take away even the tiniest objectifying edge of a miniskirt."

**[140] SKETCH FOR THE SPRING 1994 COLLECTION**

**[141] SKETCH FOR ZIG ZAG GREEN RUG COAT**
fall 1995

**[142, 143] BLOSSOM BLAZER**
Double-silk gazar jacket with ruffle collar, silk crepe pants, spring 1991

"I tried to take the silliest things, like ruffles, and toughen them up." Here, ruffles are writ large, recalling the Elizabethan ruff and giving structure to a decorative element. The jacket was produced in pink, orange, or aquamarine. The aim was to turn a daywear blazer into an article of evening dress.

**[144] ORCHID-GRID**
Silk box-plaid taffeta gown, spring 2008

**[146] ASTAIRECASE CARDBOARD BOATER HAT**
spring 2010

**[147] BRIEFCASE**
Plywood, metal, leather, spring 2010

**[149] COTTON CANDY COCKTAIL**
Mohair dress with sequins and double-face satin ribbon, fall 1994

In a bodice of embroidered sequins juxtaposed with mohair, Mizrahi pays homage to Geoffrey Beene, who was known for combining mohair with evening-wear fabrics. A blithely humorous element is introduced with a reference to a retro sixties baby-doll look in a color aptly named Pepto Pink.

**[150, 151] POODLE DRESS**
Synthetic silk dress with ribbon embroidery, spring 1995

The fifties-inspired dress, elaborately crafted with pink lace petals, is a meringue of animated volume, yet still light as air.

**[152, 253] UNDONE**
Satin ball gown, spring 1998

Like the *X-Ray* coat (page 64), this dress reveals its exoskeleton with exposed ribbing in the bodice, horsehair interfacing at the bustline, and grosgrain at the waist. The "dead rose"-color satin was inspired by a gown worn by Deborah Kerr in the musical film *The King and I*. Mizrahi sent the movie to the textile house in Italy to have the color perfectly matched.

**[154, 155] ELEVATOR PAD GOWN**
Grosgrain-ribbon bodice, quilted silk and lamb's-wool skirt, spring 2005

Workhorse elevator padding used by movers inspired Mizrahi. He appropriated the quilting technique, but elevated the shipping blanket in a patchwork of blue, green, gray, and silver silk. The bodice was shaped from grosgrain ribbons, using heat molding.

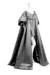

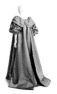

**[156, 157] JUPITER**
Silk crepe drawstring dress with silk gazar ruffle, duchess satin drawstring opera coat, spring 1991

"Anyone could wear this coat, it doesn't matter their age or shape." *Vanity Fair* famously wrapped a pregnant and bare-bellied Demi Moore in Mizrahi's iridescent coat on its August 1991 cover.

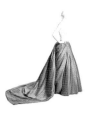

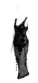
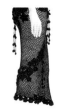

**[158, 159] BALL GOWN SPORT**
Silk taffeta ball-gown skirt, cotton
T-shirt, fall 1994

With most of his designs, Mizrahi
creates context and stories around
women's lives. In this look, one of
his most iconic, he proposes that a
woman feel extremely comfortable
while being as dressed up as possible.

**[160] SKETCH FOR EVERYFLOWER
DRESS**
fall 2007

**[161] SKETCH FOR EXPLODED POPPY
BOATNECK DRESS**
spring 1992

**[162, 163] BABY BJORN BALL GOWN**
Duchess satin strapless ball gown and
matching baby carrier, fall 1998

"The birth of a child should be
integrated into a woman's social life."

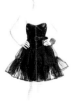

**[164, 165] WRAP BUSTIER-BELT**
Studded leather bustier-belt, black
synthetic net skirt, short cotton
pantaloons, tooled and jeweled
leather bracelets, spring 1992

Mizrahi invents a wrap belt that
is simply extended to become a
bustier. "I'm so proud of this. A real
engineering feat that seems effortless,
as if a bustier-belt had always existed."
He playfully juxtaposes his take on
S&M studded leatherwear with a frilly
tulle skirt. The studs and black leather
inform the way the bustier-belt is
seen; another version, executed in
tooled Western leather (page 75),
creates a very different impression.

**[166, 167] LEATHER SEQUIN**
Saddle-leather paillette gown, fall 1992

Sequins of all descriptions are key
components in the Mizrahi tool kit.
For this dress he invented a new
variation on the theme, working with
artisans in Paris to make delicate
paillettes of fine leather. When
sewn on chiffon, the leather is at
once rich and supple, yet allows for
translucency in the negative space
around the circles. The challenge was
to use a muscular material like leather
to create a diaphanous, fragile, and
nearly transparent dress.

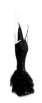

**[168, 169] MAMBO**
Handmade eagle-pattern beaded lace
dress, spring 1992

Mizrahi's love of citation from
unexpected sources is irrepressible:
traditional soutache lace is
embroidered and beaded with
Americana motifs—rondelles with
eagles and stars. "It's as if the classic
glamour of Norell's *Mambo* dress met
Miss Kitty in *Gunsmoke*."

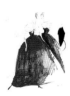
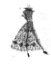

**[170] SKETCH FOR GRAY FLANNEL
LACE SKIRT AND TARGET SWEATER**
fall 2004

**[171] SKETCH FOR VELVET STRAPLESS
GOWN WITH SATIN KNOT**
fall 1988

**[172, 173] DOILY**
Black cotton string dress, semisheer
bodysuit, fall 1997

This hand-crocheted dress with
applied crocheted flowers was worn
on the runway with a sheer bodysuit.

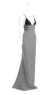

**[174] COLOR BLOCK**
Double-face wool gown, fall 2004

Mizrahi boldly mixes colors from the
hottest zone of the color wheel in a
high-waisted gown of red, pink, and
orange wool. Rather than dazzle with
a shimmering surface, he deploys a
matte finish and vibrating color.

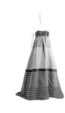

**[176, 177] KITCHEN SINK PINK**
Wool, silk, and synthetic dress,
fall 2006

The mixed use of natural and
synthetic, high-end and mass-market
fabrics is a striking feature of Mizrahi's
work. *Kitchen Sink Pink* is a cascade of
shades in a rosy palette, inspired by
the pink neon sculptures of Dan Flavin
(page 26).

# index

Page numbers in *italics* indicate illustrations.

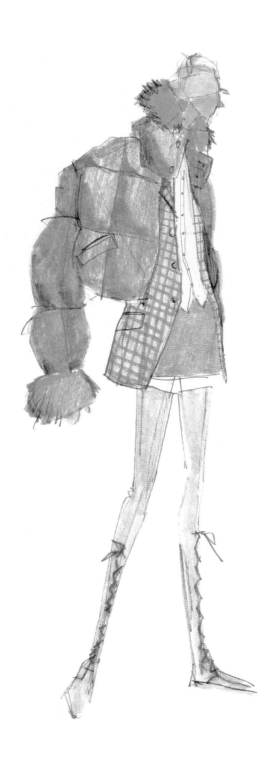

Sketch for the fall 1994 collection.

# credits and permissions

The photographers, sources of visual material other than the owners indicated in the captions, and copyright holders are listed below. Every reasonable effort has been made to supply complete and correct credits; if there are errors or omissions, please contact Yale University Press or the Jewish Museum so that corrections can be addressed in any subsequent edition. Material in copyright is reprinted by permission of copyright holders or under fair use. Page numbers are **bold**.

All clothing and artworks by Isaac Mizrahi are © IM Brands, LLC. **Pages 6, 12, 17, 24, 28, 33–38, 40–47, 50–51, 53–75, 77, 79–81, 84–93, 95–97, 99–114, 118–120, 123–127, 129–133, 135, 137–138, 142–159, 162–169, 172–177, 178, 184** top right, **198** top left, **203, 210–211, 214** top: Photographs © Jason Frank Rothenberg. **Pages 8, 10, 39, 48–49, 52, 76, 78, 82–83, 94, 98, 116–117, 112, 128, 134, 136, 140–141, 160–161, 170–171, 198** bottom, **232:** photographs by Richard Goodbody. **14:** Photograph © Annie Leibovitz/Contact Press Images. **16:** Photograph by Dan Lecca. **18:** Photograph © Isaac Mizrahi. **19:** Portman photograph by Evan Agostini, image provided by Getty Images. Minnelli image provided by Michel Haddi Studio Ltd. Parker photograph © Gregory Pace/Corbis, image provided by Getty Images. **20:** Streep photograph by Vince Bucci, image provided by Getty Images. Clinton photograph by Dimitrios Kambouris, image provided by Getty Images. Obama photograph by Chip Somodevilla, image provided by Getty Images. **21:** Photograph by Hiroyuki Ito, image provided by Getty Images. **22:** Courtesy of Target Corporation. **25:** Images © Isaac Mizrahi. **26:** Artwork © Dan Flavin/Artists Rights Society (ARS), New York, photograph provided by Dia Art Foundation, New York; photograph by Bill Jacobson © Stephen Flavin/Artists Rights Society (ARS), New York. **27:** Photograph by Dan Lecca. **180** top: photograph by Robin Platzer, image provided by Getty Images. Bottom: CBS Photo Archive, image provided by Getty Images. **181:** Photograph © Isaac Mizrahi. **183** bottom left: The Kobal Collection at Art Resource, NY. Right: poster © Miramax, image provided by Everett Collection/Alamy. **184** top

left and bottom: Images provided by the Guggenheim Museum. **186:** *Time* Magazine, September 16, 1991, © 1991 Time Inc. Used under license. **188** top left: artwork © Daniel J. Martinez, image courtesy of the artist and Roberts & Tilton, Culver City, California. Right: photograph © Isaac Mizrahi. **190:** Artwork © The Andy Warhol Foundation for the Visual Arts, Inc./Artists Rights Society (ARS), New York, digital image © The Museum of Modern Art/Licensed by SCALA/Art Resource, NY. **191** top: San Francisco Museum of Modern Art, Accessions Committee Fund: gift of Jean Douglas, Doris and Donald Fisher, Elaine McKeon, Byron R. Meyer, and Helen and Charles Schwab, artwork © Richard Prince. Bottom right: artwork © The Andy Warhol Foundation for the Arts, Inc./Artists Rights Society (ARS), New York, image provided by Christie's Images/Bridgeman Images. Bottom left: image provided by Mary Boone Gallery, New York. **192** top left: artwork © Kate Rothko Prizel & Christopher Rothko/Artists Rights Society (ARS), New York, photograph provided by Art Resource, NY. Bottom left and center: images © Isaac Mizrahi. **193:** Photograph © Isaac Mizrahi. **194** bottom: photograph by George Chinsee/W © Condé Nast. **195** left: image provided by Condé Nast Collection. **196:** Photograph by Clive Barda, image provided by ArenaPAL Images. **198:** Photograph by Dan Lecca. **201** top: photograph by Clive Barda, image provided by ArenaPAL Images. Bottom: photograph by Henrietta Butler, image provided by ArenaPAL Images. **202:** Photograph by Henrietta Butler, image provided by ArenaPAL Images. **204** left: photograph by Joan Marcus. Top right and bottom: photograph by Henrietta Butler, image provided by ArenaPAL Images. **206–7:** Photograph by rudy k, image provided by Almay. **208–9:** Photograph © Ken Howard/Opera Theater of Saint Louis. **213** top: photograph © Ken Howard/Opera Theater of Saint Louis. Bottom: photograph by Marilyn Kingwill, image provided by ArenaPAL Images. **214:** Photograph by Ken Friedman. **217** top: photograph by Hiroyuki Ito, image provided by Getty Images. **218:** Photograph © Ken Howard/Opera Theater of Saint Louis.

This book has been published in conjunction with the exhibition *Isaac Mizrahi: An Unruly History*, organized by the Jewish Museum, New York, March 18–August 7, 2016.

The Jewish Museum
1109 Fifth Avenue
New York, New York 10128
thejewishmuseum.org

Yale University Press
PO Box 209040
New Haven, Connecticut 06520–9040
yalebooks.com/art

*The Jewish Museum*
Director of Publications: Eve Sinaiko

*Yale University Press*
Publisher, Art and Architecture: Patricia Fidler
Editor, Art and Architecture: Katherine Boller
Production Manager: Sarah Henry

*Designed by*
J. Abbott Miller, Andrew Walters,
Yoon-Young Chai, Pentagram

Typeset in Aperçu type by Colophon
Separations by Professional Graphics, Inc.
Printed in China by Regent Publishing
Services Limited

Library of Congress Control Number: 2015940462
ISBN 978-0-300-21214-3

A catalogue record for this book is available from the British Library.

The paper in this book meets the requirements of ANSI/NISO Z 39.48–1992 (Permanence of Paper).

10 9 8 7 6 5 4 3 2 1

On the cover: detail of *Colorfield*, fall 2004; see page 92.

Front endpaper: detail of *Grand Pupa*, spring 2009; see page 4.

Back endpaper: details of *Poodle Dress*, spring 1995, and *Blossom Blazer*, spring 1991; see pages 151 and 142.

Page 2: *Elevator Pad Gown*, spring 2005; see page 155.

Page 6: Tibor Kalman's logo design for Isaac Mizrahi.

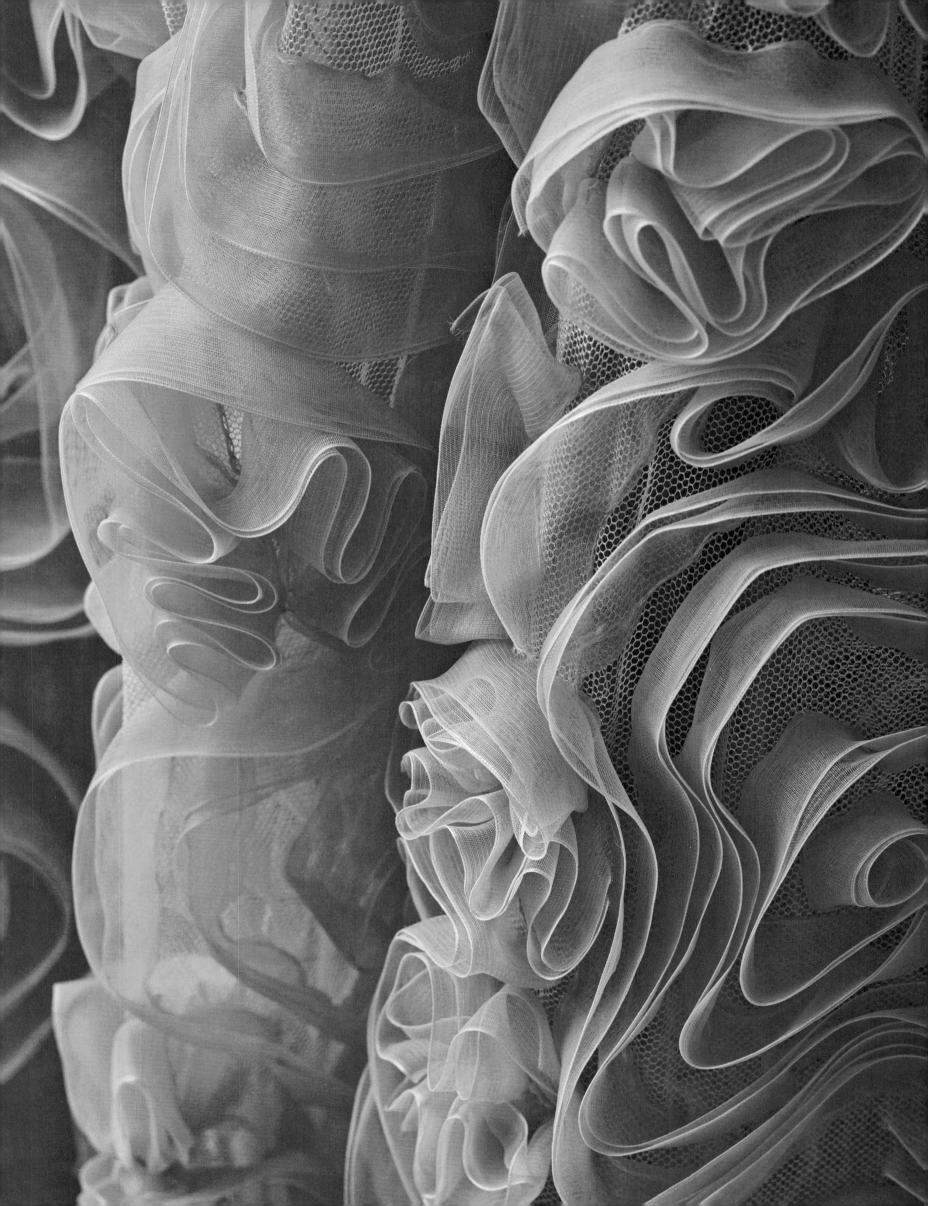